MANNY FARBER ABOUT FACE

ABOUT FACE MANNY FARBER

MUSEUM OF CONTEMPORARY ART SAN DIEGO

Foreword by Hugh M. Davies

Essays by Jonathan Crary, Stephanie Hanor,

Sheldon Nodelman, Robert Polito, and Robert Walsh

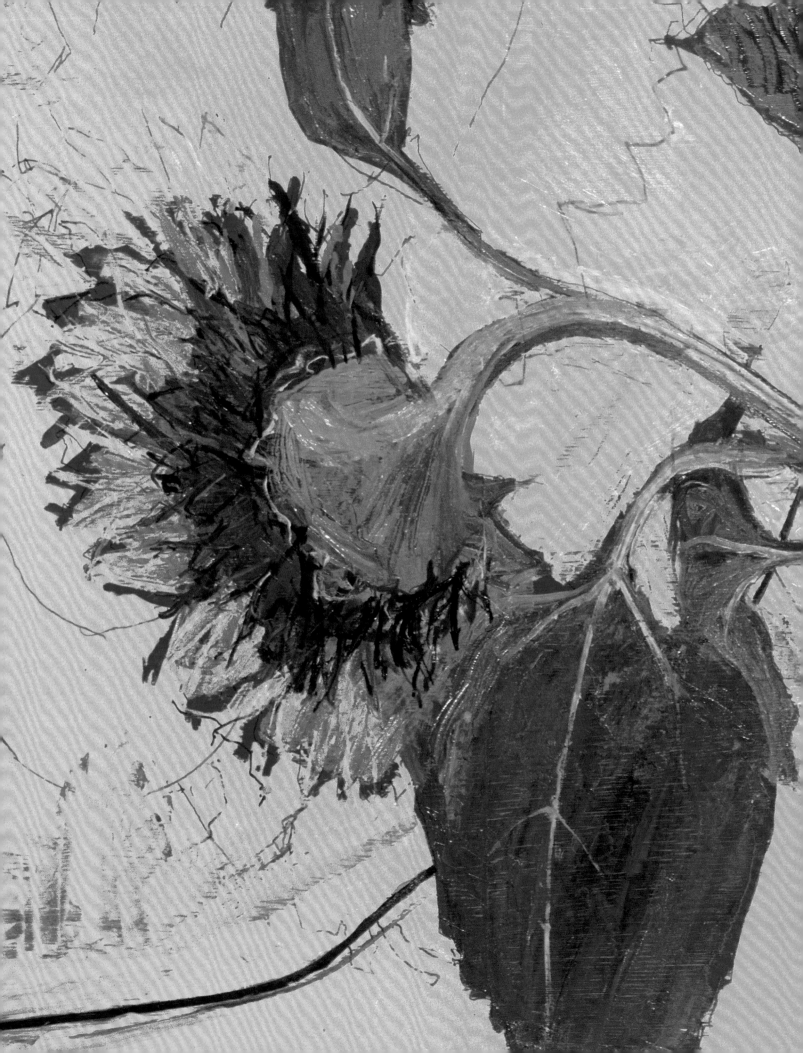

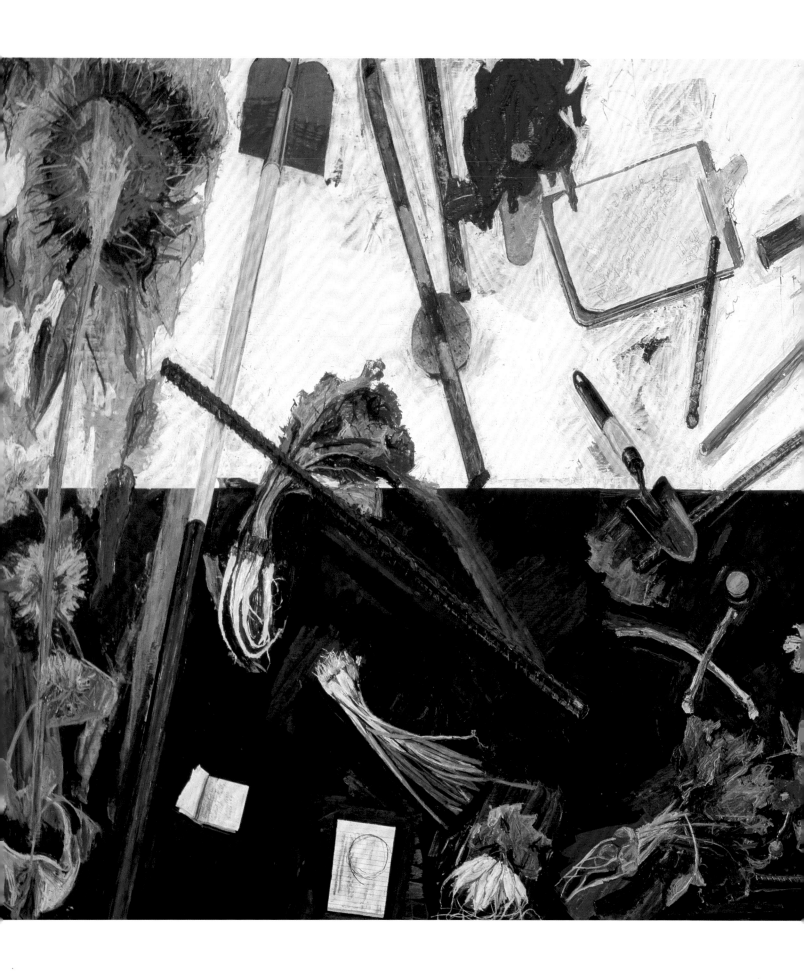

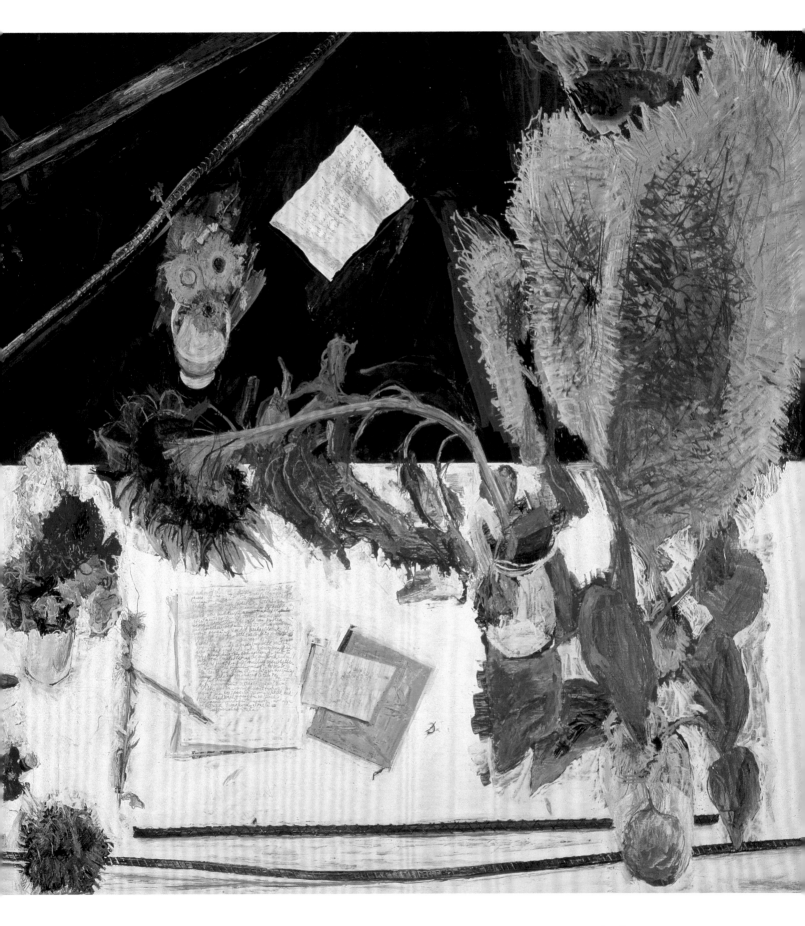

Abundance, 1991
Oil on board
60 x 120 inches

Most of what I liked is in the termite area. The important trait of termite-fungus-centipede art is an ambulatory creation which is an act both of observing and being in the world, a journeying in which the artist seems to be ingesting both the material of his art and the outside works through a horizontal coverage.

Manny Farber, Introduction to *Negative Space*, 1971

Published on the occasion of the exhibition
Manny Farber: About Face.

Manny Farber: About Face is organized by the Museum of
Contemporary Art San Diego. The exhibition is made possible by
generous support from Colette Carson Royston and Dr. Ivor
Royston, as well as the Lead Corporate Sponsor, Imperial Capital
Bank. Additional funding comes from Barbara and Charles
Arledge; Robert L. Shapiro; The Cowles Charitable Trust, New York;
The James Irvine Foundation; and the City of San Diego Commission
for Arts and Culture.

**IMPERIAL
CAPITAL BANK**

Exhibition Itinerary:

Museum of Contemporary Art San Diego
September 14, 2003–January 6, 2004

Austin Museum of Art
Austin, Texas
June 5–August 24, 2004

P.S.1 Contemporary Art Center
Long Island City, New York
Fall 2004

Contents

ISBN 0-934418-63-2

Library of Congress Control Number 2003015244

Available through D.A.P./Distributed Art Publishers
155 Sixth Avenue, 2nd Floor
New York, NY 10013
Telephone (212) 627-1999; Fax (212) 627-9784

Edited by Sherri Schottlaender
Designed by Lehze Flax
Printed by Imperial Lithograph, Phoenix, Arizona

All photographs by Roy Porello, except: Matt Flynn: pp. 59 (bottom
left), 87 (top), 134, 135, 136, 137; Brian Forrest: pp. 44–45, 84, 86 (top
and bottom), 110–11; Ralph Gibson: p. 54; David Heald: p. 83 ©The
Solomon R. Guggenheim Foundation, New York; Babette Mangolte:
p. 55; Pablo Mason: inside front cover, pp. 4–5, 14, 15, 17, 18, 19, 20–21,
22, 23, 24, 47 (top), 59 (top left and top right), 65, 78 (top and bottom),
79, 80 (top and bottom), 81 (top and bottom), 82 (bottom), 85, 89, 101,
104, 116, 122, 125, 127, 128, 138, 139, 143 (bottom), 144–45, 146, 147,
157, inside back cover; Wally Musgrave: pp. 29, 33, 60, 66, 77, 88, 90,
91, 151, 164; Jude Pardee: p. 53; cover, pp. 6, 10, 50, 51, 52, 54 (right),
55 (left), 56 courtesy of Manny Farber and Patricia Patterson; p. 119
courtesy the Jack S. Blanton Museum of Art, University of Texas at
Austin; p. 105 courtesy the Rose Art Museum, Brandeis University;
p. 82 (middle) courtesy the San Diego Museum of Art; p. 82 (top)
courtesy David Wilson.

Front cover: Manny Farber in studio.
Half-title page: **Entropy** (*detail*), 1990. Oil on board, 36 x 36 inches
Title page: **About Face** (*detail*), 1990. Oil on board, 21 x 72 inches
Inside front cover: **Untitled** (*verso, detail*), ca. 1974. Acrylic on
collaged paper, 59 3/4 x 73 inches
Inside back cover: **Untitled** (*verso, detail*), ca. 1974. Acrylic on
collaged paper, 100 3/4 x 118 1/4 inches
Back Cover: **Untitled** (*verso, detail*), ca. 1974. Acrylic on collaged
paper, 68 5/8 x 67 inches

All excerpts by Manny Farber are reprinted in **Negative Space:
Manny Farber on the Movies** (New York: Da Capo Press, 1998)

Acknowledgments

Hugh M. Davies / The David C. Copley Director
Museum of Contemporary Art San Diego

In 1978, our museum—then known as the La Jolla Museum of Contemporary Art—organized the first retrospective of Manny Farber's groundbreaking work. That exhibition, which focused on his sculptures and abstract paintings on paper, revealed just a hint of the rich figurative paintings to come. Twenty-five years later, the Museum of Contemporary Art San Diego is proud to present the most complete survey of Farber's work to date, exhibiting for the first time his magnificent early abstractions alongside his later complex and beautiful still lifes.

This exhibition and catalogue would have been impossible without the assistance of Manny Farber and his wife, Patricia Patterson. The generosity they have shown by sharing their time, information, insightful observations, good humor, and faith has been integral to this process. The strength of their relationship and their dedication to one another have directly impacted the power of Manny's work as well as the success of this exhibition.

I would like to extend a particular thank-you to Manny's longtime gallery representative, Mark Quint, who provided invaluable time and knowledge. We are also grateful to Anna Quint and Katie Lewis at Quint Contemporary Art for their enormous assistance with myriad questions, details, and logistical planning.

For providing insight, new understanding, and thoughtful analyses of Manny's work as both a critic and a painter, I am grateful to the authors who have contributed essays to this catalogue: Jonathan Crary, Sheldon Nodelman, Robert Polito, and Robert Walsh. The Museum's outstanding graphic designer, Lehze Flax, has created a beautiful catalogue design that complements the artist's works perfectly. We would also like to thank Sherri Schottlaender for her editorial counsel.

There are numerous MCASD staff members whose time and expertise have gone into this project, but my first thank-you must be extended to Assistant Curator Stephanie Hanor.

She has brought her usual high level of curatorial skill, creativity, and sensitivity to every aspect of this project, and we are grateful. Special thanks also go to Curator Toby Kamps, Assistant Curator Rachel Teagle, Curatorial Coordinator Tracy Steel, Curatorial Assistant Joanne Leese, former Education Programs Assistant McLean Johnston, Chief Preparator Ame Parsley, Preparator Dustin Gilmore, Registrarial Assistant Meghan McQuaide Reiff, Registrar Mary Johnson, and former Research Assistant Tamara Bloomberg. Other staff who have been involved in this project include Director of External Affairs Anne Farrell, Director of Institutional Advancement Jane Rice, Deputy Director Charles Castle, Executive Assistant Sonia Lee, Grants Officer Verónica Lombrozo, Annual Giving Manager Synthia Malina, Corporate Giving Manager Jennifer Reed Rexroad, former Marketing Manager Jana Purdy, Public Relations and Marketing Officer Bryan Spevak, Controller Trulette Clayes, Manager of Retail Services Jon Weatherman, and summer intern Peter Holland.

An exhibition of this scale requires significant philanthropic support, and my gratitude is extended to Trustee Colette Carson Royston and Dr. Ivor Royston, who stepped forward as the exhibition's major underwriters. Colette has served on the MCASD Board of Trustees since 1986, and she and Ivor have been longtime collectors and supporters of Manny's work as well as generous patrons of the Museum. We are grateful for their contribution. We would also like to thank Trustee Barbara and Charles Arledge, Trustee Robert L. Shapiro, and Charles Cowles, Cowles Charitable Trust, New York, for their generous gifts. The Lead Corporate Sponsor of the project is Imperial Capital Bank, and we are very thankful for the enthusiastic support of Imperial Capital Bank's George Haligowski and Rica Lindsey. In addition, the Museum has benefited from major grant support from The James Irvine Foundation and the San Diego Commission for Arts and Culture; this support helps fund our educational and interpretive programs.

The lenders to the exhibition have been extremely generous and enthusiastic about allowing us to borrow their works for the length of the MCASD exhibition and its subsequent tour. Without their support for and belief in Manny Farber and our Museum, this exhibition would not have been possible, and we extend our sincerest gratitude.

I'd like to thank the other national institutions who are participating in the tour and to acknowledge Dana Friis-Hansen at the Austin Museum of Art, Austin, Texas, and Alanna Heiss at P.S.1 Contemporary Art Center, Long Island City, New York, for recognizing the importance of Manny's paintings and for wanting to share the experience of his work with their audiences. With the participation of P.S.1, a wonderful circle is completed. In 1978, under Alanna's direction, P.S.1 gave Farber exposure in New York by hosting an exhibition of his work, and Alanna has been our willing partner in bringing his work back to New York once again.

My last words of gratitude must go again to Manny Farber and Patricia Patterson, not only for their generous participation in the organization of this project, but also for the friendship and camaraderie we have shared over the past twenty years. It is my great personal pleasure to demonstrate to a larger audience, through this traveling exhibition and the accompanying catalogue, the depth, richness, and complexity of the work of Manny Farber, truly the dean of painters in our region.

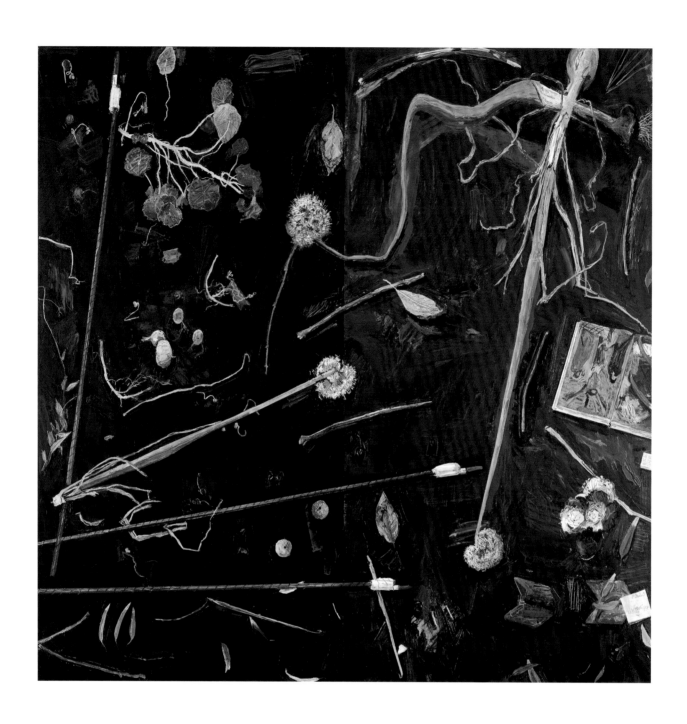

July 6, 1994 (*detail, opposite*), 1994
Oil on board
72 x 72 inches

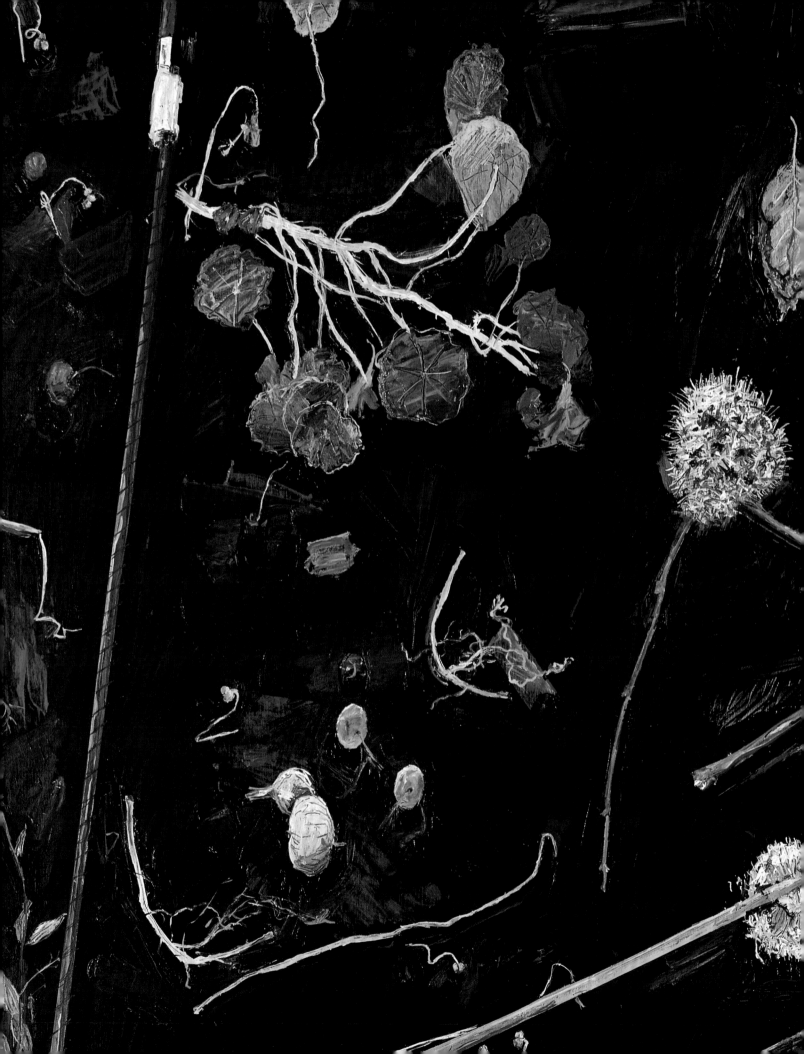

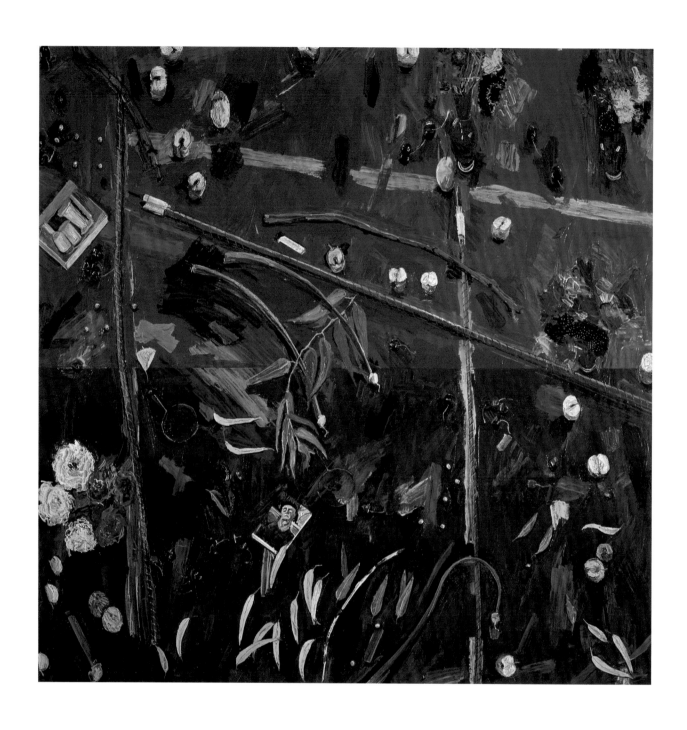

Cherry Pits, Onion Flowers, 1995
Oil on board
72 x 72 inches

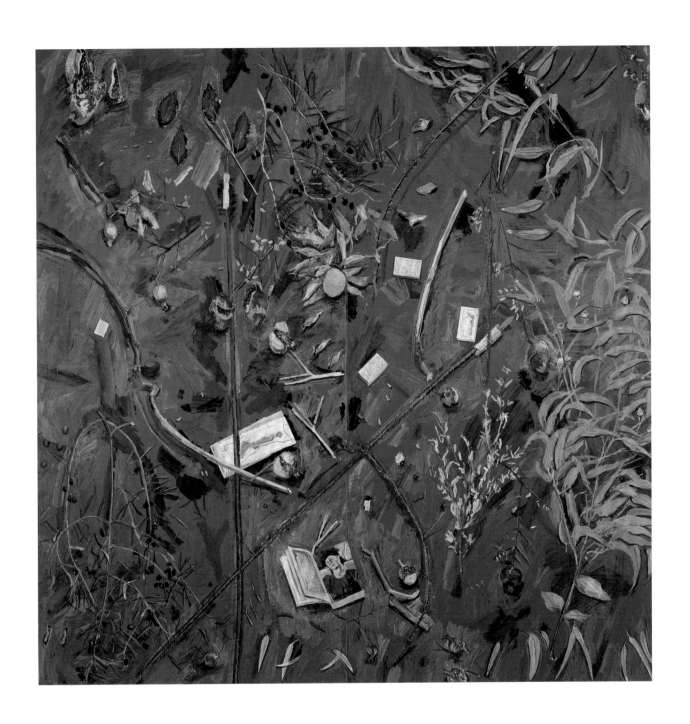

Batiquitos, 1995
Oil on board
72 x 72 inches

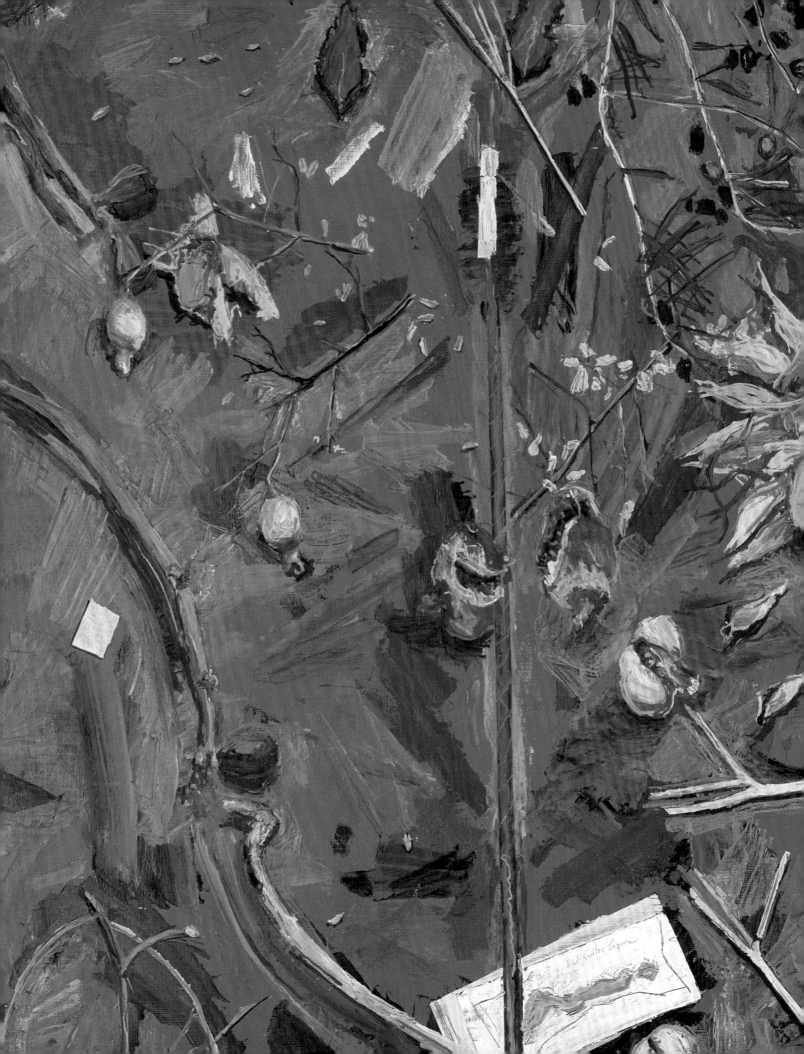

WHEN I FIRST arrived in San Diego in 1983, I was immediately impressed—in fact, infatuated—with the Manny Farber paintings I saw. In 1984 he completed the monumental and astoundingly beautiful *Domestic Movies*, and as the Museum's new young director, I brought it into our galleries on loan with the hope that someone of means would share my enthusiasm and, through this endorsement, purchase the work for our collection. Unfortunately I didn't succeed, but I did recommend the work to the prominent Los Angeles collector Robert Rowan, who immediately snapped up the painting for his own collection. In his exhibition at the Quint Gallery the next season, the artist—evidently stung that the Museum had not found a way to keep *Domestic Movies* in its own collection—included a painting with one of his characteristic illusionistic painted yellow Post-Its bearing these words: "We've been doing fine without their endorsement (La Jolla Museum) Fuck them."

Stung but undeterred, four years later we did manage to acquire his great painting *Story of the Eye* (1985), thanks to the Museum's Contemporary Collectors support group; we hoped we had redeemed ourselves in Farber's eyes. Happily, *Domestic Movies* has now returned to San Diego in a private collection, and it is featured in the current exhibition. And the Contemporary Collectors group—now in its eighteenth year—has for the first time in its history bought a second work by an artist: Farber's *Batiquitos* (1995) was added to MCASD's collection in 2003.

While a foreword is a notorious Petri dish for praise and superlatives, it is fair to state that in San Diego—which spawned John Baldessari and has been home for the past ten years to Robert Irwin—Manny Farber claims our attention and affection as our community's greatest painter. Farber is indeed a prophet in his own land. Since he joined the faculty of the University of California, San Diego (UCSD), in 1969, our Museum has acquired no fewer than four major works by the artist, and the current exhibition is the second Farber retrospective we have initiated (it follows the first survey in 1978 by

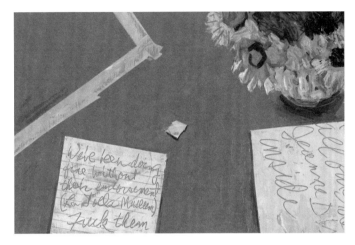

exactly twenty-five years). Southern California's recognition of Farber was also confirmed by a 1985 one-person exhibition at The Museum of Contemporary Art in Los Angeles, making him one of the first artists of our region so honored by this important and then-new West Coast museum.

Manny Farber's paintings also have been enthusiastically and generously acquired by numerous private collectors in Southern California. In our local region—not known as a center for art collecting—Farber's work has been purchased, repeatedly, by many San Diegans. His paintings have been an indispensable entry point for beginning collectors, and the obvious pleasure they have derived from living with his art has often resulted in subsequent acquisitions. Such sustained commitment and patronage of a single artist is rare in any part of the country, and certainly unprecedented in our city. Farber has particularly benefited from the intelligent, sustained support of one of the leading art galleries in San Diego, Quint Contemporary Art, for nearly twenty years. Indeed, it is the unique and reciprocally rich relationship between artist and admiring regional collectors which this retrospective chronicles and celebrates.

The fact that Farber's work has flourished over the last twenty years has much to do with his retirement from teaching, which has allowed him to focus fully in the studio.

above:
An Upbeat Title (*detail*), 1988
Oil on board
60½ x 120 inches

left:
Batiquitos (*detail*), 1995
Oil on board
72 x 72 inches

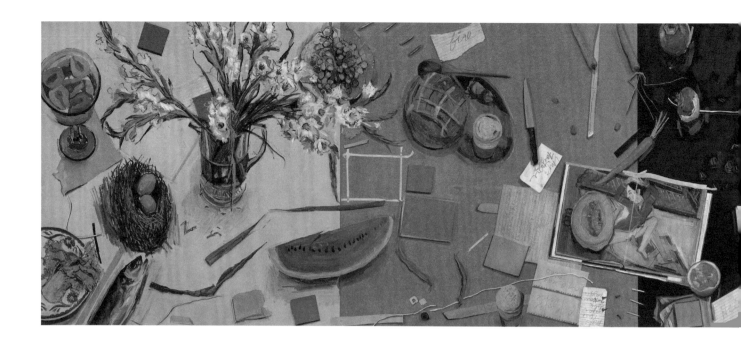

Since 1966 he has also benefited immeasurably from the nurturing and supportive intellectual and artistic relationship he shares with his wife, the accomplished artist Patricia Patterson. Comfortably ensconced in Encinitas, California, Manny and Patricia each work in individual large studios separated by the fruit tree–filled courtyard that adjoins their house. The entire artistic enclave is surrounded by an extraordinarily colorful, rich, fragrant, and seasonally evolving garden of fruits and flowers tended by Patricia.

Manny not only draws spiritual sustenance from this garden, but he also plucks still-life samples from its seasonal array to populate his paintings. If one were well versed in horticulture, it might plausibly be possible to identify the season or even the very month of a Farber picture by the size, color, and quality of its vegetal and floral contents. This intimate personal world and studio sanctuary, replete with the sounds of caged finches and wild birds feeding on the garden, is located less than a mile from the ocean to the west, and a short walk from the large, riparian Batiquitos Lagoon to the east; it is idyllic rather than Edenic due to neighboring Interstate 5, with its six throbbing lanes of traffic connecting San Diego and Los Angeles.

San Diego's—and indeed, all of Southern California's—enthusiastic embrace of Manny Farber undoubtedly con-

tributes to the fact that his work has often been viewed with a certain reserve, if not outright suspicion, by non-West Coast art-world audiences. His lush and vibrant palette, loose brushwork, casual facility with composition, and the superficially pretty appearance of his works perhaps make the paintings seem, to the New Yorker, undisciplined, self-indulgent, and overly sybaritic. In fact, Farber's warm palette, like that of his West Coast colleagues Richard Diebenkorn, Sam Francis, and Wayne Thiebaud, is an accurate impression of the bright light and intense colors of the California climate, in distinct contrast to the darker, somber palette of, say, Mark Rothko, Brice Marden, or Terry Winters. As much as art created by Matisse in the South of France or Morandi in Bologna, Farber's work is site-specific: it reflects his immediate domestic environment, which is constantly sunny and saturated with intense color.

Farber's work draws further criticism because he has eschewed the big impact of formal crescendo, preferring instead in his paintings to create skeins or series of linked little epiphanies. He articulates and occupies a shallow tabletop's horizontal space and moves about the surface of the painting with the same intuitive close focus as Pollock, but without his predecessor's muscularity and pace. Similar to his profound, insightful film criticism, Farber

Story of the Eye, 1985
Oil on board
36 x 180 inches

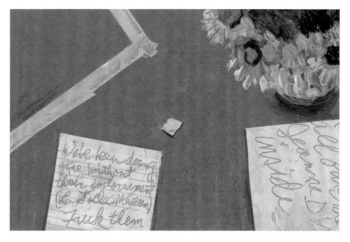

WHEN I FIRST arrived in San Diego in 1983, I was immediately impressed—in fact, infatuated—with the Manny Farber paintings I saw. In 1984 he completed the monumental and astoundingly beautiful *Domestic Movies*, and as the Museum's new young director, I brought it into our galleries on loan with the hope that someone of means would share my enthusiasm and, through this endorsement, purchase the work for our collection. Unfortunately I didn't succeed, but I did recommend the work to the prominent Los Angeles collector Robert Rowan, who immediately snapped up the painting for his own collection. In his exhibition at the Quint Gallery the next season, the artist—evidently stung that the Museum had not found a way to keep *Domestic Movies* in its own collection—included a painting with one of his characteristic illusionistic painted yellow Post-Its bearing these words: "We've been doing fine without their endorsement (La Jolla Museum) Fuck them."

Stung but undeterred, four years later we did manage to acquire his great painting *Story of the Eye* (1985), thanks to the Museum's Contemporary Collectors support group; we hoped we had redeemed ourselves in Farber's eyes. Happily, *Domestic Movies* has now returned to San Diego in a private collection, and it is featured in the current exhibition. And the Contemporary Collectors group—now in its eighteenth year—has for the first time in its history bought a second work by an artist: Farber's *Batiquitos* (1995) was added to MCASD's collection in 2003.

While a foreword is a notorious Petri dish for praise and superlatives, it is fair to state that in San Diego—which spawned John Baldessari and has been home for the past ten years to Robert Irwin—Manny Farber claims our attention and affection as our community's greatest painter. Farber is indeed a prophet in his own land. Since he joined the faculty of the University of California, San Diego (UCSD), in 1969, our Museum has acquired no fewer than four major works by the artist, and the current exhibition is the second Farber retrospective we have initiated (it follows the first survey in 1978 by

exactly twenty-five years). Southern California's recognition of Farber was also confirmed by a 1985 one-person exhibition at The Museum of Contemporary Art in Los Angeles, making him one of the first artists of our region so honored by this important and then-new West Coast museum.

Manny Farber's paintings also have been enthusiastically and generously acquired by numerous private collectors in Southern California. In our local region—not known as a center for art collecting—Farber's work has been purchased, repeatedly, by many San Diegans. His paintings have been an indispensable entry point for beginning collectors, and the obvious pleasure they have derived from living with his art has often resulted in subsequent acquisitions. Such sustained commitment and patronage of a single artist is rare in any part of the country, and certainly unprecedented in our city. Farber has particularly benefited from the intelligent, sustained support of one of the leading art galleries in San Diego, Quint Contemporary Art, for nearly twenty years. Indeed, it is the unique and reciprocally rich relationship between artist and admiring regional collectors which this retrospective chronicles and celebrates.

The fact that Farber's work has flourished over the last twenty years has much to do with his retirement from teaching, which has allowed him to focus fully in the studio.

above:
An Upbeat Title (*detail*), 1988
Oil on board
60½ x 120 inches

left:
Batiquitos (*detail*), 1995
Oil on board
72 x 72 inches

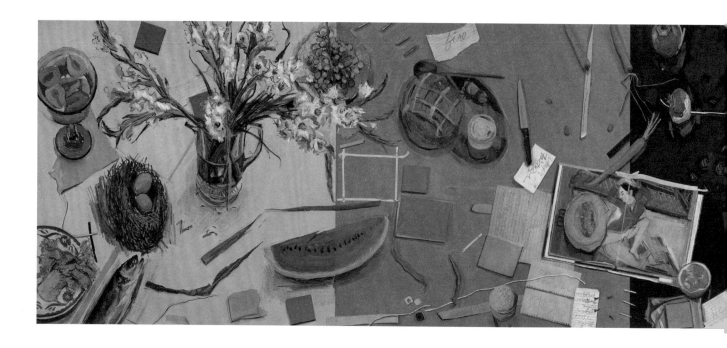

Since 1966 he has also benefited immeasurably from the nurturing and supportive intellectual and artistic relationship he shares with his wife, the accomplished artist Patricia Patterson. Comfortably ensconced in Encinitas, California, Manny and Patricia each work in individual large studios separated by the fruit tree–filled courtyard that adjoins their house. The entire artistic enclave is surrounded by an extraordinarily colorful, rich, fragrant, and seasonally evolving garden of fruits and flowers tended by Patricia.

Manny not only draws spiritual sustenance from this garden, but he also plucks still-life samples from its seasonal array to populate his paintings. If one were well versed in horticulture, it might plausibly be possible to identify the season or even the very month of a Farber picture by the size, color, and quality of its vegetal and floral contents. This intimate personal world and studio sanctuary, replete with the sounds of caged finches and wild birds feeding on the garden, is located less than a mile from the ocean to the west, and a short walk from the large, riparian Batiquitos Lagoon to the east; it is idyllic rather than Edenic due to neighboring Interstate 5, with its six throbbing lanes of traffic connecting San Diego and Los Angeles.

San Diego's—and indeed, all of Southern California's—enthusiastic embrace of Manny Farber undoubtedly con-

tributes to the fact that his work has often been viewed with a certain reserve, if not outright suspicion, by non-West Coast art-world audiences. His lush and vibrant palette, loose brushwork, casual facility with composition, and the superficially pretty appearance of his works perhaps make the paintings seem, to the New Yorker, undisciplined, self-indulgent, and overly sybaritic. In fact, Farber's warm palette, like that of his West Coast colleagues Richard Diebenkorn, Sam Francis, and Wayne Thiebaud, is an accurate impression of the bright light and intense colors of the California climate, in distinct contrast to the darker, somber palette of, say, Mark Rothko, Brice Marden, or Terry Winters. As much as art created by Matisse in the South of France or Morandi in Bologna, Farber's work is site-specific: it reflects his immediate domestic environment, which is constantly sunny and saturated with intense color.

Farber's work draws further criticism because he has eschewed the big impact of formal crescendo, preferring instead in his paintings to create skeins or series of linked little epiphanies. He articulates and occupies a shallow tabletop's horizontal space and moves about the surface of the painting with the same intuitive close focus as Pollock, but without his predecessor's muscularity and pace. Similar to his profound, insightful film criticism, Farber

Story of the Eye, 1985
Oil on board
36 x 180 inches

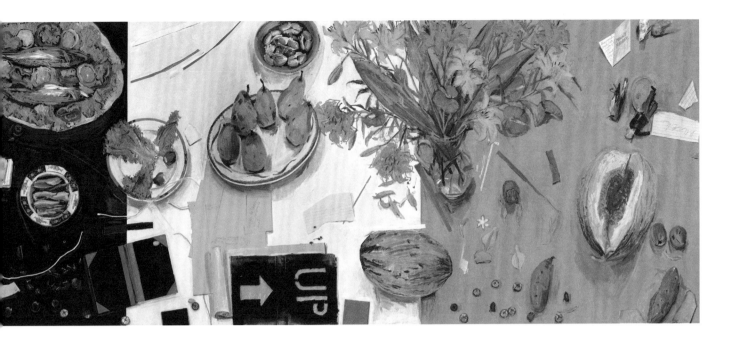

distrusts the "big idea" in his painting, preferring, in "termite" fashion, to sneak up and compose the Big Picture through a sustained sequence of apparently unrelated small observations and discoveries. Yet I would venture to say that many an artist could build an entire career out of the formal inventions and brushwork found in five square inches of a single Farber painting, as his virtuosity flourishes at both the macro- and micro level.

One's impression is that, for Farber, writing came hard, that he labored for hours, if not days, to turn the precise phrase that would result in a series of apparently modest observations adding up to a remarkably insightful understanding of the film at hand. I believe that with painting, however, Farber is easier on himself. He is prolific, confident, trusting, and even self-indulgent, permitting himself the pleasure of pairing and repetition. Liberated by age and hard-won self-confidence—perhaps because he is himself a critic—he is less paralyzed by the prospect of others' opinions and subsequent scrutiny.

The fact that a tough, terse, former New York film critic could allow himself such liberties and revel in the sensual joy of painting is a remarkable balancing act and testament to a very strong intellectual constitution. Although they are superficially sensuous, light, and bright, the works also

reveal a very somber side when viewed in totality. The full import of *nature mort* is often evident in the selection of still-life elements such as dead flowers and dead birds, and the foreground and background palettes frequently skew to the somber spectrum of ochres, burgundies, and blacks as the artist confronts the ephemeral and the fugitive *memento mori* of his tabletop tableaux. Farber frequently takes us right down into the earth with the iconic rusting reinforcing rods that structure so many of his compositions.

In the end, like any truly great artist, Manny Farber cannot be pinned down to a single style or statement. His vast contribution over a life encompassing more than eighty-six years is complex, nuanced, and rich beyond easy categorization or simple understanding. Thank goodness we have the opportunity to live with, study, and learn from these remarkable paintings, as well as to celebrate their author with grateful thanks in the form of this exhibition and catalogue, which document his extraordinary achievement.

pages 22—24:
Story of the Eye (*details*), 1985
Oil on board
36 x 180 inches

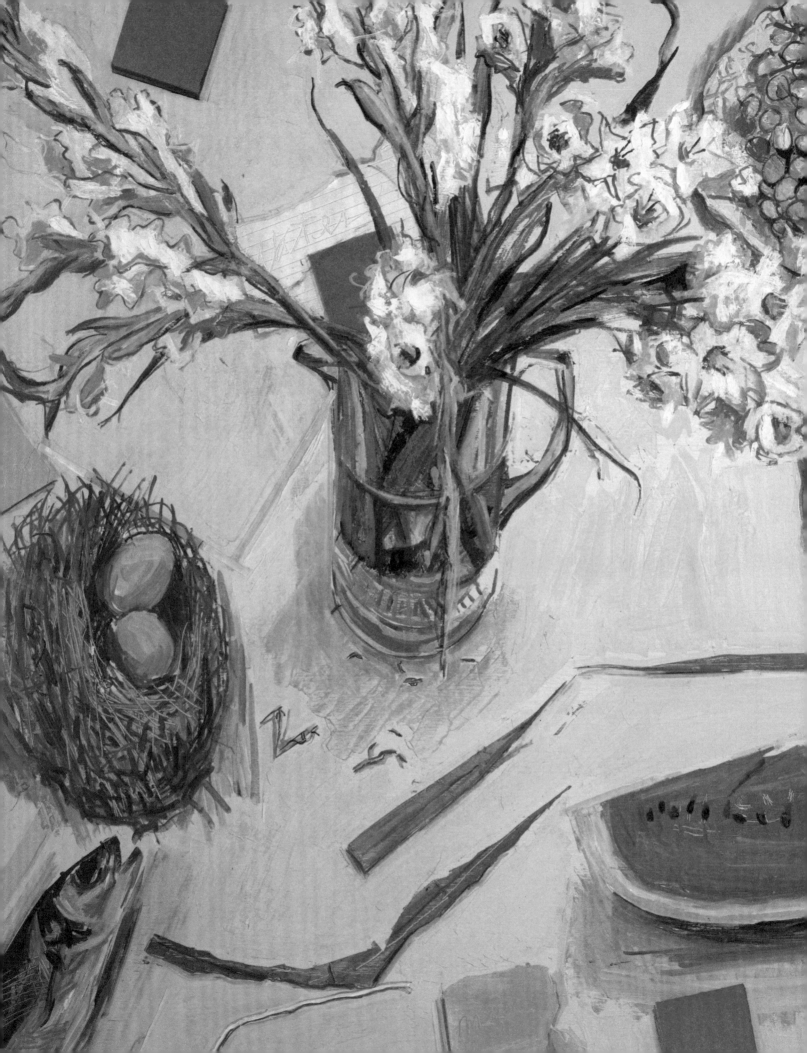

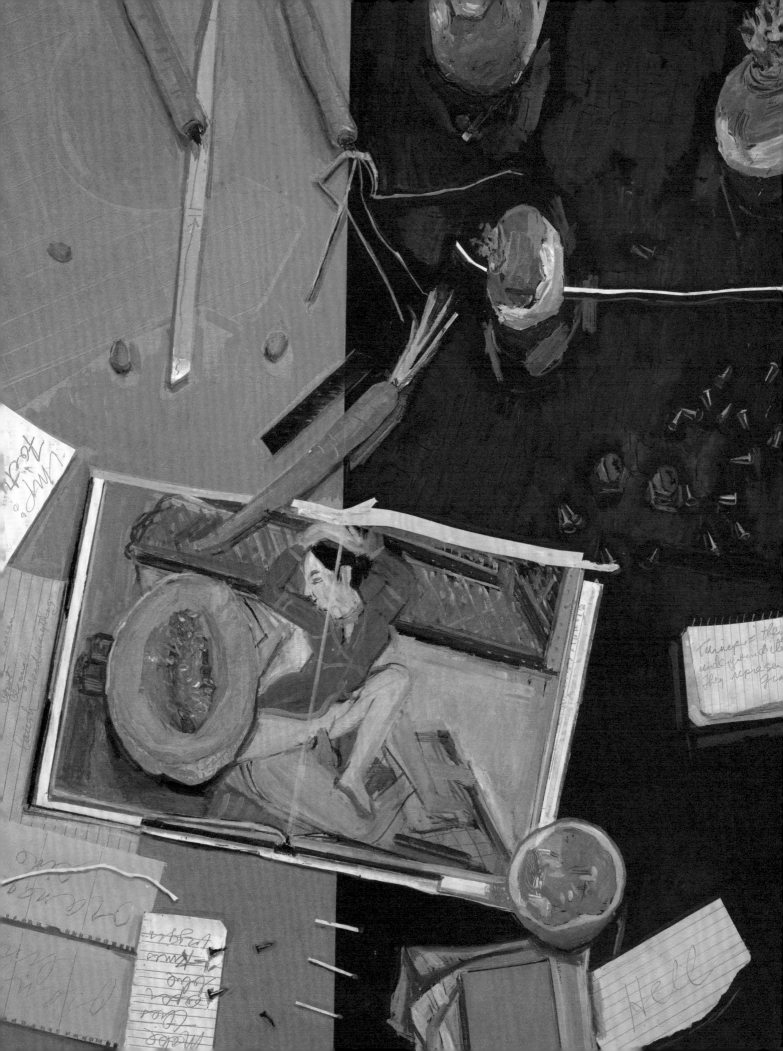

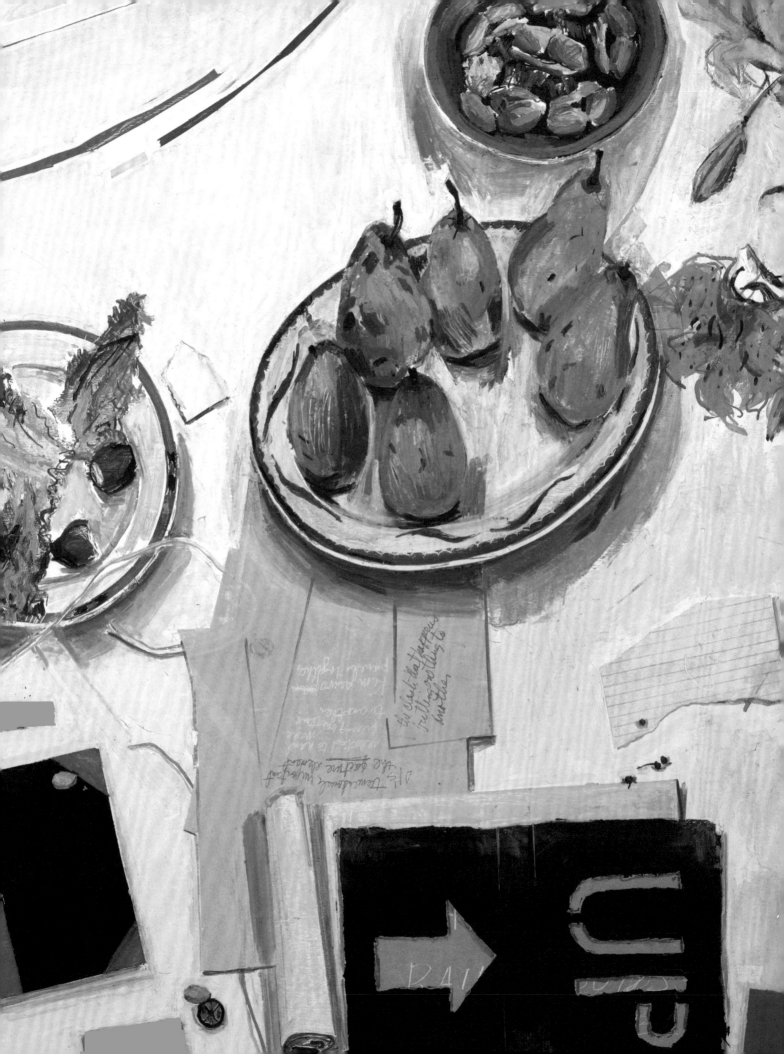

Robert Walsh

In the world of Manny Farber, **A** is for **Abstract Expressionism** or **action painting**: Farber's work was exhibited in early Abstract Expressionist shows, and his friends included Jackson Pollock, Robert Motherwell, and many other New York artists. (His appreciation of Pollock was published in *The New Republic* as far back as 1945.)

A is also for **additive method**: In their essay "The Farber Machine," Jean-Pierre Gorin and Patrick Amos point out that Farber's method is "never one of either/or; he favors 'and . . . and . . . and'"—which can be read as one thing plus another plus another, or as a kind of stammer.

A is for **aerial vantage** (or bird's-eye view), for **allover composition**, and for two phases of Farber's work: the self-explanatory "**American Candy**" series, and the "**Auteur**" series, which featured material and associations related to such film directors as Howard Hawks and Preston Sturges, on to Rainer Werner Fassbinder, Jean-Marie Straub and Daniele Huillet, and Marguerite Duras.

Masterpiece art, reminiscent of the enameled tobacco humidors and wooden lawn ponies bought at white elephant auctions decades ago, has come to dominate the over-populated arts of TV and movies. The three sins of white elephant art (1) frame the action with an all-over pattern, (2) install every event, character, situation in a frieze of continuities, and (3) treat every inch of the screen and film as a potential area for prizeworthy creativity.

Manny Farber, "White Elephant Art vs. Termite Art," 1962

B

is for a feeble, slightly derogatory term for Farber's spatial orchestrations—**balance**; B is also for oil on **board**, not canvas.

C

—a major entry—is for **carpentry**, which is how Farber earned a living for much of his life and which shows up in the paintings in a predilection for building materials such as rebar, crowbars, rakes, and shovels.

C is for **Cézanne**: Farber described some of his earliest work as "Scenes around the house, around jobs, around unemployment offices, all done in a Cézannesque manner but which was actually weak realistic painting."

C is for Farber's avoidance of the **clichéd** and **corny**, in terms of subject matter and in his day-to-day life. "I think it's sinful," Farber once said, "to give the audience material it knows already." Talking about the 1930s, he explained, "Since all the other incipient artists were going down to the WPA, I thought it was a corny thing to do, so I went down to the union hall and looked at all the trades." (Which leads us back to carpentry . . .)

C is for **closure**—or the deliberate campaign against it—and for **clutter**.

C is for bled **color fields**: Farber produced hundreds of paper paintings in the 1960s and early 1970s— these were double-sided, with no supports, sometimes tacked directly to the wall, sometimes hung away from it like a sail. He described them as "primarily single-colored with a great amount of varicolored underpainting which seeped through the top layer. A great deal of chance and process effects. The color and surface were melded together, and the goal was to make the luminous presence of each picture command a great deal of the room's space, in front and to the sides of the picture."

C is also for the morphing but crucial notion of **continuation**, which Farber said "involves constant attempts to stretch out the moment"; it is a progression from the visual and tactile specificity of an object through what William James called "widening rings of relation." Rick Thompson has spoken of "the movement from description to analysis" in Farber's film essays as paralleling "the movement from specification to continuation" in the paintings.

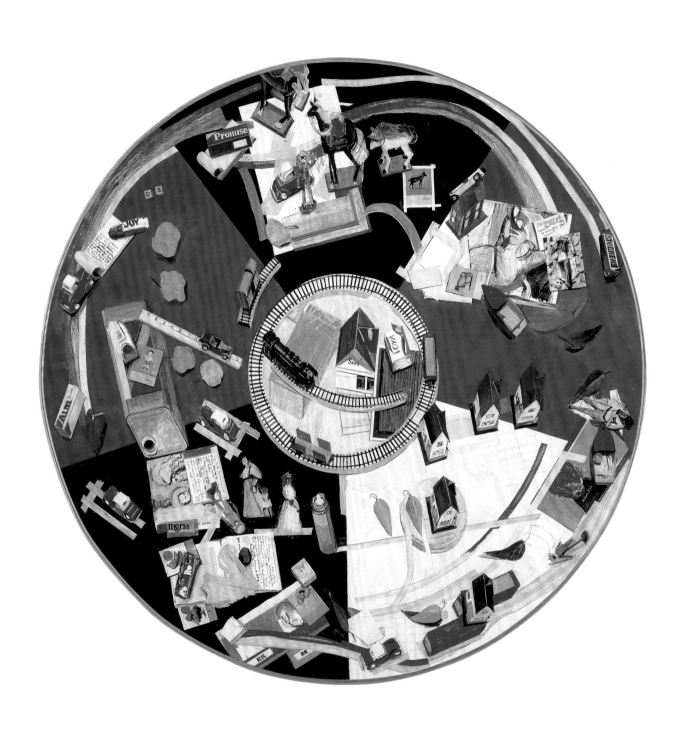

"The Joyces felt humiliated," 1983
Oil on board
68 inches diameter

27

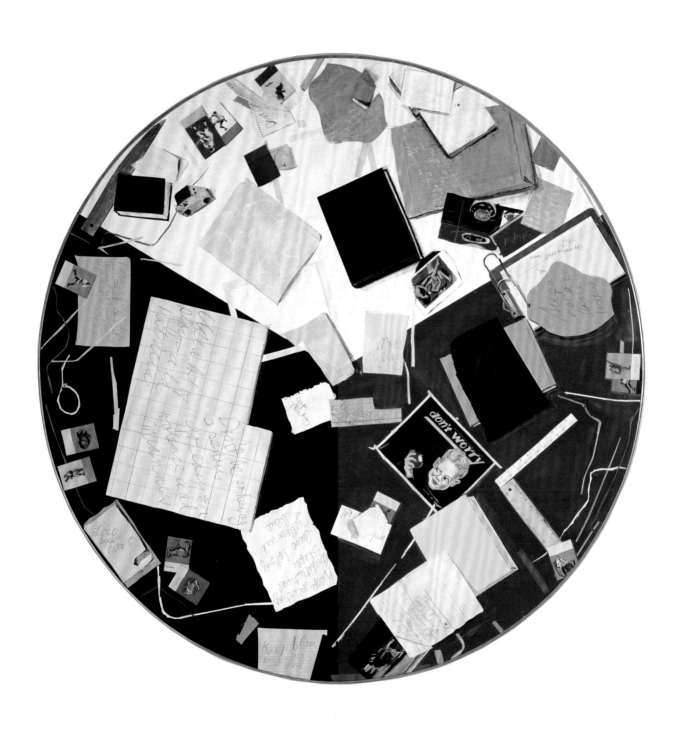

"Keep blaming everyone," 1984
Oil on board
72 inches diameter

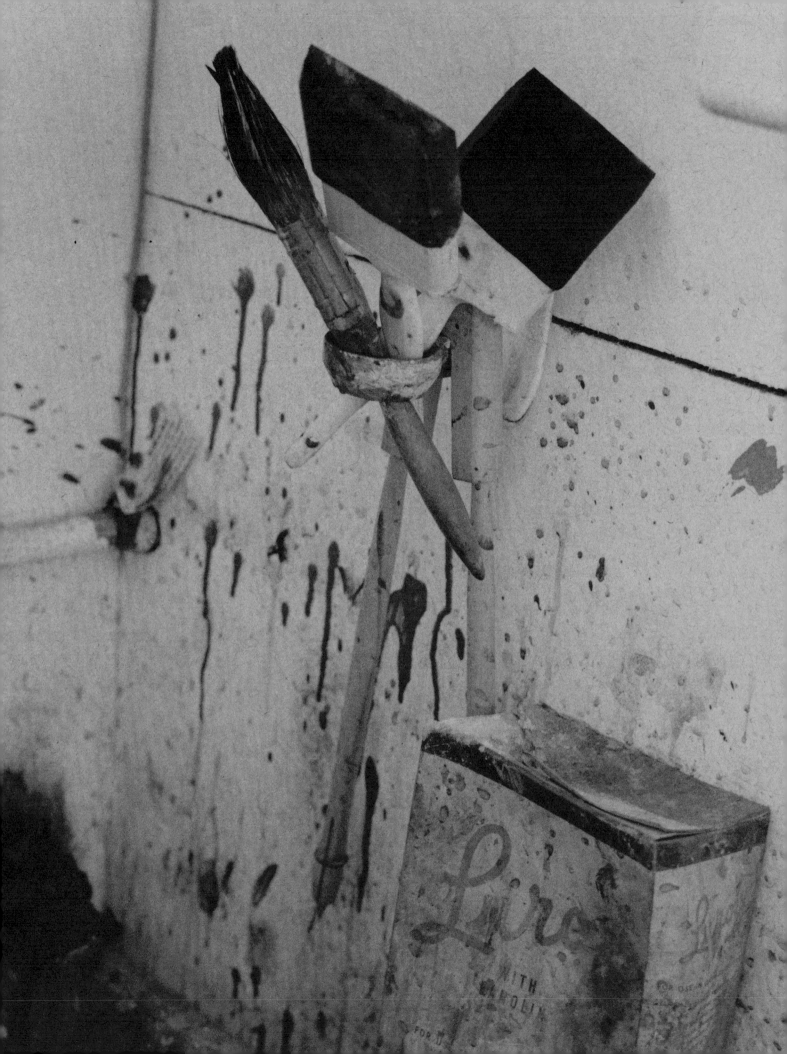

D

is for **debris**, **digression**, and **dispersal**, and for **decentering**. D is for the **demystification** of the work of art—a willingness to expose and play with the technical processes of the making of a painting (so that you will see masking tape and what appear to be rough drafts of an image) and the web of everyday life surrounding it (so that whatever Farber is seeing, hearing, even eating might put in an appearance in a picture).

D is for Farber's devotion to the **domestic**—in art, as in the movies—and for lifelong **drawing**: as a young boy Farber began to copy photos and cartoons of sports heroes from his local newspaper, the *Douglas Daily Dispatch*. His renditions of Fox Fontaine cartoons, or of any number of painters from different eras and traditions, demonstrate how fine a mimic he can be.

And despite all the humor of Farber's work, D is for various kinds of thematic **darkness**: **desperation**, **doom**, and **death**.

E

is for the Indian and Japanese **erotic** prints that appear in several of the paintings, and for **Eros** in general, which is everywhere in Farber's sensual work.

F

is for **figures and grounds**, their shifts and progressive undermining, and for what Jonathan Crary refers to as "**confrontational fields**," in the sense of expanses and of a transaction and resonance of elements which is mysterious and suggestive—a kind of poetry.

F is for the **food** and **flowers** that came to dominate Farber's paintings of the 1980s, and F is for the endless attention to the subtlest ways of handling the **frame** in almost any one of his works.

G

is for **Giotto** and **Goya**, of whose work Farber has done several interpretations or paraphrases; for his teaching colleague and "twin brain" **Jean-Pierre Gorin**, whose film *Routine Pleasures* abutted sequences about Farber's paintings with scenes involving the activities of a group of model railroad aficionados; and for Farber's friend, the late **Clement Greenberg**, with whom he was in critical dialogue for many years.

31

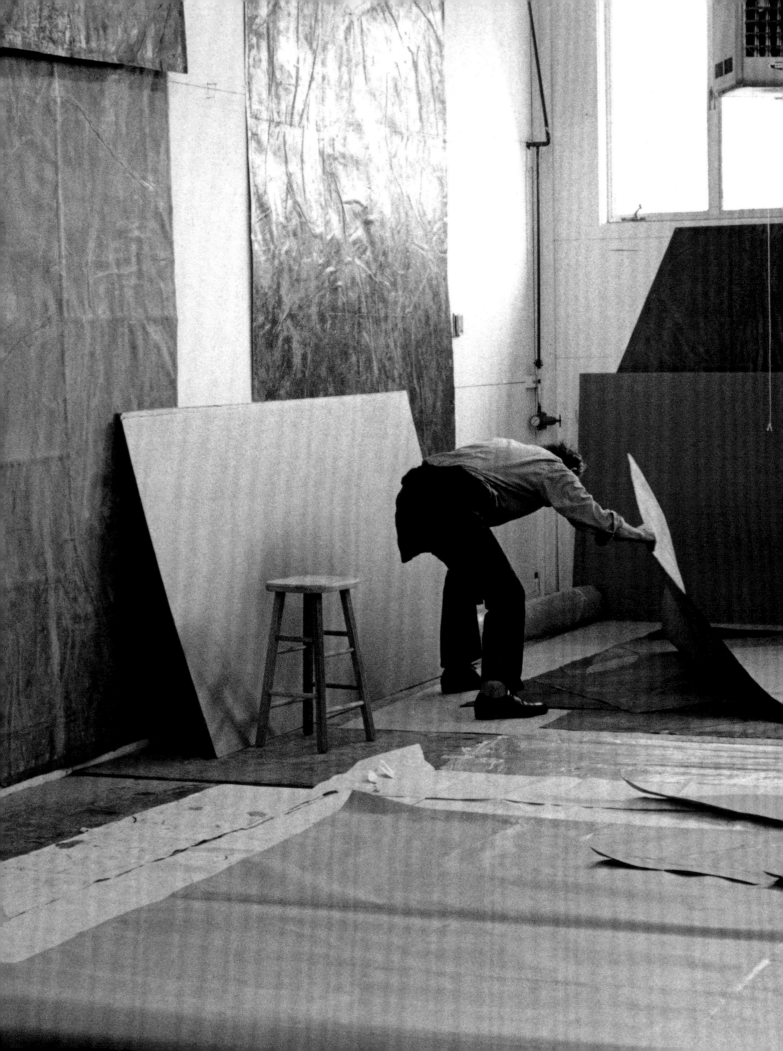

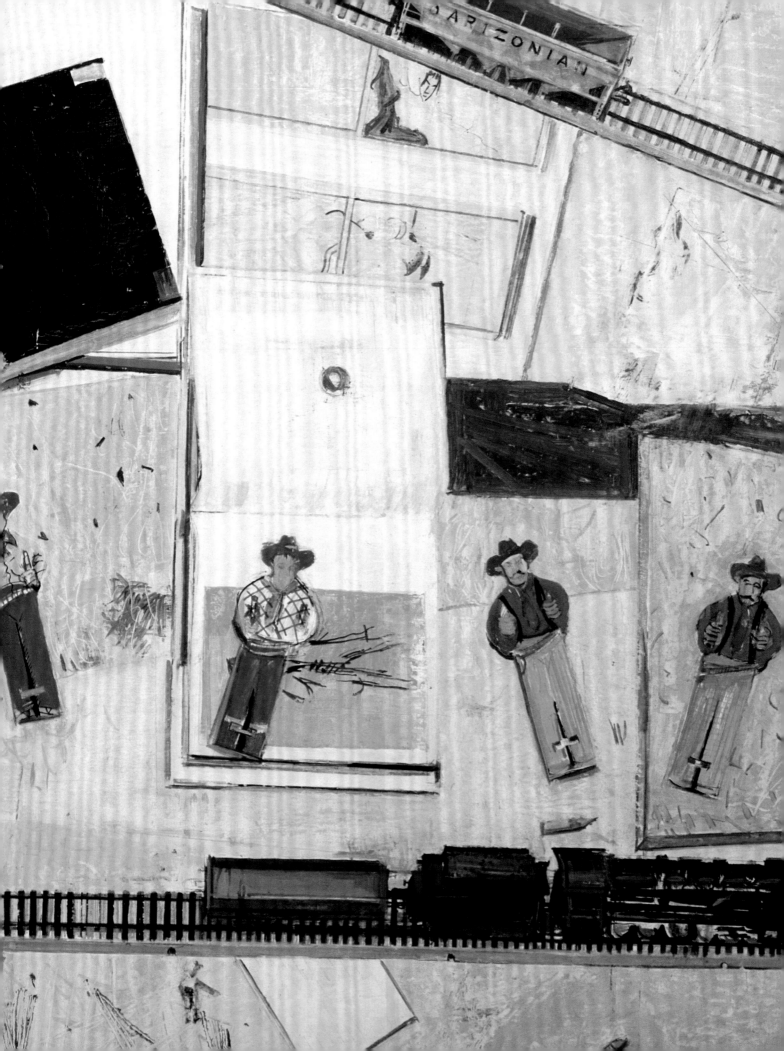

Manny Farber's Termite Path

Stephanie Hanor

Smart yet unpretentious, tough, complex, idiosyncratic, candid, at times funny, and overwhelmingly appealing, Manny Farber's paintings are the embodiment of autobiography. In diaristic fashion, Farber carefully records the small and seemingly inconsequential details of his everyday life in his paintings. Handwritten notes, canceled checks, movie candy, Liquid Paper bottles, sketchbooks, rebar, and eucalyptus leaves converge in unpredictable paths, creating pictorial spaces universally recognizable in their subject matter, yet intensely personal in their construction and content.

The exhibition's title, *About Face*, is as multilayered as the works featured in the show. Also the name of a startling yellow painting depicting the relationship of two sunflowers, one turned sharply away from the other, the phrase is an apt metaphor for the directions that have developed in both Farber's painting and his life. Farber has experienced abrupt changes in his career path as well as his painting style, moving among the realms of art and film critic, carpenter, painter, and teacher, and exploring enormous abstract paintings, small realist works on paper, shaped paintings on board, and large-scale expressive still lifes. The paintings themselves build a case in which biography and object inform each other in a wonderfully complex web of multiplicity and radically shifting avenues. Looking at the trajectory of the work, it becomes clear that Farber rarely looks back, instead preferring to close one chapter and open the next profoundly informed by what has proceeded. Farber's painting embodies the restless, unpretentious "termite paths" that he champions in his film criticism, those details and choices that eat away at the immediate boundaries of his art, which constantly turns in upon itself in surprising ways.[1]

Despite this consistent lack of predictability, there are certain constants that drive Farber's painting and that can be seen throughout his body of work: an interest in the viewer's experience of looking; the deliberate revelation of the painting process; and the creation of painting that at its heart is about painting. He deliberately draws the eye through a work, creating compositional arrangements that force the viewer to confront the surface of the painting, to trace interweaving narratives, and to see works as both a whole and as discrete parts. Farber's paintings are very much about the process, history, characteristics, and problems of painting—and old masters of painting, including Cézanne, Goya, and Caravaggio, are his artistic heroes, cropping up in his late work as the standard-bearers of technique.

There is nothing arbitrary in Farber's work. Every compositional element, color choice, and arrangement is specific to each painting and is based on the

1 See Manny Farber, "White Elephant Art vs. Termite Art" (1962). Reprinted in *Negative Space*, ed. Robert Walsh (New York: Da Capo Press, 1998).

pages 31—32:
Untitled (*recto and verso*), ca. 1972
Acrylic on collaged paper
116 3/4 x 83 1/2 inches

left:
Birthplace: Douglas, Ariz. (*detail*), 1979
Oil on board
44 1/4 x 57 3/4 inches

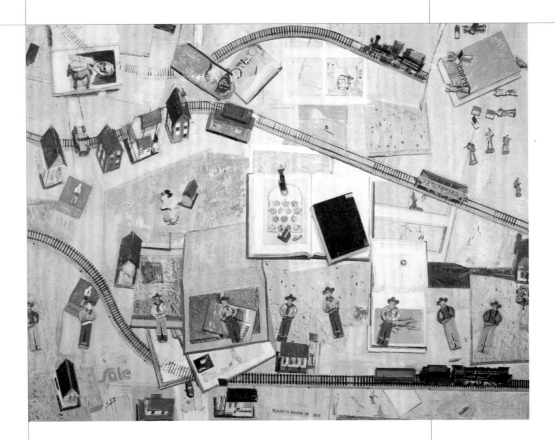

conceptual and formal needs of the piece. For Farber, the act of composing is literally laid out on the painting: rather than organize items in a tableau and then copy them onto a canvas as in a traditional still life, objects are set directly upon the painting's wood surface. By working on a horizontal plane and rendering items life-size, there is a distortion and abstraction of the objects when the painting is finally hung on the wall. Flowering onions appear almost prehistoric in scale, and daffodils tower unnaturally in their pots, making the viewer acutely aware of the artificiality and arbitrariness of rendered space. Farber's painting process develops like a movie—shot by shot—with the artist serving as director. He is concerned with moving the viewer through the work object by object, wrestling with how to get from one point to another in space. In seemingly casual notes scattered across the surfaces of his paintings, Farber reminds himself to "put this figure upside down," "keep asserting architectural shapes," "leave lots of yellow and blue," and "stop the masking tape," effectively revealing and also demystifiying his artistic process. The artist's fascination with process can be seen in his exploration of ideas in series, and his painting career can be traced through an evolution of bodies of work.

Much has been written about Farber's friendships with the Abstract Expressionist painters during his almost thirty-year tenure in New York from 1942 to 1970, and certainly the gestural abstraction that dominated

Birthplace: Douglas, Ariz., 1979
Oil on board
44¼ x 57¾ inches

36

American painting during the 1940s and 1950s had a tremendous impact on the direction of Farber's work in that period (and it continues to influence his painting today). The artist's colorful gestural canvases of the 1950s, with brush marks reminiscent of letter forms, developed into the sophisticated color field works on paper of the late 1960s and early 1970s; these were made of collaged brown Kraft paper, with no additional support, and they were displayed pinned directly to the wall. Created with a pouring technique, these works are double-sided monochromes that reveal layers of underpainting. The monumentality of scale and allover painting of these early abstractions are related to Abstract Expressionism, as is the process of working on the floor, a method borrowed from Jackson Pollock, whose work Farber had admired in an early review.[2]

Crucial to this period in Farber's work are the painted wood assemblages he created in the early 1960s. These often-overlooked gems are key to understanding not only the Kraft paper constructions, but aspects of Farber's work as a whole. Constructed of scrap materials scrounged from various carpentry job sites, the sculptures maintain a direct relationship to painting, not only through their painted surfaces, but with their largely two-dimensional perspective. Although created three-dimensionally, the works are often hung directly on a wall, thus denying the traditional spatial relationship between viewer and sculpture in the round.

Farber's experience as a carpenter serves as an important source for how he thinks about construction and space. The paper abstractions present themselves simultaneously as shapes and color — as objects directly related to sculpture. Farber's acquaintance with Clement Greenberg (both were writers for *The Nation*) placed him in proximity to theories on support, color, surface, and structure in painting. Greenberg called for painters to acknowledge the limitations imposed upon them by the flat surface and shape of their canvases, and he recognized the entwinement of sculpture and painting prevalent at the time. Farber was part of a milieu of New York painters interested in these issues, and his abstractions were among the works championed by the influential New York gallerist Richard Bellamy, who sought out originality and unique artistic vision. The abstractions were contemporaneous with Richard Tuttle's irregularly cut, dyed canvases that are pinned to the wall; much like Farber's works, Tuttle's pieces create an ambiguity between painting and sculpture while emphasizing color and form and expanding notions of what painting can encompass.

Carpentry is an important influence for Farber's later works, too; this influence can be seen in the wood support for the paintings, the depiction of construction materials such as rebar and nails, as well as the joining of different planes of color. The artist also cites the "carpenter's crow's-eye view" of looking down from buildings as a source for his unusual working method. By the mid-1980s abutted blocks of color became an increasingly important device for delineating space within his compositions. Farber sees this facture in his later paintings as a joinery influenced by carpentry—even going so far as to point out such an instance to the viewer with a note in *Story of the Eye* (1985).[3]

2 See Manny Farber, "Jackson Pollock," *New Republic* 112 (25 June 1945): 871.

3 See Farber's comments regarding carpentry in Jerry Tallmer, "Vow Set in Concrete," *New York Post* (23 April 1993).

In 1975 Farber abruptly stopped painting large abstractions, shifting full circle to small-scale, intimate, realistic arrangements of candy such as Hershey Bars, Black Crows, Big Hunks, Abba-Zabas, and Cracker Jack—the kind of sweets often found in movie theaters. These works from the "American Candy" series convey a certain nostalgia inspired by his own youthful times spent in the sanctuary of movie palaces in the 1930s. While there may be a superficial resemblance to Pop paintings of the 1960s by Wayne Thiebaud or Andy Warhol in the use of common consumer items as subject matter, Farber insists that his works deny the clichés in Pop.[4] His paintings present these items as narrative compositions that speak to ways of viewing, his own personal history, and a specifically American culture.

With these works Farber demonstrates his stridently individualistic manner and interest in the unfashionable. Still life is not a popular genre in contemporary painting and is generally marginalized by art historians. Seemingly in defense, in the painting *Dig* (1984) Farber warns the viewer: "These are not still life paintings." And indeed, the works are highly kinetic in their effect, never conveying the static of traditional still lifes. Yet Farber's representational paintings embody several of the characteristics of still life as set forth by Norman Bryson, specifically, the depiction of artifacts of domestic space, the everyday world of routine and repetition, and an interest in the material practice and methods of painting.[5] Farber uses the genre of still life to explore the nature of both looking at and constructing visual images through items that are at once personally meaningful and instantly recognizable. His still lifes abound with myriad personal motifs and references, constituting almost a Manny Farber lexicon of recurring images.

Much as a critic has to build a picture with words, Farber builds his paintings with discrete items that together make visual paragraphs. Nowhere are the connections between Farber's film criticism and his painting more explicit than in the "Auteur" series paintings begun in 1976. Directly related to specific directors and films supported by Farber in his criticism, such as Howard Hawks, R. W. Fassbinder, Jean Renoir, and the films *Honeymoon Killers*, *History Lessons*, and *McCabe and Mrs. Miller*, these paintings are much more than just subject matter, and it would be a mistake to read them only as illustrations of films. The qualities in movies that Farber admires translate to his paintings: big, honest, and about the pleasure of looking.

The auteur paintings were greatly impacted by Farber's teaching at the University of California, San Diego (UCSD), in one of the first integrated visual arts departments in the country, which combined visual arts, film, performance, and art history. Moving to Southern California in 1970, Farber joined a coterie of influential art makers and thinkers, including David Antin, Allan Kaprow, and Harold Cohen. In such a conceptually driven department, it is revealing that Farber not only maintained the medium of painting, but introduced still life into his work. Originally hired to teach painting and drawing, within three months the department had added a three-hundred-seat film class to Farber's schedule,

4 "Manny Farber and Patricia Patterson Interviewed by Richard Thompson" (1977). Reprinted in *Negative Space*, p. 354.

5 Norman Bryson, *Looking at the Overlooked: Four Essays on Still Life Painting* (London: Reaktion Books, 1990), p. 14.

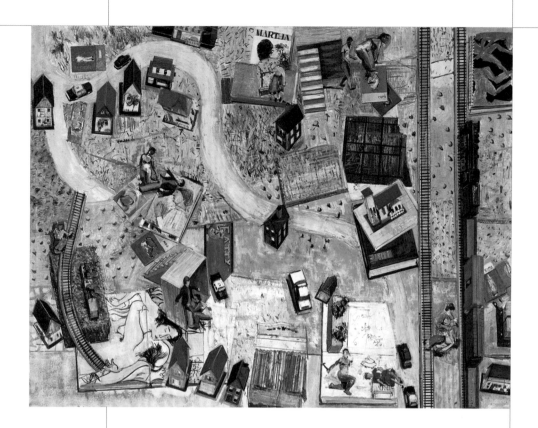

and soon he was teaching critical writing as well. Through his friendship with Tom Luddy, then director of the Pacific Film Archives in Berkeley, Farber had access to the most avant-garde films and filmmakers of the period, bringing in European directors such as Roberto Rossellini, Daniele Huillet and Jean-Marie Straub, Georges Franju, and Werner Herzog to address his students; he also incorporated references to their films in his paintings.

As much as film-watching informed his painting, painting informed how he taught film. Farber often refused to show films straight through, preferring to screen one scene repeatedly, sometimes with the sound off and occasionally backwards, to emphasize viewing film in relation to forms. For Farber, the 1970s and early 1980s were spent almost entirely indoors—either in the studio, in classrooms, or in theaters—a situation that directed the choices he made in his paintings. By the early 1980s Farber's paintings work much like frames in a film. In *"Have a chew on me"* and *Nix* (both from 1983), for example, the boldly colored, segmented backgrounds give an ordered structure to a complicated and decentralized narrative. The circular shape of the tondos, such as *Rohmer's Knee* (1982), adds an additional layer, allowing no defined borders and no clear reference to top or bottom. In these paintings Farber locks the imagery into hard-edged color fields, losing the earlier painterliness of his backgrounds. Railroad tracks serve as a point of entry and exit, functioning as visual paths simultaneously leading the eye through the painting and defining the structure of the work.

Honeymoon Killers, 1979
Oil on board
44 x 57½ inches

39

Adding to the layers of references and sources were Farber's serendipitous discoveries of Alfred Jensen's paintings and medieval Spanish illuminated manuscripts and frescoes. In 1978, what was then the La Jolla Museum of Contemporary Art co-hosted a traveling exhibition of Jensen's work with the Mandeville Gallery at UCSD, providing an opportunity for extended viewing of these idiosyncratic canvases. Jensen's use of multiple, brightly colored grounds as a means for organizing his various systems and calendars provided a model for a unique representation of movement through time and space. Perhaps more direct were the Spanish illustrations, whose flat, multicolored backgrounds liberated the elements of the storytelling narrative from the constraints of illusionistic space. While Farber's paintings deny the stiffness of both of these sources, conveying instead a constant shifting and sense of movement, the liberation of the ground provided him with a way of opening the paintings up and extending them beyond still life.

By the mid-1980s overt film references begin to disappear from Farber's paintings, although literal depictions of film leader can be found in *Story of the Eye*, providing the same visual device as the railroad tracks of earlier paintings. Works from this period, including *Domestic Movies* (1985) and *Cézanne avait écrit* (1986) convey the sensuality of painting through their sinuous lines, luscious use of color, and densely populated surfaces, a theme that would grow stronger in Farber's later paintings. One can trace a shift in the work which is related to Farber's retirement from teaching in the late 1980s. All the paintings completed in his home studio were executed in natural light, as opposed to the fluorescent lighting of his campus studio; as a result, one can see a change in color in Farber's works—the palette becomes brighter, and more primary colors are utilized. The paintings also become much more conversational, an element Farber attributes to teaching painting.[6] There is a "talking" component to the works, a conversation created through the arrangement of elements that in turn produces a complex choreography of objects leading the eye through a dance along the surface of the painting.

Austere black-and-white backgrounds serve as the organizing fields for ever more complicated and painterly compositional arrangements in the early 1990s. The sparsely elegant surface of root vegetables, dead gophers, and gardening implements seen in *From the Bottom* (1989) gives way to the almost claustrophobic combination in *Purple Lake* (1993) of flowers, art books, and wire that strains at the seams with an intense vigor. The importance of color cannot be underestimated in Farber's work, and his career attests to an exploration of color in conjunction with a thorough resistance to prettiness. By the mid-1990s the flat backgrounds shift to vibrantly painted junctures of beautifully difficult coloring. This aspect is epitomized in *Batiquitos*, a 1995 work that combines references to the artist's daily life (with sketchbooks of the Batiquitos lagoon near his home and overripe pomegranates from his garden), an awareness of current art criticism (in a sly note referencing *New York Times* art reviewer Roberta Smith), and an active engagement with the process of painting (conveyed through vigorous brushwork and unique color choices) in a complex composition that is at once tough and stunning.

6 Manny Farber, conversation with the author, February 2003.

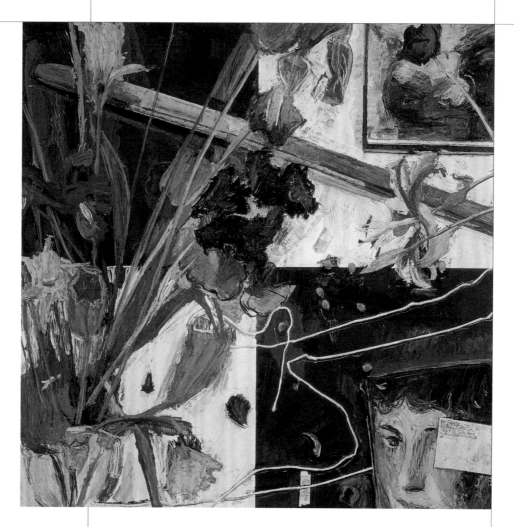

The most recent work of the past ten years is increasingly rhythmic, with echoing pairs of elements creating an internal musicality. Some of Farber's most ambitious and persuasive work, these paintings owe a great deal to the great masters of painting. Representations of images by Mantegna, Vermeer, and Carpaccio often serve as anchors, weighting the paintings with a nod toward previous experimentations with light, form, and space. Works such as *Between Bosch and Cézanne* (2001) retain the allover painting effect first seen in Farber's earliest works—a compositional device never given up, just adapted to different subjects. He explains the vitality of his paintings in terms of the idea of force field, or a complex relationship of space and movement which resonates as energy within the composition. Known in his criticism for being able to describe a path of action, Farber is concerned in his paintings with demonstrating the spirit of an object by drawing attention to the distance between facts, effectively moving the viewer through the space of the painting object by object.[7] Richard Bellamy recognized this strength of Farber's still lifes early on, writing of their "lasting and accreting power,

page 40:
Twelfth-century fresco of nativity scene
Museu Diocesà i Comarcal de Solsona, Solsona, Spain

Purple Lake, 1993
Oil on board
37 x 37 inches

7 Farber, conversation with the author, February 2003.

substance, invention," and noting that "no stronger fields of force have I seen put on board (or canvas)."[8]

When writing about film, Farber's emphasis is on the directors—the people who not only have the creative vision, but also a responsibility to the viewer. It is clear from his work that Farber takes this role of responsibility quite seriously in his paintings. In a 1977 interview, he stated:

I'm taking what I think are new, advanced positions on color (not prismatic or tube color but organic, multi-mixed color), composition (not centered portraiture but a composition which uses the field of the paintings as a performing stage for deployments, paths), space (dispersed, like a throw of the dice), line (like in early American painting rather than European), and texture (handmade, endlessly worked, slow, plodding).[9]

These issues have haunted the artist throughout his career, and they continue to reverberate in his paintings today. Drawing on a lifetime of intersections and shifting paths, Manny Farber has created a body of painting that is as much about himself as it is about how he wants us to see.

8 Letter to Manny Farber from Richard Bellamy, 25 February 1982.

9 "Manny Farber and Patricia Patterson Interviewed by Richard Thompson," p. 354.

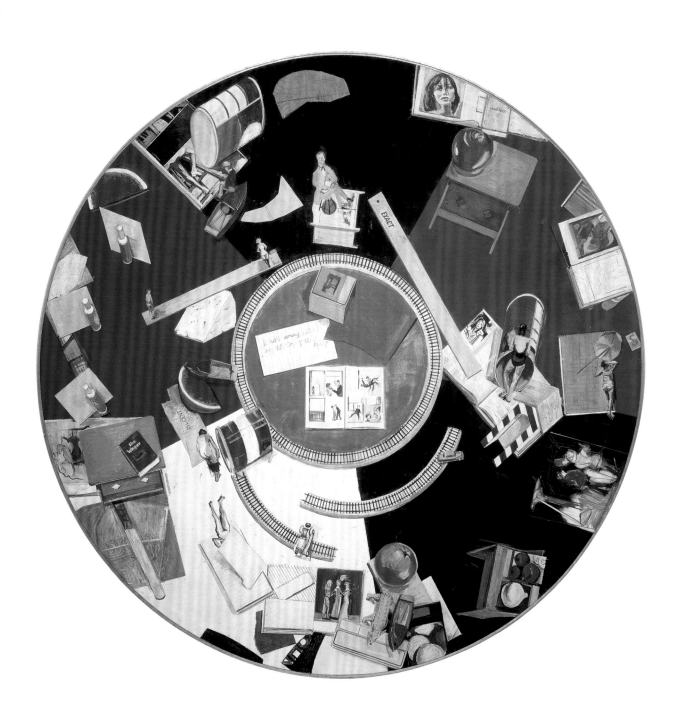

Rohmer's Knee, 1982
Oil on board
72 inches diameter

43

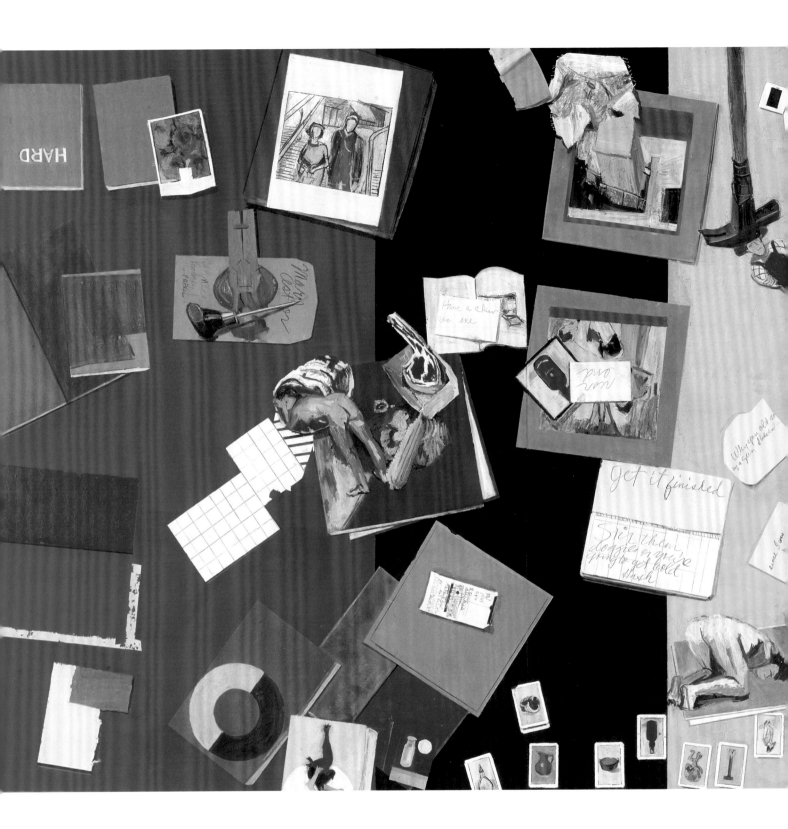

44

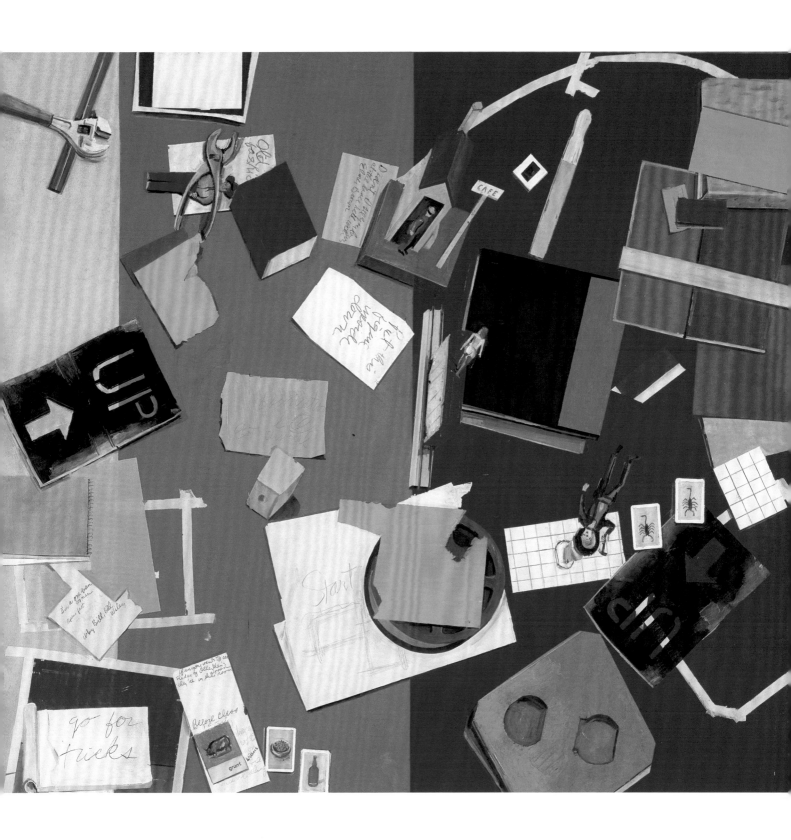

"Have a chew on me," 1983
Oil on board
58 x 134¹/₂ inches

45

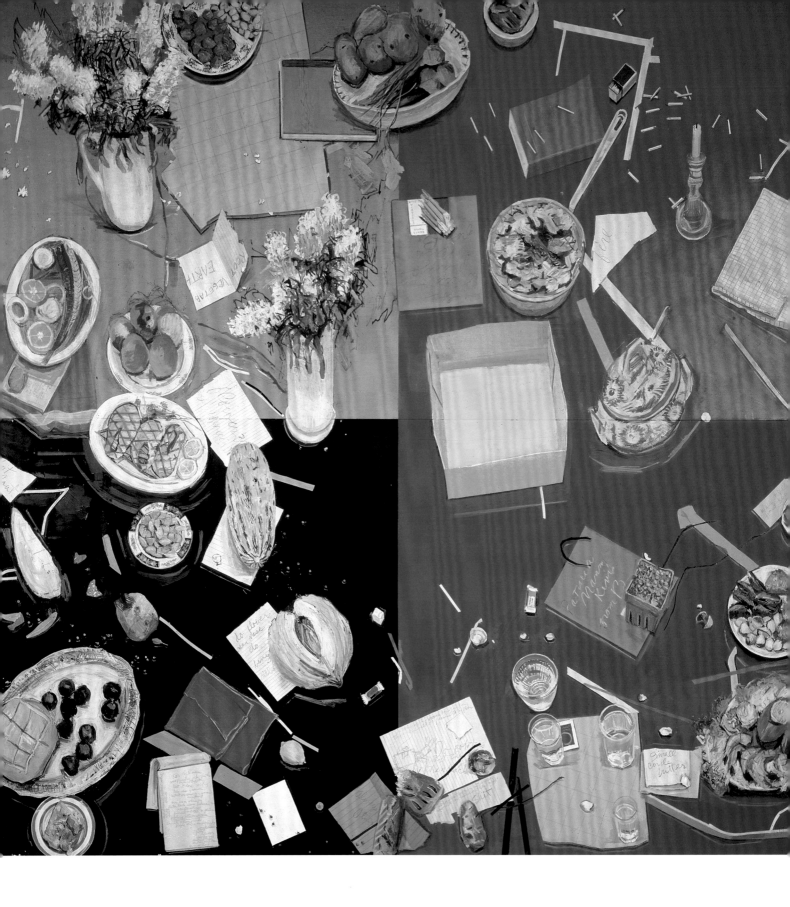

Earth, Fire, Air, Water, 1984
Oil on board
96 x 96 inches

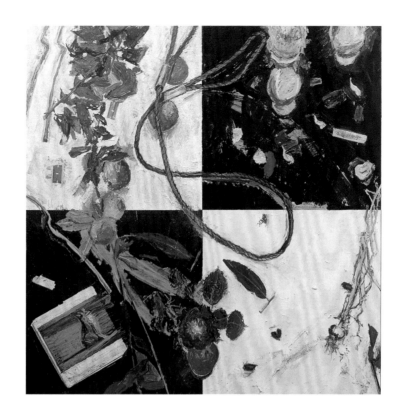

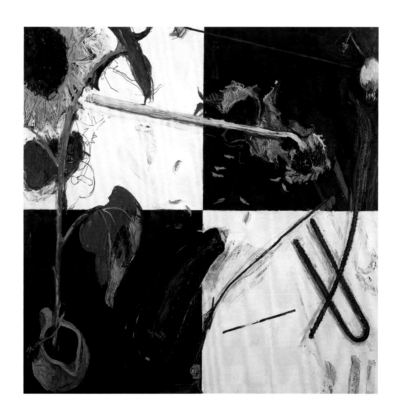

Carpaccio's Dog, 1997
Oil on board
36 x 36 inches

Entropy, 1990
Oil on board
36 x 36 inches

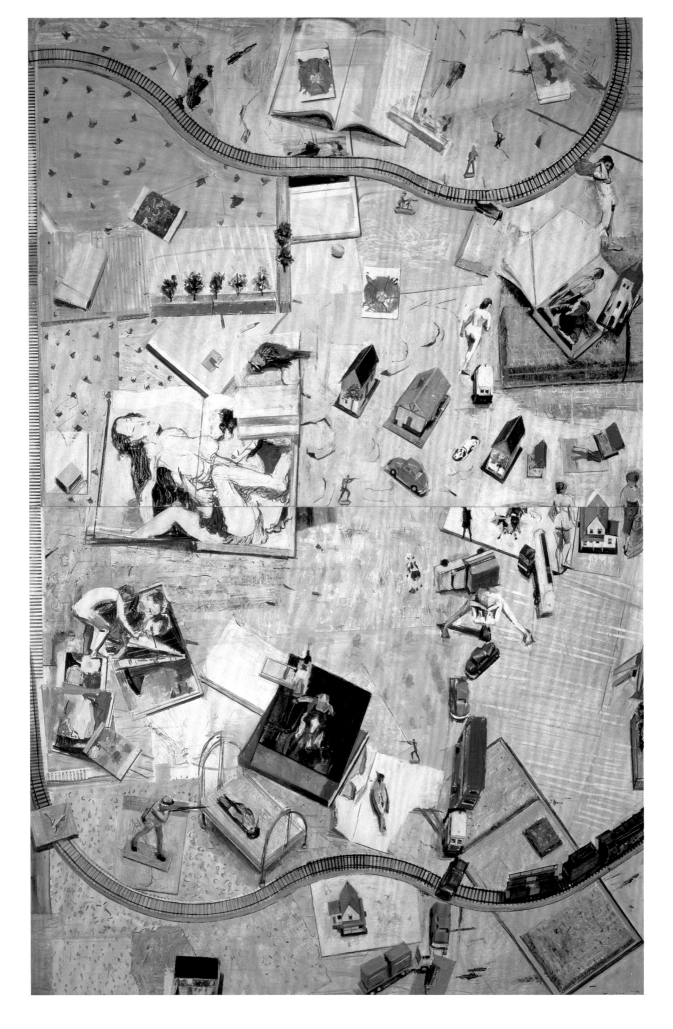

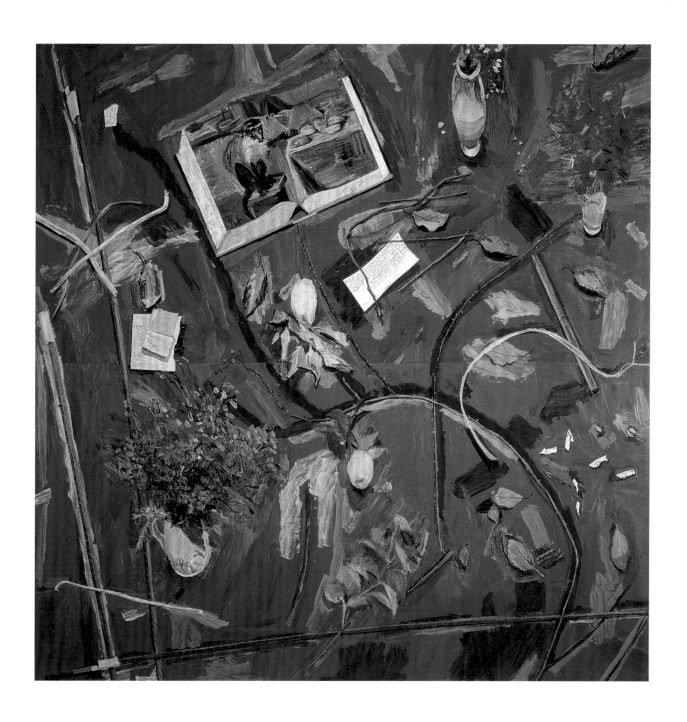

left:
Thinking About "History Lessons," 1979
Oil on board
89 x 57¾ inches

above:
April 13, 1994, 1994
Oil on board
72 x 72 inches

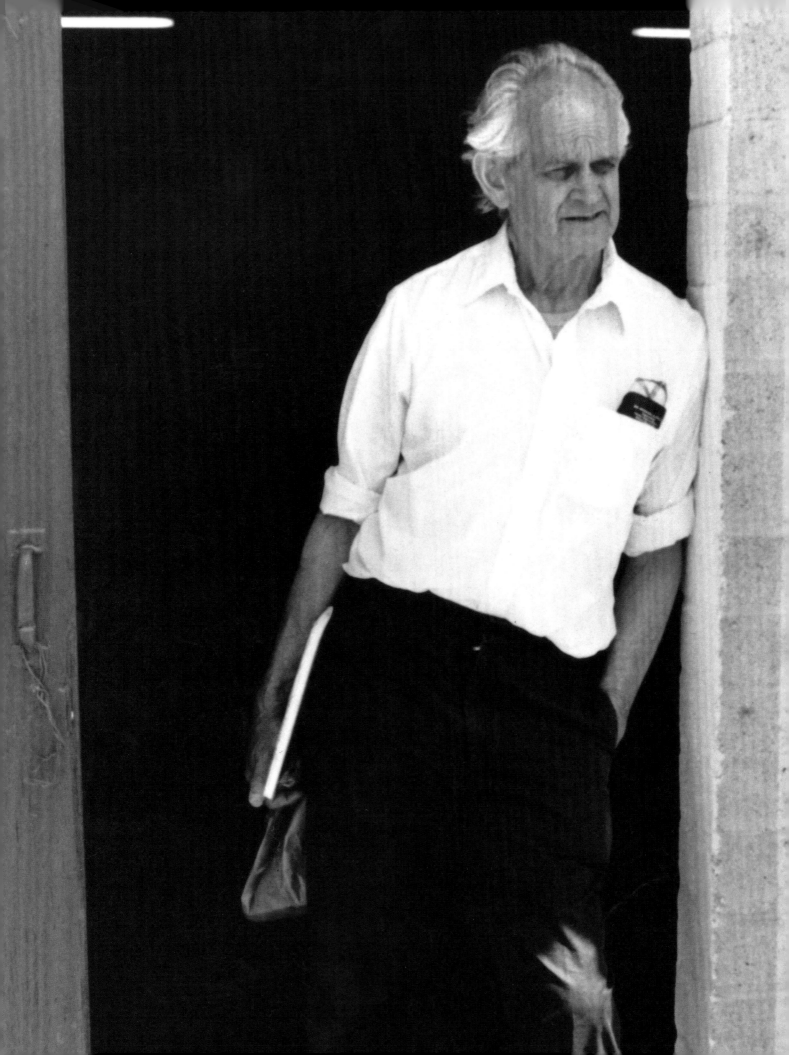

1917—24

Manny Farber born February 20, 1917, in Douglas, Arizona. His family, Russian emigrants to Southwest, own several dry goods stores. Chief influences on later art: rolls of brown Kraft wrapping paper; father's calligraphic-style writing on items and prices for store windows; flat, arid landscape; and region's only industry, Phelps Dodge copper smelter. Two memorable events in Cochise County, Arizona: appearance of evangelist Aimee Semple McPherson and emigration of Black Sox baseball stars (banished after being bribed to throw 1919 World Series), who form their own Outlaw League.

1925

Begins copying photos and cartoons of sports stars from *Douglas* (Arizona) *Daily Dispatch*.

1931

Sports writer and illustrator (Mickey Mouse and pals are motif) for *Copper Kettle*, school annual. Forms jazz orchestra with brothers and Corporal Adams, saxophone teacher from African-American army camp on outskirts of Douglas.

1932

Family moves to Vallejo, California. Farber plays alto sax and clarinet in Kenny Clark's jazz orchestra and is briefly celebrated as halfback on high school football team. Parents' dress store does flourishing business with prostitutes; prostitution is a major profession in Vallejo, a Navy city.

1934—35

Enters University of California, Berkeley. Becomes sportswriter for *Daily Bruin* newspaper and plays freshman football. Enters Stanford as sophomore and takes first drawing class.

1936—37

Moves to pre—Clyfford Still California School of Fine Arts where fellow students and friends include Hassell Smith, Janet Terrace, and Carl George, then enrolls at Rudolf Schaefer School of Design, San Francisco.

1938

Marries Janet Terrace, figurative painter and writer, and couple builds own furniture for apartment. Farber works as guard and Saturday morning children's art instructor at San Francisco Museum of Art. Begins apprenticeship in carpenters and joiners union; builds tract homes and participates in construction of World's Fair held on Treasure Island.

1939

Relocates to Washington, D.C. Teaches painting and finishes apprenticeship on Bethesda Naval Hospital, Jefferson Memorial dome, and Army and Navy barracks in area. Paints Cézanne-like portraits and narratives relating to carpentry jobs.

1942

Moves to Greenwich Village, New York. Begins career as critic, writing first about art, then movies, for *The New Republic*. Work brings him into contact with Trotskyites and writers such as Alfred Kazin, Edmund Wilson, Saul Bellow, David Bazelon, Walker Evans, Jean Stafford, Bob Warshow, James Agee, and Mary McCarthy.

1943—46

Moves to 219 West 14th Street, near influential European artist/teacher Hans Hoffman, whom he meets. Becomes friendly with painters Jackson Pollock, Robert Motherwell, and William Baziotes. Meets artists around Hoffman School such as Nell Blaine, Virginia Admiral, Robert De Niro, and Larry Rivers, who influence move to brighter color and push-pull brushwork. Farber and wife separate. Begins painting bold semi-abstractions with Matisse-like coloration and iconic, striped figuration. Works attract attention of art impresario Sam Kootz but do not result in support contract.

1947–49

Leaves *The New Republic* and begins to write about art, jazz, furniture, and films for *The Nation*. Takes over as *Time* film critic from James Agee for six months.

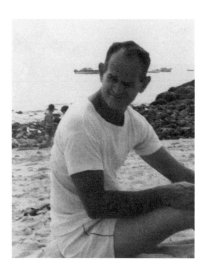

1950

Due to relocation to walk-up on Hudson Street, smaller paintings result. Thinner, stainlike paint application brings actual texture of support and material into finished product; abstract content suggests ribbons, flags, or targets. Marries Marsha Picker. Returns to write about films and art at *The Nation*, where he becomes friendly with subeditor Jerry Tallmer, one of the founders of the *Village Voice*.

1951–54

Included in first group exhibition, organized by Peggy Guggenheim in New York in 1951. Resumes carpentry and starts to write long position articles, including the "Gimp" analysis of Wellesian impact for *Commentary*; a collaboration with Willy Poster about Preston Sturges for *City Lights* (which is not published for a year); and "Blame the Audience" for *Commonweal*.

1955

Introduces written words and ribbonlike brushstrokes into smaller-scale works.

1956–57

Writes defense of Hawks–Mann genre movies, "Underground Films," a three-year project published by *Commentary*. "Hard-Sell Cinema," all-media analysis of fifties art world, published in single-issue magazine *Perspectives*. Marries Marsha Picker. Daughter Amanda born in 1957. First one-person exhibition at Tibor de Nagy, New York.

1960

Works as part of rough construction crew on supermarkets, Levitt buildings, and beach resorts around Manhattan's perimeter (Roslyn, New York). Continuing carpentry work on forty Lefrak apartment buildings in Forest Hills leads to sculpture phase: hundreds of wooden constructions made of three-quarter-inch decking recycled from construction project's garbage. Also created plywood and stick works composed of syncopated lines cut by hand-held electric saw. Works explore color transparency, suggest nonexistent openings, and investigate ambiguity between solid and open, back and front.

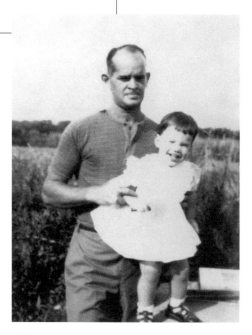

1961

Works on canvas parallel sculpture and break with Abstract Expressionism: using black, white, and yellow palette, results are simple geometric compositions, floating and transparent rather than bounded and flat. Writes multimedia criticism for *The New Leader*.

1962

Group and one-person sculpture exhibitions at Kornblee Gallery, New York. Canvases also transformed by idea of freeing shapes from confining, controlling supports and painting off forms. Over summer months, gallery converted into single environment created by Farber, including ceilings, walls, and floors.

1963

Begins painting on unstretched raw linen or muslin canvases using stencil and imprint techniques with collaged cardboard and cutout letters that seem sculpted. Also works on elevator shafts of Columbia Broadcasting System (CBS) building. Writes "The Fading Movie Star," analysis of new auteur cinema (where film director is considered primary creative force in movie) for *Commentary*.

1964

Work surfaces change to found cardboard and paper. Makes mural consisting of twenty-three joined pieces. Takes carpentry job at Corning Glass and commutes between Manhattan and Corning, New York, on weekends.

1965

Picker and Farber separate. Begins sharing apartment with writer Chandler Brossard while working on nonunion carpentry jobs. Writes monthly column for *Cavalier*.

1966

Helen Levitt, photographer and poker partner, introduces Farber to Patricia Patterson, artist and teacher for Catholic Archdiocese of New York. Farber and Patterson co-rent loft at 20 Warren Street, near City Hall.

1967

Begins abstractions using format, character, and three-dimensionality of sculpture. Develops process of bleeding acrylic paint through Kraft paper. Experiments on strengthening paper and its ability to hang flat through pleating, then doubling edge, or overlapping and staggering separate sheets. One-person exhibition at Warren Street studio attended mainly by close friends. Receives Guggenheim Fellowship to complete compendium of critical writing titled *Negative Space*.

1968

One-person exhibition at Bard College, Annandale-on-Hudson, New York. Begins shaping paintings, hung by pushpins, into large ovals, trapezoids, and rhomboids with brushwork applied through muslin. Discards details of shapes to increase sculptural impact. Close friend Donald Phelps devotes issue of magazine *For Now* to short Farber anthology. Begins to teach script writing and art history at School of Visual Arts, New York. Receives painting grant from National Endowment for the Arts. With Patricia Patterson and friend Jeremy Lebensohn, Farber renovates 1815 Federal House, where all three reside. Commences monthly movie column for *Artforum* under editor Philip Leider.

1969

Runs writing workshop at School for Visual Arts, where he meets film critics and future friends Greg Ford and Duncan Shepherd. One-person exhibition at 20 Warren Street sponsored by O.K. Harris gallery. *Art on Paper*, group exhibition, at Witherspoon Gallery, Greensboro, North Carolina.

1970

Retrospective of critical career published in December. Joins University of California, San Diego (UCSD), visual arts faculty, which includes artists Michael Todd, Ellen van Fleet, Newton Harrison, Gary Hudson, and Harold Cohen, as well as critics Amy Goldin and David Antin and art historian Jehanne Teilhet.

1971

Praeger publishes *Negative Space: Manny Farber on the Movies*. One-person exhibitions at O.K. Harris, New York; San Diego State University; and Parker Street 470 Gallery, Boston. Group exhibitions *Painting Without Supports*, at Bennington College, Vermont, and *Highlights of the 1970–71 Season* at Aldrich Museum of Contemporary Art, Ridgefield, Connecticut. Meets Tom Luddy of Pacific Film Archives; this contact results in many interactive film programs between Berkeley and San Diego.

1972

Begins incorporating lines made with paint-soaked string within abstractions. Also increases use of colored-paper squares and chalk to enhance density. One-person exhibitions at O.K. Harris, New York, and San Diego State University. Spends two weeks at Venice Film Festival on first European trip. Sees films by Rainer Werner Fassbinder and other young European directors and builds "Radical Film" course at UCSD around experiences. Gives two lectures at Pacific Film Archives on Jean-Marie Straub and Fassbinder, as well as seminar at New York University which marks change of critical concern with Hollywood action films to experimental New York filmmakers and radical directors outside U.S. Meets like-minded filmmaker Jean-Pierre Gorin, who later joins UCSD faculty.

1973

Begins experiments with foldovers and extension devices, bringing abstractions off the wall and adding to objectlike look of the works. One-person exhibitions at Parker Street 470 Gallery, Boston; Suzanne Saxe Gallery, San Francisco; David Stuart Gallery, Los Angeles. Juries American Film Festival, Dallas.

1974

Commences narrative-type paintings using bird's-eye viewpoint and small objects to explore ideas about composition; backgrounds replaced by stagelike platforms. Projects combine concerns and materials allied to experience in movie theaters. One-person exhibition at Jack Glenn Gallery, Los Angeles. Teaches painting at Art Center College of Design, Pasadena. Softbound version of *Negative Space* reissued as *Movies*.

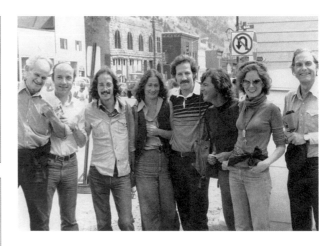

1975

Farber and Patricia Patterson co-author seven articles for *City Magazine* which define divisions between traditional box-office films and other cinema by Straub, Nagisa Oshima, Michael Snow. Visits Mexico City, Oaxaca, and New York Film Festival.

1976

Marries Patricia Patterson. Begins "Auteur" paintings, adding to narratives by using allusions, puns, and cues that refer to subject matter of actual films along with painted notes from his own movie criticism. Teaches course on films of Werner Herzog, Oshima, Jacques Rivette, and Budd Boetticher at New York University. Included in UCSD faculty exhibition. One-person exhibition at Illinois Wesleyan, Bloomington. Writes article about *Taxi Driver* for *Film Comment*.

1977

One-person exhibitions at Seder/Creigh Gallery, Coronado, California, and O.K. Harris, New York. Awarded fellowship by National Endowment for the Humanities. Published interview with Rick Thompson appears in *Film Comment* explaining style and content changes in Patterson-Farber collaboration.

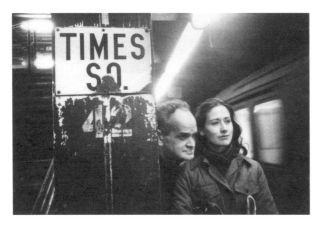

1978

Awarded Guggenheim Fellowship to write book on Munich films; book never published, but research leads to numerous paintings. One-person exhibitions at Converse College, Spartanburg, South Carolina; Ruth Schaffner Gallery, Los Angeles; Hansen-Fuller Gallery, San Francisco. Group exhibition at P.S.1 Contemporary Art, Long Island City, New York. First retrospective exhibition at La Jolla Museum of Contemporary Art, San Diego [now MCASD], accompanied by lectures on films *Katzelmacher*, *Christmas in July*, *Me and My Gal*, and *History Lessons*. Completes second "American Stationery" series using plywood ground to simulate actual surface used in still-life setups. Paints second "Auteur" series, discarding silver color harmony and increasing intensity, items, and scale changes for more Baroque-style effects. Gives lecture series at Pacific Film Archives, Berkeley, on works of Boetticher, Anthony Mann, and Fassbinder.

1979

Changes painting support from paper to wood and/or canvas and moves from restricted color to high-keyed palette in order to create fuller pieces. Teaches film lecture course that contrasts films from 1930s with those of 1970s. Uses material for lecture at Museum of Modern Art, New York.

1980

One-person exhibition at Tyler School of Art, Philadelphia; included in UCSD faculty exhibition.

1981

One-person exhibition at MiraCosta College, Oceanside, California, and group exhibition *19 Artists: Emergent Americans* at Exxon National Exhibit, Solomon R. Guggenheim Museum, New York.

1982

Lengthy interview with editors and Jean-Pierre Gorin published in April edition of *Cahiers du Cinéma*; Farber painting, *A Dandy's Gesture* (1977), appears on cover. Accidentally sets fire to wife's studio and is incarcerated in campus police station after altercation with campus policeman. Results in conviction for resisting arrest; sentenced to teach forty hours of writing classes to pre-freshmen students. Concurrent exhibitions at Oil and Steel Gallery in New York; Diane Brown, Washington, D.C.; and Janus Gallery, Los Angeles.

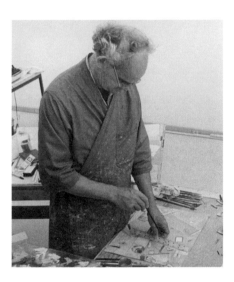

1983

One-person exhibition at Larry Gagosian Gallery, Los Angeles, includes first examples of primary-colored backgrounds. Daughter Amanda starts graduate school at UCSD, studying art. Begins work on wooden cutouts with small details enlarged to bring events on crowded canvases closer to viewer. Awarded plaque for film scholarship by Los Angeles Film Circle. Work included in *California Current* at L.A. Louver, Venice, California. First trip to Europe with Patricia Patterson, a car journey through Northern Spain; visit leads to three weeks of intensive Madrid–Barcelona street drawings.

1984

Exhibits at Quint Gallery, San Diego, where works juxtapose cutouts with intricate narratives. Spanish food display influences artist, who begins making own food arrangements in two fifteen-foot horizontal paintings titled *Duty, Ritual, Art Moves* (1984) and *Story of the Eye* (1985). Works combine strong eroticism (food used as sexual symbol) with everyday imagery.

1985

Devotes himself to painting and following San Francisco 49ers football games. Begins attempt to envelop viewers in saturated color and detailed reading of objects or notes within works. Commences lecture series at UCSD dealing with domesticity in all cultures, much of which is absorbed into diaristic paintings. La Jolla Museum of Contemporary Art [now MCASD] exhibits one of these works alongside shaped-paper abstraction of 1972. One-person exhibition at The Museum of Contemporary Art, Los Angeles. J.P. Gorin makes film *Routine Pleasures* about Farber.

1986

Takes car trip with Patterson from Barcelona to Rome looking at everything from Catalonian Romanesque murals to the "Piero Trail."

1987

Retires from teaching at UCSD in order to paint without distractions.

1988

Has a steady series of one-person exhibitions in the late 1980s and early 1990s, including shows at the Texas Gallery, Houston (1988); Krygier-Landau Gallery, Los Angeles (1990); Susanne Hilberry Gallery, Birmingham, Michigan, (1991); and Quint Gallery (1990 and 1991).

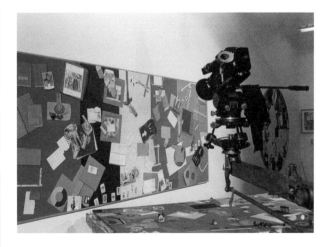

1989

Spends time drawing in Paris and Brittany. Begins to fully develop series of black-and-white paintings, a compositional device begun in 1985—brightly colored backgrounds give way to black-and-white grounds with a more open arrangement of items on the paintings' surfaces.

1990

Receives Telluride Film Festival award for contribution to film; picks up award on same evening that Clint Eastwood receives his.

1992

First exhibition of Farber's black-and-white paintings at Mandeville Gallery, University of California, San Diego.

1993

Major museum exhibition at Rose Art Museum, Brandeis University, featuring work from 1984 to 1993. Compositions become more dense and layered at this point with inclusion of Farber's sketchbooks and artbooks within paintings. From 1993 to 1996 Farber has important series of gallery exhibitions in New York at Rosa Esman Gallery (1993), Frumkin-Adams Gallery (1994), and Charles Cowles Gallery (1996), which give New York audiences a chance to see his recent paintings.

1994

New work is shown at the Carnegie Museum of Art, Pittsburgh. Leaves black-and-white paintings and concentrates on series of complicated color works. Creates large square pictures that are more painterly in their surfaces and backgrounds, incorporating many of the now-classic Farber motifs of fruit, vegetables, flowers, sketchbooks, art books, and rebar. Begins to include fewer notes in paintings, instead inserting more literal references to specific painters such as Raphael and Corot.

1995

Paul Schrader makes short film, *Untitled: New Blue*, an introspective look at Farber's painting of the same title. Farber is honored with award for his body of work in criticism by PEN Center. Trip to Italy with Patterson to visit Lombardy and Po Valley.

1998

Reissue of *Negative Space* with new material, including collaborative reviews written with Patterson in the 1960s for *Artforum*, triggers revival of interest in both Farber's paintings and criticism. Continues showing new paintings at Quint Contemporary Art, with steady schedule of one exhibition per year. Returns to exploring black-and-white backgrounds, looser paint handling.

1999

Chris Petit releases short film titled *Negative Space*, a documentary about Farber's way of looking at movies, which is shown on BBC and at numerous film festivals. Texts by and about Farber are featured in *Framework: The Journal of Cinema and Media*.

2000

Eleven essays by Farber reprinted in *Cinema Nation*, a compendium of the best film criticism published in *The Nation*. Work included in Los Angeles County Museum of Art exhibition *Made in California: Art, Image, and Identity, 1900–2000*.

2001

Continues to produce large-scale works that demonstrate use of repetition as a means of creating rhythm within the work. Painting *Cézanne avait écrit* (1986) used as poster art for 39th New York Film Festival. "A Tribute to Manny Farber" organized by *Artforum* and the New School Graduate Writing Program, with talks and commentary by Jonathan Crary, Kent Jones, Jim Lewis, Greil Marcus, Robert Polito, Luc Sante, Robert Walsh, and Stephanie Zacharek.

2002

Feature article in *Artforum* by Robert Polito addresses connections between Farber's paintings and criticism. Excerpts from previous year's tribute are reproduced.

2003

First-ever joint exhibition with Patricia Patterson at Athenaeum Music and Art Library, La Jolla, California. Exhibition features the two artists' sketchbooks, which have never been exhibited before. Farber honored with award from Pacific Film Archives in Berkeley. Translation of *Negative Space* into French by publisher Trafic, which has published Farber's articles in the journal *Revue de Cinéma*. Opening of Farber's major retrospective *Manny Farber: About Face* at the Museum of Contemporary Art San Diego.

2004

Manny Farber: About Face opens at the Austin Museum of Art, Austin, Texas and P.S.1 Contemporary Art Center, Long Island City, New York.

The painting, sculpture, assemblage becomes a yawning production of overripe technique shrieking with preciosity, fame, ambition; far inside are tiny pillows holding up the artist's signature, now turned into mannerism by the padding, lechery, faking required to combine today's esthetics with the components of traditional Great Art.

Manny Farber, "White Elephant Art vs. Termite Art," 1962

H is for Farber's **handwriting**, which may slow down a viewer's eye or be read transparently, simply for its messages, but which is actually quite carefully worked as prose and as painting.

And **H** is for Farber's sense of **humor**, another kind of Eros.

I is for Martin Buber's **I-Thou** relations—for giving each object its due, for a deep sense of encounter with, a giving-over or surrender to, a part of the world.

J is for Farber's standing at the crossroads of **Jackson Pollock** and **Jasper Johns**; for the ever-present **jazz**—Eric Dolphy, Charles Mingus—and other music played in Farber's studio; for the always startling **juxtapositions** in the paintings; and for Farber's professed desire to impart a feeling of **joy**.

K is for palette **knife**, Farber's favored tool, and for the **Kornblee Gallery**, which he transformed into a single environment in 1962, coating every surface of the place—the walls, ceiling, and floor.

K is for **Kraft** paper and for **Pauline Kael**, who loved and admired Farber's paintings and always had a couple of his exhibition announcements pinned to her *New Yorker* office walls.

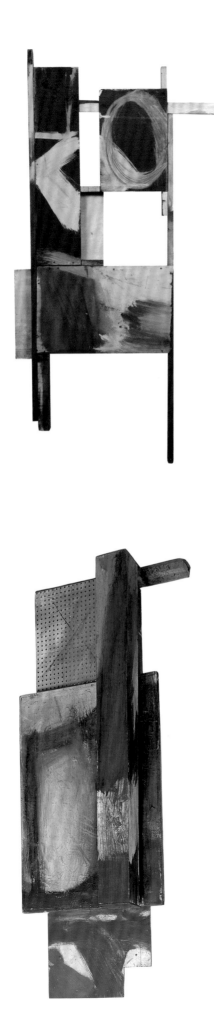

top left:
Untitled, 1960—62
Acrylic on wood
52 x 41¹/₂ x 2 inches

right:
Untitled, 1960—62
Acrylic on wood
44 x 11¹/₄ x 5 inches

bottom left:
Untitled, 1960—62
Acrylic on wood
60 x 22 x 5 inches

Untitled (*verso*), ca. 1974
Acrylic on collaged paper
105 1/2 x 114 inches

61

Untitled (*recto*), ca. 1974
Acrylic on collaged paper
105 1/2 x 114 inches

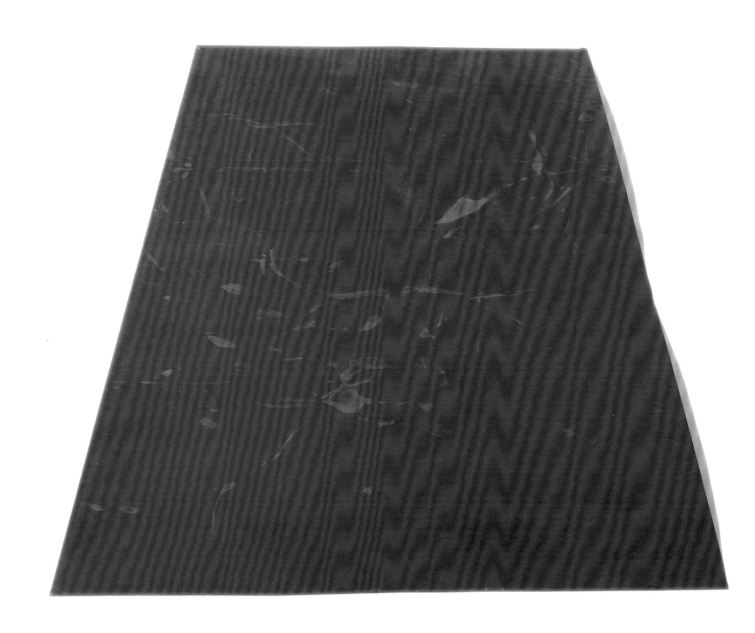

Untitled (*verso*), ca. 1974
Acrylic on collaged paper
89³/₄ x 115¹/₂ inches

Untitled (*recto; detail opposite*), ca. 1974
Acrylic on collaged paper
89 3/4 x 115 1/2 inches

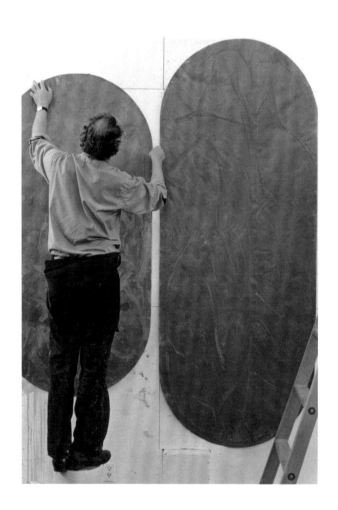

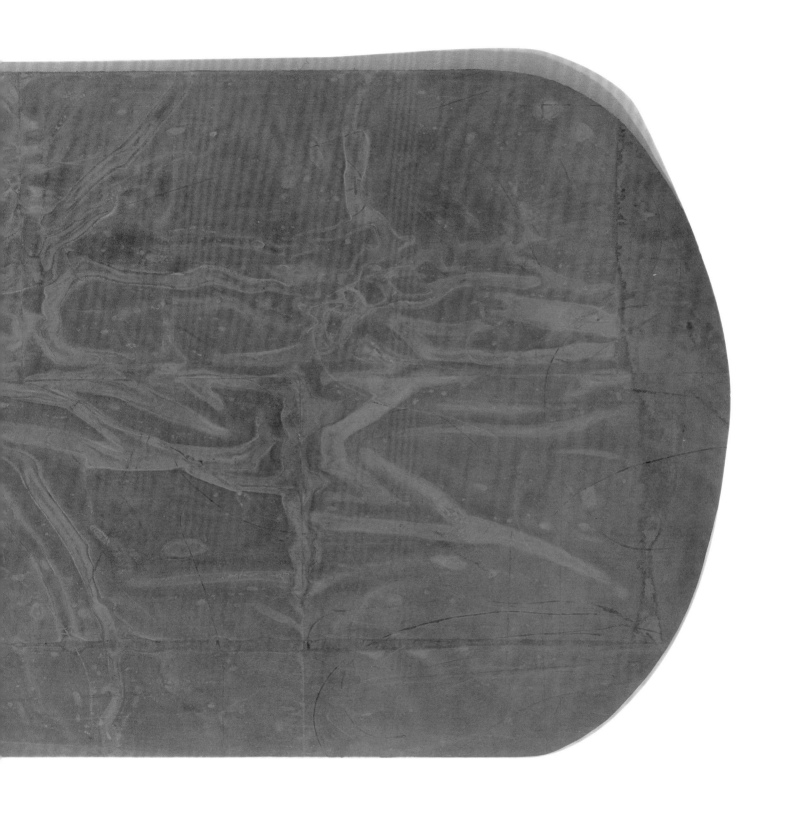

Untitled (*verso*), ca. 1972
Acrylic on collaged paper
44 3/4 x 101 inches

Untitled (*recto*), ca. 1972
Acrylic on collaged paper
44 3/4 x 101 inches

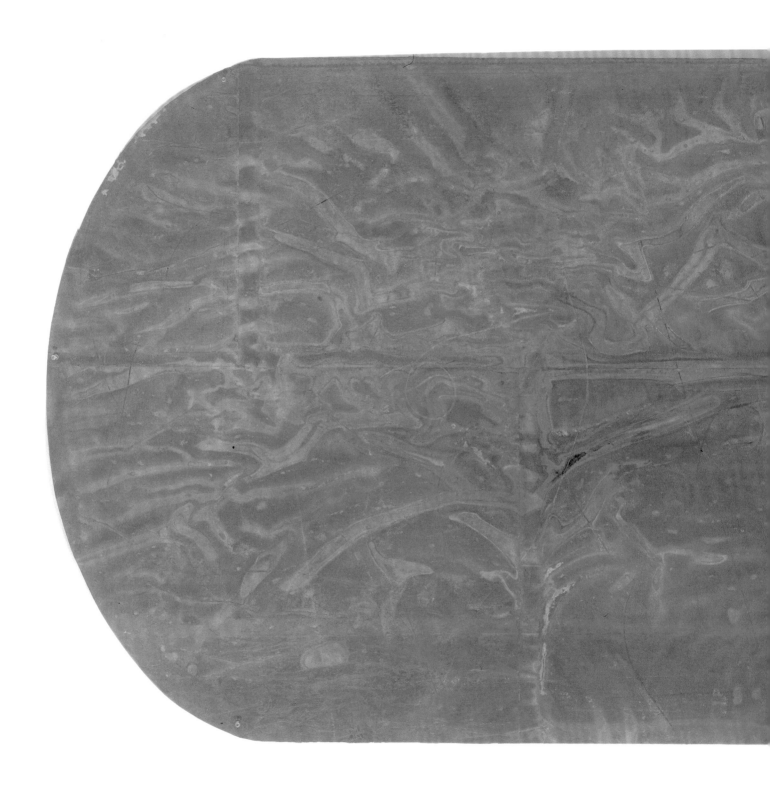

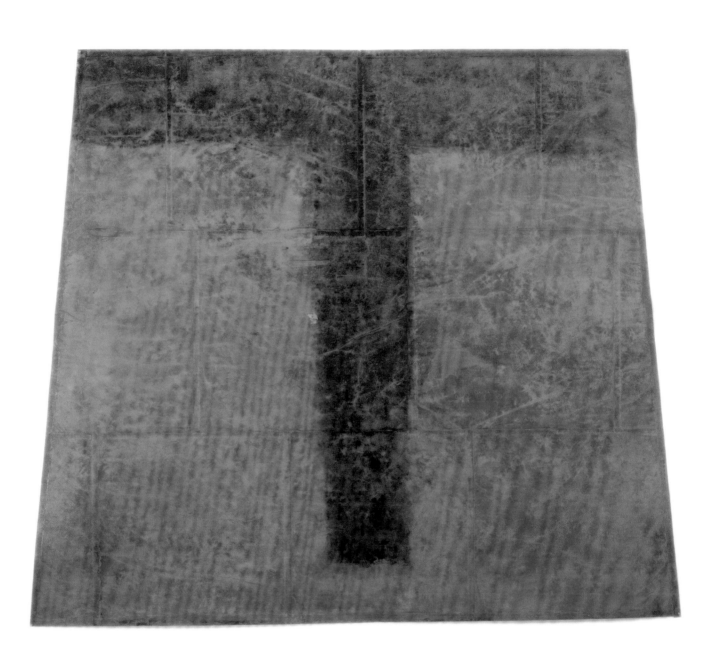

Untitled (*recto*), ca. 1974
Acrylic on collaged paper
100 3/4 x 118 1/4 inches

Untitled (*verso*), ca. 1974
Acrylic on collaged paper
100 3/4 x 118 1/4 inches

Untitled (*recto and verso*), ca. 1974
Acrylic on collaged paper
59³/₄ x 73 inches

Untitled (*recto and verso*), ca. 1974
Acrylic on collaged paper
89 3/4 x 115 inches

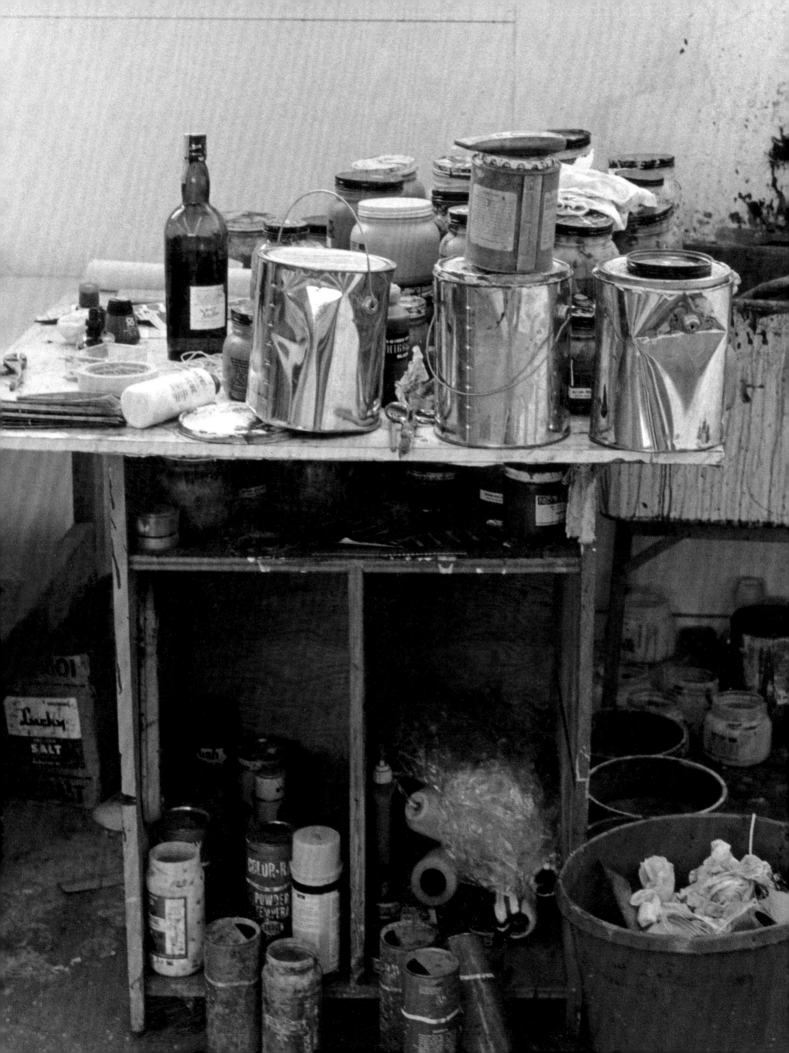

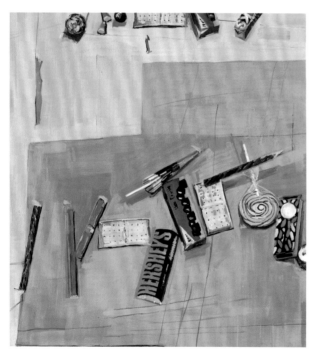

Cracker Jack, 1973—74
Oil on paper
23 1/4 x 21 3/4 inches

Black Crows, 1974
Oil on paper
23 1/4 x 21 3/4 inches

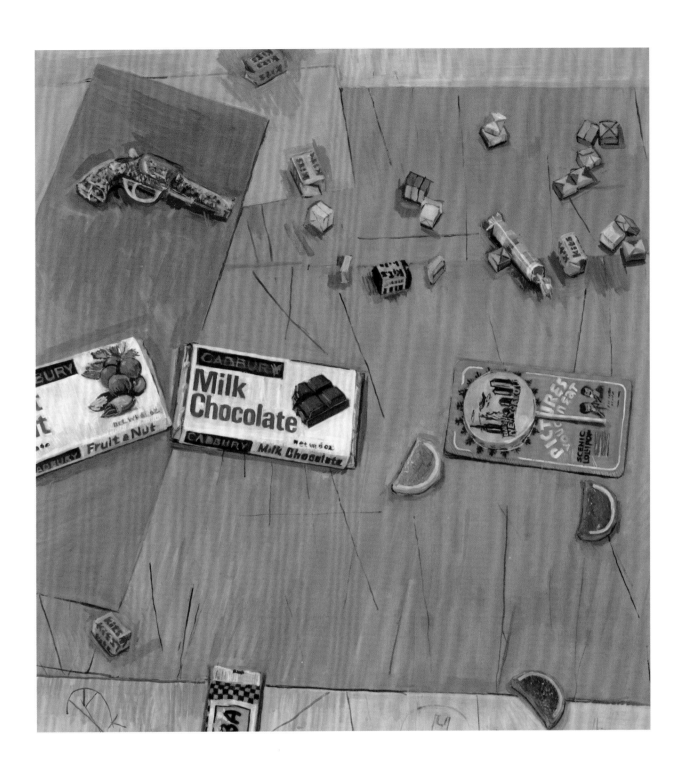

Kits, 1975
Oil on paper
23¼ x 21¾ inches

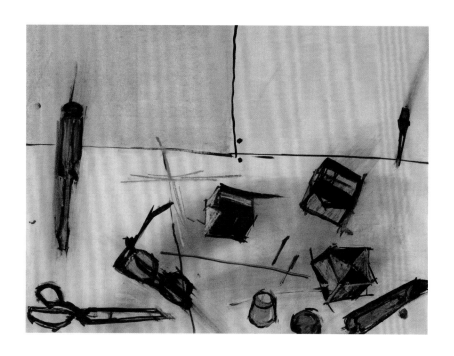

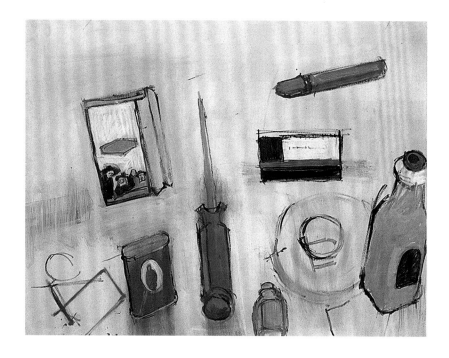

Untitled, 1973
Oil on paper
18 x 24 inches

Untitled, 1973
Oil on paper
18 x 24 inches

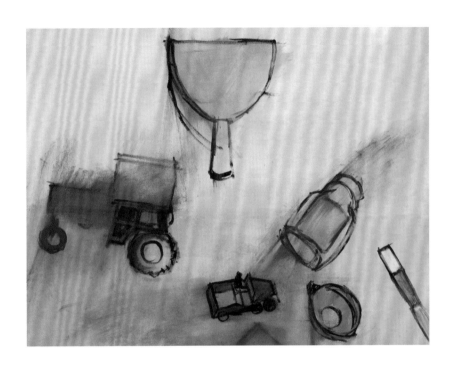

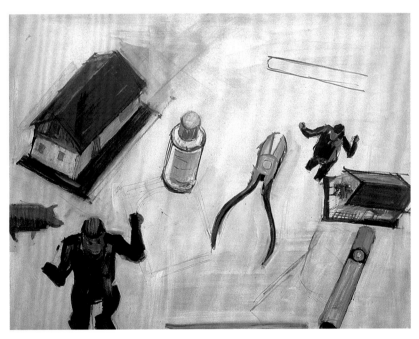

Untitled, 1973
Oil on paper
18 x 24 inches

Untitled, 1973
Oil on paper
18 x 24 inches

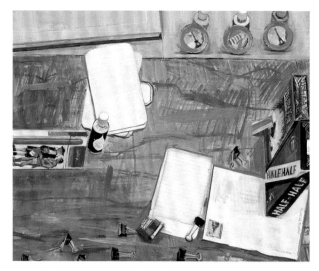

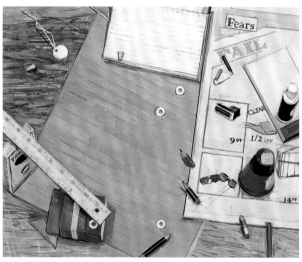

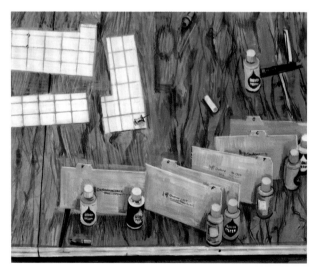

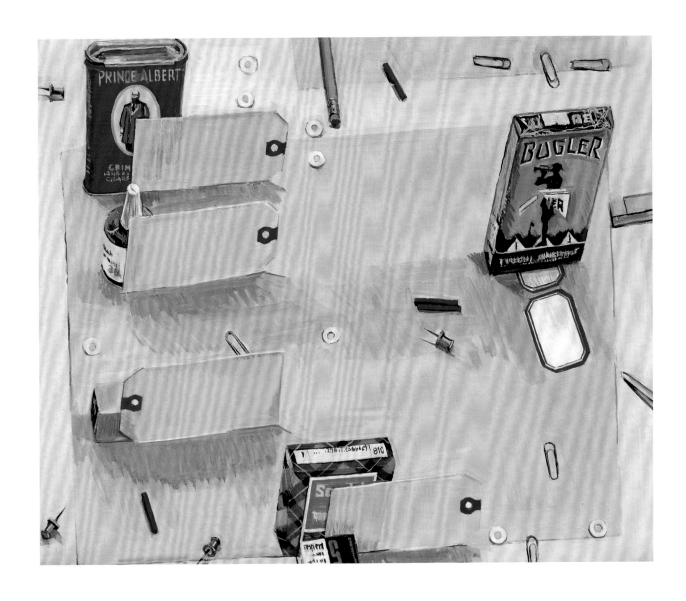

left, top to bottom:
Razors and Two Tobacco Boxes, 1978
Oil on paper
14 x 17 inches

Ad Sheet with Yellow Thayer Box, 1978
Oil on paper
14 x 17 inches

Eight Liquid Paper Bottles, 1978
Oil on paper
14 x 17 inches

above:
The Red Can, the Push Pin, and the White Label, 1976
Oil on paper
14 x 17 inches

83

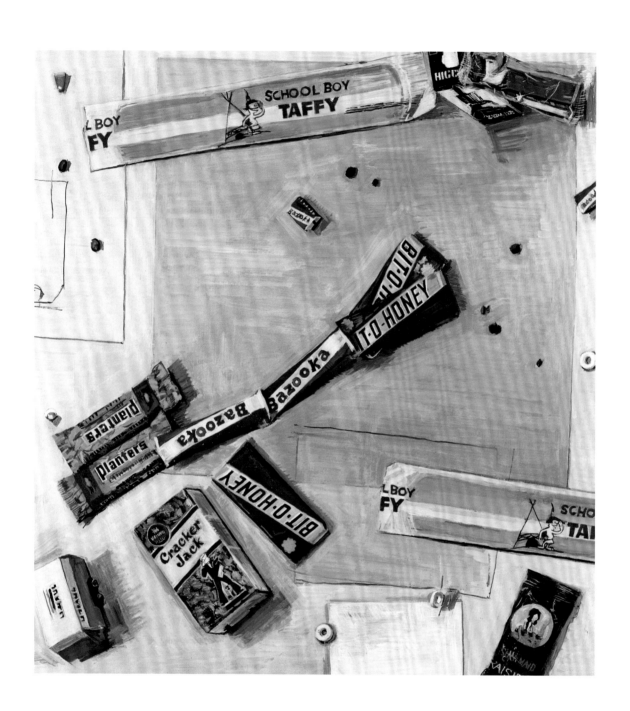

School Boy Taffy, 1976
Oil on paper
23¼ x 21¾ inches

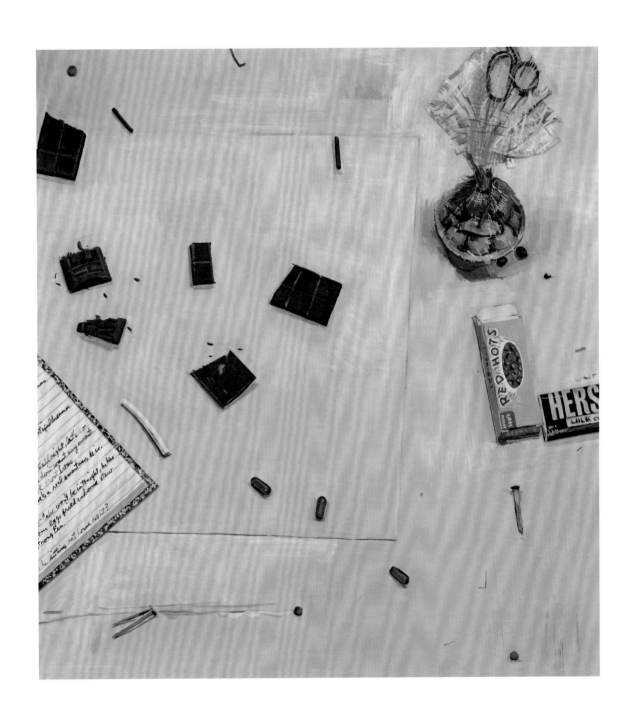

McCabe and Mrs. Miller 1976
Oil on paper
23¼ x 21¾ inches

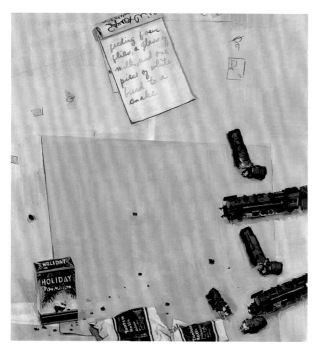

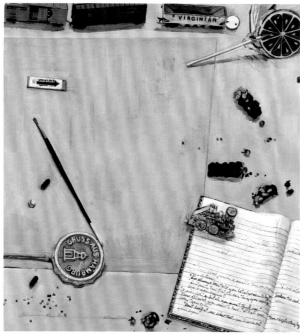

The Lady Eve, 1976—77
Oil on paper
23¹/₄ x 21³/₄ inches

Jean Renoir's "La Bête Humaine," 1977
Oil on paper
23¹/₄ x 21³/₄ inches

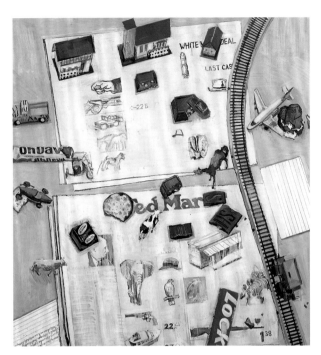

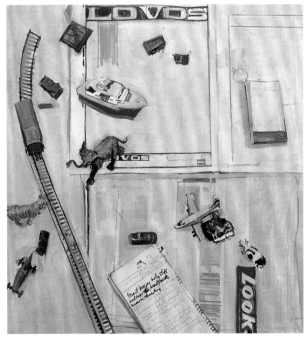

Howard Hawks II, 1977
Oil on paper
23¼ x 21¾ inches

A Dandy's Gesture, 1977
Oil on paper
23¼ x 21¾ inches

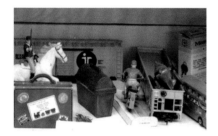

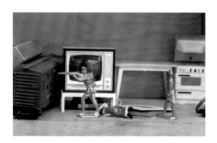

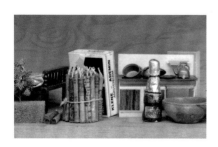

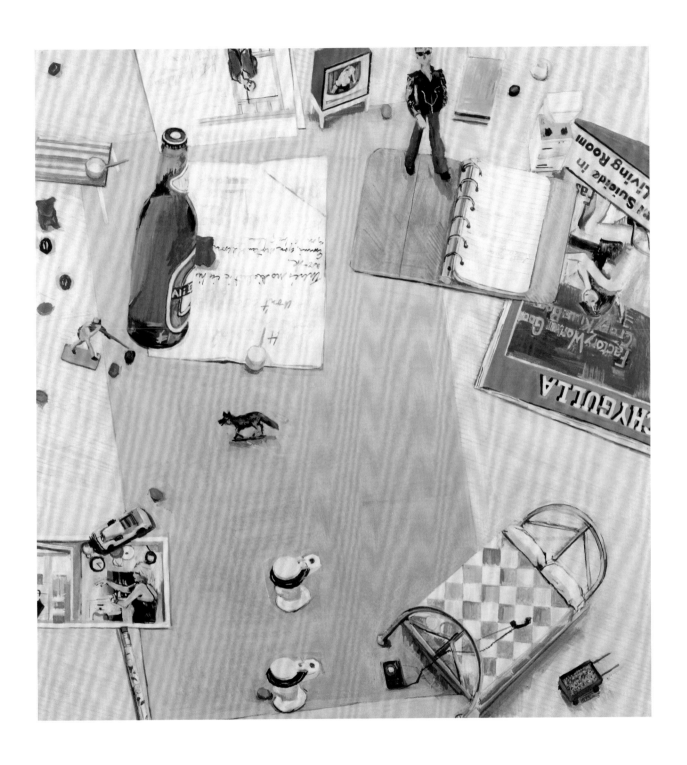

The Films of R. W. Fassbinder, 1977
Oil on paper
23¼ x 21¾ inches

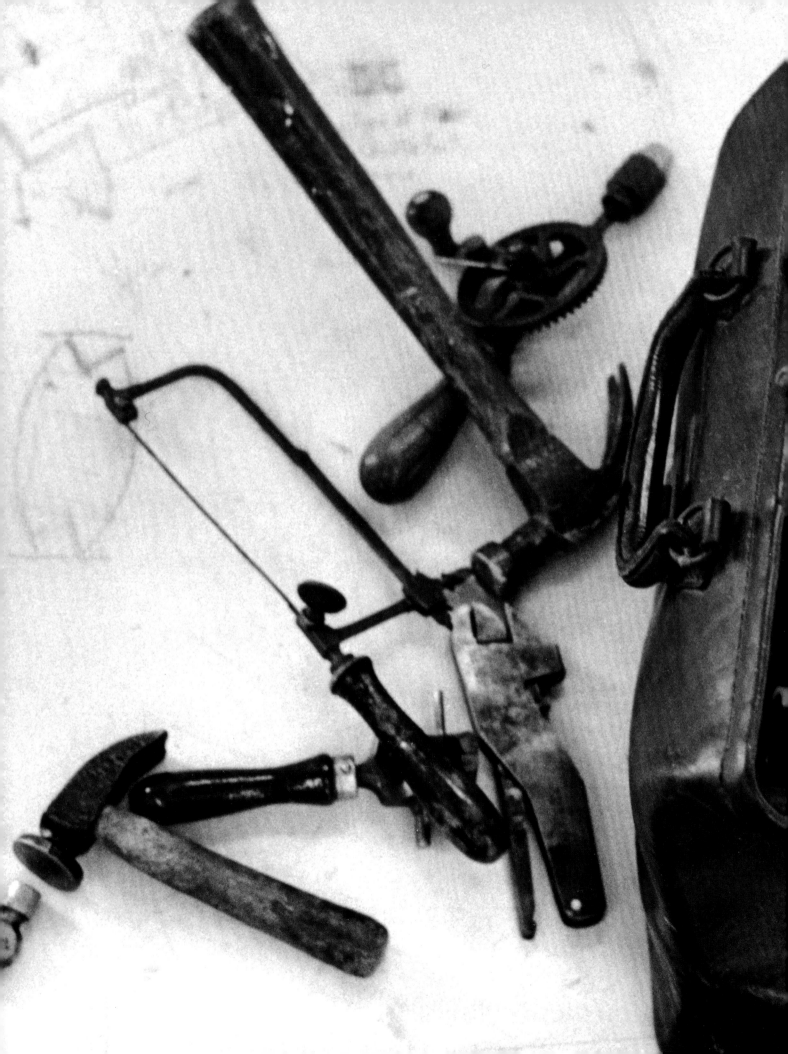

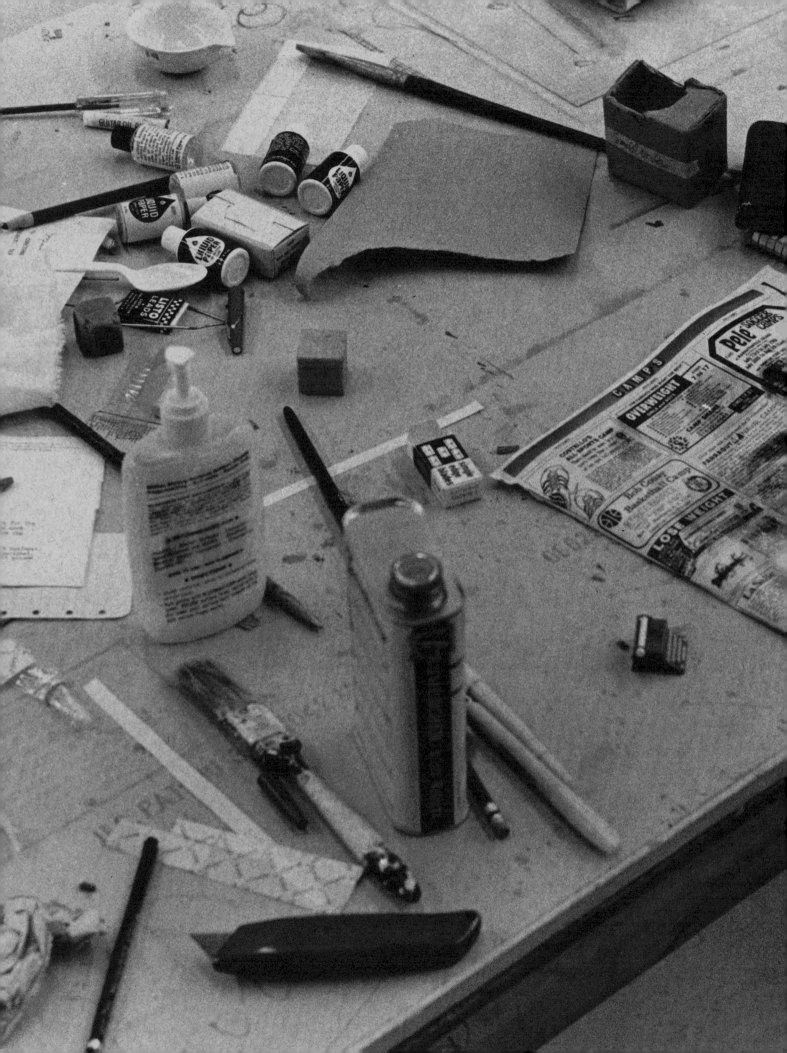

L

is for the **lagoons** and tiered **landscapes** of Leucadia, north of San Diego, where Farber has lived since the 1970s. And **L** is surely for unabashed **lushness**.

M

is for the **miniatures** of the "Auteur" series and the tondo paintings, miniatures now long superseded by the life-size, except for art reproductions that are reduced before Farber gets his hands on them. **M** is for **musicality**—a more accurate word than balance—and for **multiples**, i.e., the repetitions or duplicates of an object in a single painting and for similar variations from painting to painting.

N

is for **notes to himself**, or more generically, the **notes to oneself** of so many paintings of the 1980s and 1990s. These notes include dream journals, letters to and from friends, slogans, quips, self-addressed advice, and nagging reminders—all a bit ventriloquized, since they can seem to be Farber's own voice, no matter what the actual source.

And **N** is for **nailing** an object—spatially or sculpturally, and in terms of color and characterization.

O

is for Richard Bellamy's **Oil and Steel Gallery**, which, twenty years ago, offered the last chance for New Yorkers to see a full-scale exhibit of Farber's work. And **O** is for **getting old**, a recurrent, almost chronic theme of Farber's work of the last few years.

is for the division of a painting into **quadrants**, one of Farber's methods of multiplying the possibilities for playing with the frame; **Q** is also for his dealer, supporter, and champion in Southern California, **Mark Quint**, and for being on the *qui vive*, exemplified by the work's alertness and liveliness.

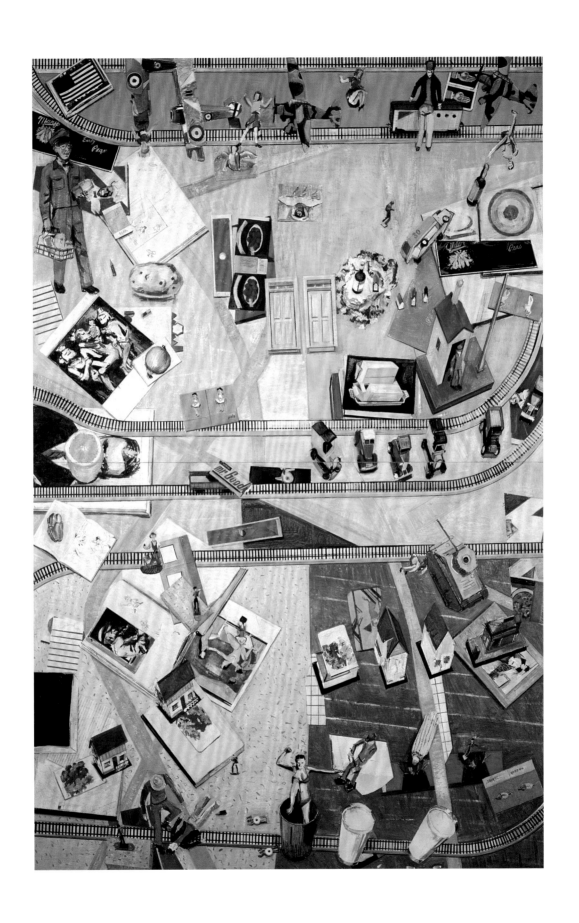

Roads and Tracks, 1981
Oil on board
89 x 57 inches

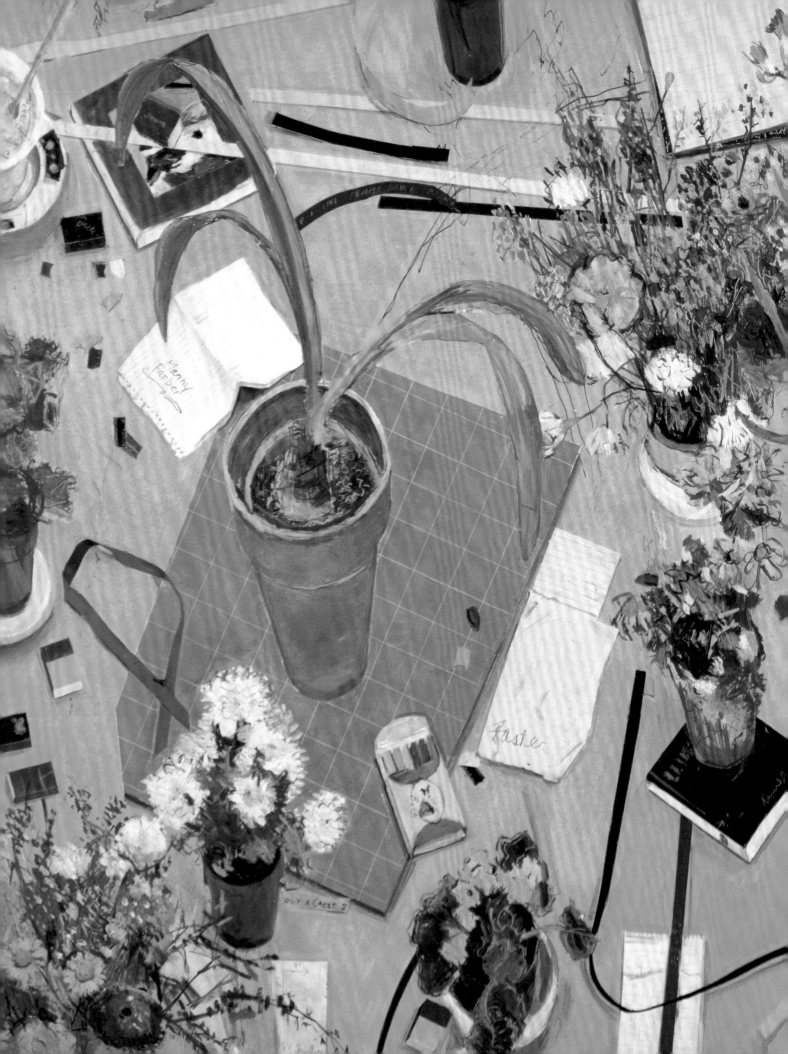

The Farber Equation
Robert Polito

The Farber equation is never simple. That sentence is a variation on a Samuel Beckett line I've wanted to adapt for an essay, review, biography, even poem, ever since I read the original in college. As the opening sentence to his first book Beckett wrote, "The Proustian equation is never simple," and from the outset I was comforted by the promise of persistent, accelerating, perhaps eternal difficulty and puzzle. But as over the years I repeated to myself the sentence, "The Proustian equation is never simple," at the blind start of any obstinate piece of writing, I found myself startled by Beckett's conflation of "Proustian" and "equation": his brisk juxtaposition of involuntary memory and the painstaking working through of quantities and variables.[1]

I never found a space for the sentence because the bewilderment the arrival of Beckett's six words in my head customarily signaled turned out always to expose only a lack of preparation or confidence, a private anxiety that refused to intersect the subject at hand. But in Manny Farber's paintings and film criticism, the introductory oddities, muddles, crises, contradictions, dead ends, multiple alternatives, and divergent vistas spiral along "chains of rapport and intimate knowledge" (to quote his *Artforum* essay on Don Siegel) into still more tangled and intractable mysteries; following Beckett on Proust, the Farber equation "creates a sustained, powerful, and lifelike pattern of dissonance" (to quote his *City Lights* essay on Preston Sturges) that insists on insinuating the steeped-in-time personal and sensual alongside the abstractly intellectual, formal, and conceptual.[2]

For much of his writing life Farber was branded an advocate merely of action films and B-movies—as though it might not be distinction enough to have been the first American critic to propose serious appreciations of Howard Hawks, Samuel Fuller, William Wellman, Raoul Walsh, and Anthony Mann. Yet Farber resisted many *noir* films of the 1940s, believing them to be inflated and mannerist—"Over the past couple of years, one movie after another has been filled with low-key photography," he complained in 1952, "shallow perspectives, screwy pantomime, ominously timed action, hollow-sounding vices." Farber also was among the first critics to write about Rainer Werner Fassbinder, an early champion of Werner Herzog, and an exponent of such experimental directors as Michael Snow, George Kuchar, Andy Warhol, and Chantal Akerman. *Village Voice* film critic J. Hoberman told me that upon discovering Farber in college, he was "stunned by how eclectic Farber was, how wide-ranging his references were. I wasn't that interested in commercial films. I was interested in underground movies, the French new wave, and such B-movies as existed. I would read Andrew Sarris, I would read Kael, but I felt they were operating from a different perspective—

1 Samuel Beckett's 1931 *Proust* as reprinted in the (then) complete edition of his writings (New York: Grove Press, 1970).

2 All quotations from Manny Farber's 1971 *Negative Space* come from the expanded later edition (New York: Da Capo Press, 1998).

left:
Domestic Movies (*detail*), 1985
Oil on board
96 x 96 inches

95

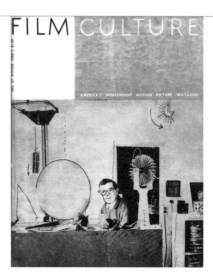

whereas Farber seemed to me to be a much hipper intellect."[3] As Hoberman quipped in the introduction to his collection *Vulgar Modernism*, Farber played "both ends off against the middlebrow."[4]

Still, Farber's notoriety as a film critic largely resides in his B-movie-steeped, careering slams of the fifties and sixties—"The Gimp" (for *Commentary*, 1952), "Underground Films" (also for *Commentary*, 1957), "Hard-Sell Cinema" (for *Perspectives*, 1957), and particularly "White Elephant Art vs. Termite Art" (for *Film Culture*, 1962). The termite/white elephant essay cashiered "masterpiece art, reminiscent of the enameled tobacco humidors and wooden lawn ponies bought at white elephant auctions decades ago." White elephant directors "blow up every situation and character like an affable inner tube with recognizable details and smarmy compassion" or "pin the viewer to the wall and slug him with wet towels of artiness and significance." Farber instead tracked the termite artist: "[O]rnery, wasteful, stubbornly self-involved, doing go-for-broke art and not caring what comes of it." Termite art (or "termite-fungus-centipede art," as he also tagged it) is "an act both of observing and being in the world, a journeying in which the artist seems to be ingesting both material of his art and the outside world through horizontal coverage." Against the white elephant "pursuit of continuity, harmony," termite art mainly inheres in moments—"[A] few spots of tingling, jarring excitement" in a Cézanne painting "where he nibbles away at what he calls his 'small sensation'"; John Wayne's "hipster sense of how to sit in a chair leaned against a wall" in *The Man Who Shot Liberty Valence*; and "one unforgettably daring image" in *Jules et Jim*, "kids sniffing the bicycle seat just vacated by the girl in the typical fashion of voyeuristic pornographic art."

Farber's attention to vivifying details and gestures over the encrusted masterwork reminds me of Robert Frost in his *Paris Review* interview. "The whole thing is performance and prowess and feats of association," Frost asserted of his poems. "Why don't critics talk about those things— what a feat it was to turn that that way, and what a feat it was to remember that, to be reminded of that by this."[5] Farber similarly personalized his termite/white elephant division for the introduction to *Negative Space*: "The primary reason for the two categories is that all the directors I like . . . are in the termite range, and no one speaks about them for the qualities I like." As termite artists he indicated a diversity of painters, writers, photographers, producers, and actors, which spanned Laurel and Hardy, Otis Ferguson, Walker Evans, Val Lewton, Clarence Williams, J. R. Williams, Weldon Kees, Margie Israel, Isaac Rosenfield, sometimes James Agee, and film directors Hawks, Walsh, Wellman, Fuller, Mann, and Sturges.

3 Manny Farber, interview by author, September 2002.

4 J. Hoberman, *Vulgar Modernism: Writing on Movies and Other Media* (Philadelphia: Temple University Press, 1991).

5 The Robert Frost interview appeared in *Writers at Work: The Paris Review Interviews*, ed. George Plimpton (New York: Viking, 1963).

Farber's essay "The Subverters" was published in *Cavalier* (July 1966) "White Elephant Art vs. Termite Art" was published in *Film Culture*, (Winter 1962—63).

Manny Farber published his last film essay, "Beyond the New Wave: Kitchen Without Kitsch," in *Film Comment*, in 1977, a few years after he moved from New York to San Diego with his wife, the artist Patricia Patterson, to teach film and painting at the University of California. Among his reasons for abandoning criticism, as he recently told me: "I no longer wanted to be viewed as the film critic who also paints."[6] In New York Farber traveled among the late 1930s generation of New York writers and critics, many aligned with *The Partisan Review*—Clement Greenberg, Agee, Saul Bellow, Jean Stafford, Mary McCarthy, Kees, and Ferguson, among others. For his reviews and essays for *The New Republic*, *The Nation*, *Time*, *Commentary*, *Commonweal*, *The New Leader*, *Cavalier*, *Artforum*, and *City Magazine*, Farber tracked obvious and enduring affinities, particularly with Ferguson, Agee, and Greenberg. Yet Farber's approach to the actual writing could not be more divergent, incongruous, idiosyncratic, perverse. Where Greenberg aimed at what might be styled an elegant lucidity, even as he traced the destruction of representation, and Ferguson and Agee offered distinctive variations on conversational lyricism—Ferguson tilting toward twenties jazz, Agee canting into rhapsody—Farber is perhaps the only American critic of modernism to write as a modernist. He emerged as the boldest and most literary of film and art critics of the forties/fifties by coursing along almost stridently antiliterary tangents. Farber advanced a topographical prose that aspired, termite fashion, through fragmentation, parody, allusions, multiple focus, and clashing dictions to engage the formal spaces of the new films and paintings he admired.

His friend, the late Pauline Kael, condescended slightly to Farber during a *Cineaste* interview, remarking, "It's his analysis of the film frame as if it were a painter's canvas that's a real contribution."[7] Farber could direct painterly thoughtfulness to issues such as color in Disney cartoons or slackness of camera in Hollywood features as far back as his first *New Republic* reviews, and always in his criticism references from film and art crisscross and trespass. Still, the correspondences in Farber's film criticism and his paintings are more radical and strategic. During nearly all the years he actively wrote criticism, Farber worked as an abstract artist—as a painter, sculptor, and the creator of gallery installations and monumental oils on collaged paper.[8] But after he moved to San Diego, Farber shifted to representational paintings—a profusion of candy bars, stationery, film titles, film directors, and domestic still lifes—and soon discontinued his film writing. Characteristically these new paintings are multifocused and decentered. Intense detailing arrests the eye amid spiraling chains of association—visual, cultural, or personal. They sometimes imply narratives, but without positing the entrances, exits, and arcs of any particular preexistent story lines. Despite their subjects, these works can hardly be mistaken for Pop—yet for all their conceptual focus on the medium, or on art history, they aren't abstract either.

Farber's paintings import film dynamics, but paradoxically. The controlling intelligence of an auteur director atomizes into a profusion of stories and routes; much as with an interactive e-book, a viewer can enter a painting only by realigning the givens. But in Farber's film criticism, I want to suggest, is a

6 Farber, interview by author, August 2002.

7 Leonard Quart, "I Still Love Going to Movies: An Interview with Pauline Kael," *Cineaste* 25, no. 2 (2000).

8 Farber's 1969 articles on the films of his friend Michael Snow offer, I believe, thoughtful parallels to the monumental oils on collaged paper of the early 1970s. See "Canadian Underground" and "Michael Snow" in *Negative Space*.

prediction of the painter he would become. Certain reverenced film directors—Hawks, Wellman, Sturges, Lewton, Don Siegel, Jean-Luc Godard, Robert Bresson, Warhol, Fassbinder—arise from the essays almost as self-portraits of that future painter. The painter Farber will be is forecast in his observations and descriptions of his favorite directors, actors, and film moments, but also (and more vividly) in his writing style.

Farber once described his prose style as "a struggle to remain faithful to the transitory, multi-suggestive complication of a movie image and/or negative space." No other film critic has written so inventively or flexibly from inside the moment of a movie. His writing can appear to be composed exclusively of digressions from an absent center. One of his standard moves is a bold qualification of a qualification, in a sequence of vivid repositionings. His strategies mix self-suspicion, retreat, digression, and mulish persistence, so that Farber (once more Beckett-like) often proceeds as if giving up and pressing on simultaneously. There are rarely introductory overviews or concluding summaries; his late reviews in particular spurn plot summaries and might not even name the director of a film, and transitions seem interchangeable with non sequiturs. Puns, jokes, lists, snaky metaphors, and webs of allusions supplant arguments. Farber wrenches nouns into verbs (Hawks, he writes, "land-scapes action") and sustains strings of divergent, perhaps irreconcilable adjectives such that praise can look inseparable from censure. *Touch of Evil*, he writes, is "basically the best movie of Welles's cruddy middle peak period." He will cast prickly epigrams—"Huston is unable to countenance the possibility of every gentleman being a murderer at heart, preferring instead every murderer being a gentleman at heart." His sentences will dazzle through layers of poise and charm:

What's so lyrical about the ending [of Don Siegel's *The Lineup*], in San Francisco's Sutro Museum, is the Japanese-print compositions, that late afternoon lighting, the advantage taken of the long hallways, multilevel stairways, in a baroque, elegant, glass-palace building with an exposed skating rink, nautical museum, and windows facing the sea with eye-catching boulders.

But Farber *qua* Farber typically arrives at a kind of backdoor poetry: not "lyrical," or traditionally poetic, but original and startling. This is Farber on *How I Won the War*: "At its best, it has a crawling-along-the-earth cantankerousness and cruddiness, as though the war against fascism were being glimpsed by a cartooned earthworm on a fake hillbilly spread somewhere in the Carolinas." Or here he famously invokes the "underground" theaters along 1950s Manhattan's 42nd Street:

The hard-bitten action film finds its natural home in caves: the murky, congested theaters, looking like glorified tattoo parlors on the outside and located near bus terminals in big cities. These theaters roll action films in what, at first, seems like a nightmarish atmosphere of shabby transience, prints that seem overgrown with jungle moss, sound tracks infected with hiccups. The spectator watches two or three action films go by and leaves feeling as though he were a pirate discharged from a giant sponge.

Many of these writerly aspects are on display in Farber's magnificent Hawks piece, originally published in *Artforum* in 1969. The essay manages neither a welcoming preface nor a resolving conclusion—the start and finish are all canny abruptness. The first four long paragraphs compose a docket, or roster—one Hawks film for each paragraph. Farber situates Hawks inside a vast allusive complex—Piero's religious paintings, cubist composing, Breughel, F. Scott and Zelda Fitzgerald, Tolkien, Muybridge, Walker Evans, and Robert Frank; almost a kind of collage of allusive appropriation. Many phrases anticipate Farber's later paintings: "secret preoccupation with linking," "builds detail

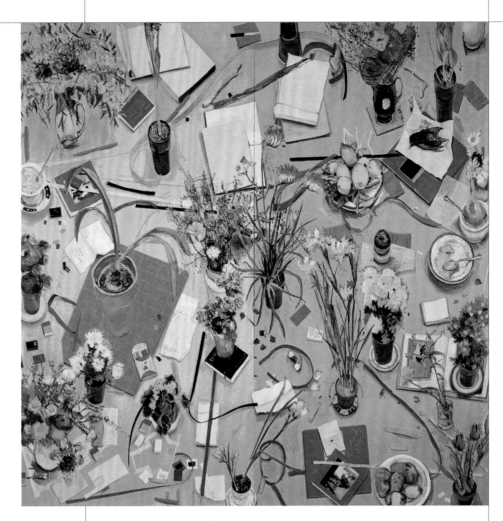

upon detail into a forbidding whirlwind," "each bumping into the other in an endless interplay," "many plots are interwoven," "the idea of topping, outmaneuvering," "intricately locked humor," "the ingenuity of its pragmatic engineering," and "the geography of gesture." And, rare for Farber's prose, there is an explicit autobiographical reference—to the border town of his birthplace. The seaport in *Only Angels Have Wings* might be good, he writes, for a Douglas, Arizona, high-school production.

In *A Dandy's Gesture* (1977), one of two paintings focused on Hawks, Farber —using toys and miniatures—glances at images from the films: an airplane crashing into a chocolate candy mountain, from *Only Angels Have Wings*; a tiger, from *Bringing Up Baby*; an elephant, from *Hatari!*: a boat, from *To Have and Have Not*; and newspaper layout pages, from *His Girl Friday*, with gangster Johnny Lovo (from *Scarface*) in the headline. But by following the train scooting down the track on the left of the painting to a notebook, we discover Farber slyly inserting himself into the painting: a little reporter's pad quotes his own notes for his film class on Hawks at UC San Diego. What might be the lines connecting a director at work in the Hollywood studio system and a painter at

Domestic Movies, 1985
Oil on board
96 x 96 inches

work in a university—here, cramming for a lecture; or, perhaps, not cramming, but painting *A Dandy's Gesture* instead? Who is the gestural dandy of the title? Howard Hawks? Or Farber himself?

Hawks is only the most courtly of these projections of Farber's future paintings. In his inaugural review for *The New Republic* on February 2, 1942, Farber insisted on a multiplicity of expression and form, criticizing a Museum of Modern Art exhibition where each artist "has his one particular response to experience, and no matter what the situation, he has one means of conceiving it on canvas. . . . Which is all in the way of making a plea for more flexibility in painting and less dogma." Long before he started to collaborate with Patricia Patterson on his film writing, Farber managed to insinuate a sense of multiple perspectives, even multiple voices, into his critical prose—his *New Republic* and *Nation* columns often found him so insistently mixed as to suggest (at least) a pair of contrary authors; subsequent pieces review disparate films and discuss them all at once. Among Farber's last solo pieces was his anti-auteurist "The Subverters" for *Cavalier*, in July 1966, the summer that photographer Helen Levitt introduced him to Patricia:

One of the joys in moviegoing is worrying over the fact that what is referred to as Hawks might be Jules Furthman, that behind the Godard film is the looming shape of Raoul Coutard, and that when people talk about Bogart's "peculiarly American" brand of scarred sophisticated cynicism they are really talking about what Ida Lupino, Ward Bond or even Stepin Fetchit provided in unmistakable scene-stealing moments.

His Preston Sturges essay (*City Lights*, 1954, co-written with W. S. Poster) etches a variant on Farber's nostalgia-for-the-future self-portraits. After remarking on "the almost aboriginal Americanism" of the character actors in Sturges's comedies, he celebrates the director for his "multiple focus," "fragmented action," "high-muzzle velocity," "easy handling of multiple cinematic meanings," and "this modern cinematic perspective of mobility seen by a mobile observer." Echoing his first *New Republic* article, he surmises, "It is also probable that [Sturges] found the consistency of serious art, its demand that everything be resolved in terms of a logic of a single mood, repugnant to his temperament and false to life." Still more closely intuiting his own distant paintings, Farber wrote: "Basically, a Sturges film is executed to give one the delighted sensation of a person moving on a smoothly traveling vehicle going at high speed through fields, towns, homes, even through other vehicles. The vehicle in which the spectator is traveling never stops but seems to be moving in a circle, making its journey again and again in an ascending, narrowing spiral until it diminishes into nothingness." Farber would eventually quote fragments of his Sturges essay on a notepad he sketched into his "auteur" painting *The Lady Eve* (1976—77).

Raoul Walsh materializes as another stand-in for the painter—"Walsh's style is based on traveling over routes"—as do other such "underground" filmmakers as Wellman and Mann, who open up a scene "by roadmapped strategies that play movement against space in a cunning way, building the environment and event before your eyes." By the early 1970s and his joint productions with Patricia Patterson, Farber's surrogates are not limited to action directors, nor are the directors only American. On Godard: "His is basically an art of equal emphasis. . . . Dissociation. Or magnification of the molehill against the mountain, or vice versa. . . the words becoming like little trolley-car pictures passing back and forth." On Herzog: "[T]he awkward framing, unpredictable camera positions . . . the droll, zestful, looming work of a filmmaker still on the prowl, making an exploratory work each time out." On Fassbinder: "[A] kind of lurching serpentine. . . ." Buñuel conjures Farber's future paintings, but acidly, from inside a dark mirror:

Manny Farber illustrations for his art reviews in *The New Republic* (February 2 and February 16, 1942)

Each movie is a long march through small connected events (dragged out distressingly to the last moment: just getting the movie down the wall from a candle to a crucifix takes more time than an old silent comedy), but it is the sinister fact of a Buñuel movie that no one is going anywhere and there is never any release at the end of the film. It's one snare after another, so that people get wrapped around themselves in claustrophobic whirlpool patterns.

Many of these directors, along with Sam Peckinpah, Wim Wenders, Budd Boetticher, Jean-Marie Straub, Marguerite Duras, and Eric Rohmer, would prompt "auteur" paintings from Farber during the late 1970s and early 1980s. The witty, devastating *Roads and Tracks* (1981) issues from films of William Wellman, shadowing inversions and reversals. At the top of the canvas, the staid women falling (or jumping?) from airplanes, for instance, are from *Wings*; they immediately transform into angels, probably in a punning reference to Hawks's *Only Angels Have Wings*. In a counterimage to the angels, near the bottom center of the painting, a modern pop-tart woman in a bathing suit pops up from a glass. The cowboy stomping the man on the tracks at the lower right is from *The Oxbow Incident*, while the tracks themselves arrive courtesy of a favorite Wellman film of Farber's, *Other Men's Women*, a love triangle among railroad roustabouts, with many scenes set in a kitchen (hence the butter, the corncob, the lettuce, and bottles). The appearance of James Cagney with a grapefruit on his face is a twist on the famous scene in *Public Enemy*.

Throughout, crisscrossing tracks and roads frame—and force—an impression of stuttering immobility; for all the alleged motion, they don't go anywhere. They're blocked, and destructive. Besides figures from action and war films, the painting is full of clichéd, often toy reproductions of 1930s small-town, working-class life—a milkman, old advertisements, the houses, cars—and also teasing intimations of a world outside that life: most notably, the art book open to the Indian tantric sex painting at the lower left.

Along and inside the tracks Farber races trains of associations historical, cultural, and private. *Roads and Tracks*, like all of his "auteur" paintings, refutes the notion of any single authorial consciousness—the multiperspectives of the winding allusions, their various knowledges, visual textures, and experiences, are at once too public and personal for that.

Farber's "auteur" series flaunts conspicuous links to his film criticism which other paintings will probe ingeniously and boldly. An explosion of the notion of a still life, *Domestic Movies* (1985) likely derives its smart title from the suggestion of time and motion through a tilted perspective and the film leaders that take the viewer up and down the painting. Farber got rid of the object in the center, and the perspective is almost vertiginously multiple—the overhead view of the bowls of lemons, for instance, is distorted by the upward push of the various potted flowers. The flow along the film leaders and up the stalks is checked by other forms of verticality—the donuts, for example, or subtly raised objects, such as the dead bird on what looks like a book, or the

Hacks, 1975
Oil on paper
23¼ x 21¾ inches

101

plant on a rectangle of blue cardboard on the left. Movement also is checked by the intensive detailing of the lemons and the half-eaten bowl of oatmeal. The film leaders contain titles of films Farber was teaching at the time, such as Yasujiro Ozu's 1962 *An Autumn Afternoon*, and there are scattered written notes, one a snatch of movie dialogue: "I want this room filled with flowers."

Story of the Eye (1985) riffs on Georges Bataille's notorious novel of the same title, and on the "I," the first-person pronoun. The images of food here are autobiographical, Farber told me, as all the food came from his kitchen and was prepared by his wife, Patricia.[9] Vegetables, perhaps scallions, and bits of string replace film leader strips or railroad tracks and move the "eye" across the five color fields. Instead of the saturation of *Domestic Movies*, there is an elegance to the spacing, a leisurely but meticulous positioning of notebooks, for example, or the three plates. The book open to an erotic Indian painting provides one clue to *Story of the Eye*—nearly all the food images involve sex, many shaping visual puns on female genitalia. Farber again attends simultaneously to the flow and the detailing—every seed, for instance, of the melon at the far left.

Flow and detailing. Over and over Farber's writing prizes the detail—"the real hero is the small detail," he observes in "Underground Films," and termite art radiates "walls of particularization," "focusing only on a tiny present area," and "buglike immersion in a small area without point or aim, and over all, concentration on nailing down one moment without glamorizing it." Decorous, over-wrought white elephant art, "tied to the realm of celebrity and affluence," accents (as noted above) "the continuity, harmony, involved in constructing a masterpiece." Yet Farber also will argue for the subservience of all parts to a flowing totality—"Everything in a good movie is of a piece," he affirms in the "Introduction" to *Negative Space*. Other essays criticize directors and actors who indulge electric, illuminating "bits" instead of a "panoramic unfolding," a "continuously developing, forming personality," or "an inevitable train of events." Farber's paintings, no less than his film criticism, operate along a stress, maybe a contradiction, that sometimes honors a grace note over the whole, and at other times exalts organic form over the niceties of any incandescent moment.

Hacks (1975), from the "American Candy" series, is one of Farber's earliest representational paintings, and my favorite of his oils on paper. Against overlapping gray-silver planes, Farber arrays networks of circles and lines. The circles: a lollipop at the bottom, a candy tin at the top left, the corks. The lines: various candy bars—Tootsie Rolls, Black Crows, and the wondrous Hacks. All these candies would have been familiar to Farber from the movie concession stands of his childhood, much as the ground colors cue the silver screen, and it's tempting to stroke some of the associations. The childhood movie candy vies with icons of adult life—the chocolate cigar at the right, the corks by the Tootsie Rolls. There is the sense of "hack" as in "cut" or "bludgeon"—a number of candy items are chopped off by the frame, or already half-eaten. During 1975 Farber also was writing movie reviews for Francis Ford Coppola's *City Magazine*, and he was roughly eighteen months away from his last article. Inevitably, given all the film hints, might the notion of the "critical hack" surge as well from the wily web of resonance? Farber hardly can expect a viewer to complete more than a few of the circuits he has coiled into his paintings like springs inside a jack-in-the-box. But as in Beckett's confounding of "Proustian" and "equation," it's the snarl of mechanism and memory that Farber is chasing here, the way the formal dynamics of multiperspective slide against the instinctive disclosures of a life. The Farber equation, as I said, is never simple.

9 Farber, interview by author, August 2001.

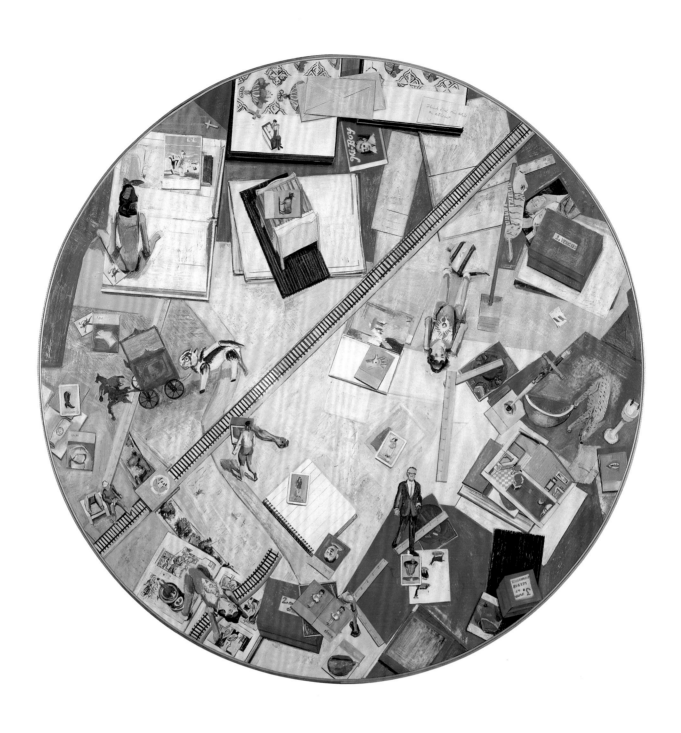

"Thank God I'm still an atheist," 1981
Oil on board
68 inches diameter

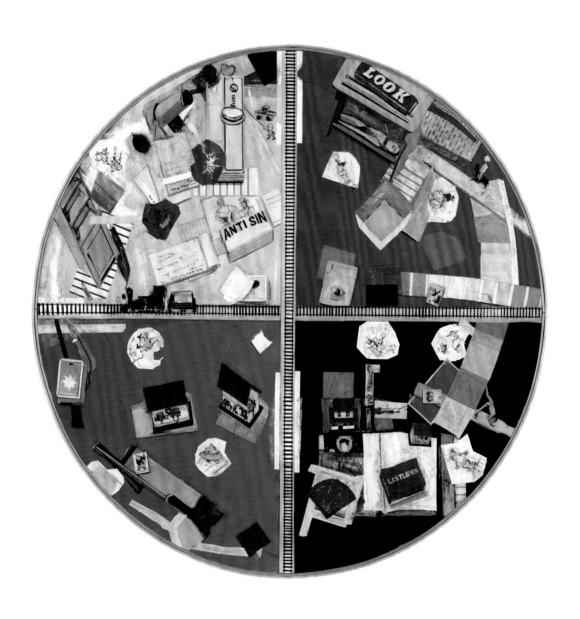

Sherlock, Jr., 1982
Oil on board
48 inches diameter

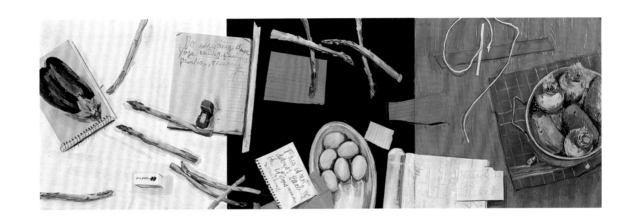

"Passive is the ticket," 1984
Oil on board
21 x 60½ inches

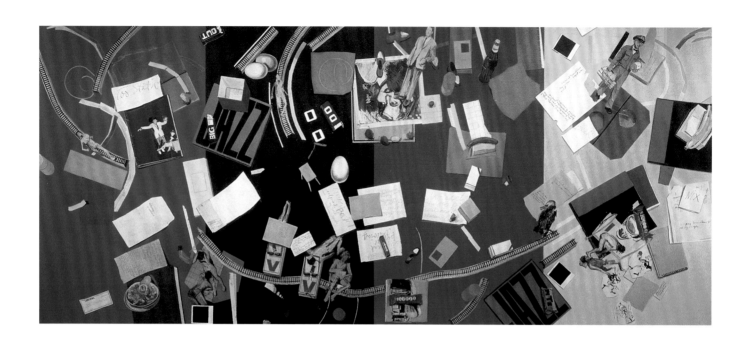

Nix, 1983
Oil on board
58 x 133 1/2 inches

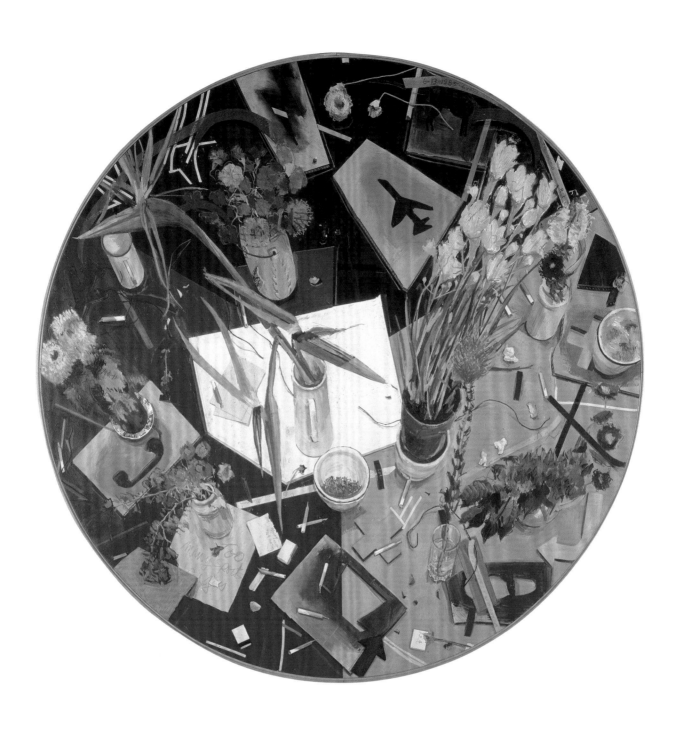

Steve's Stencils, 1985
Oil on board
68 inches diameter

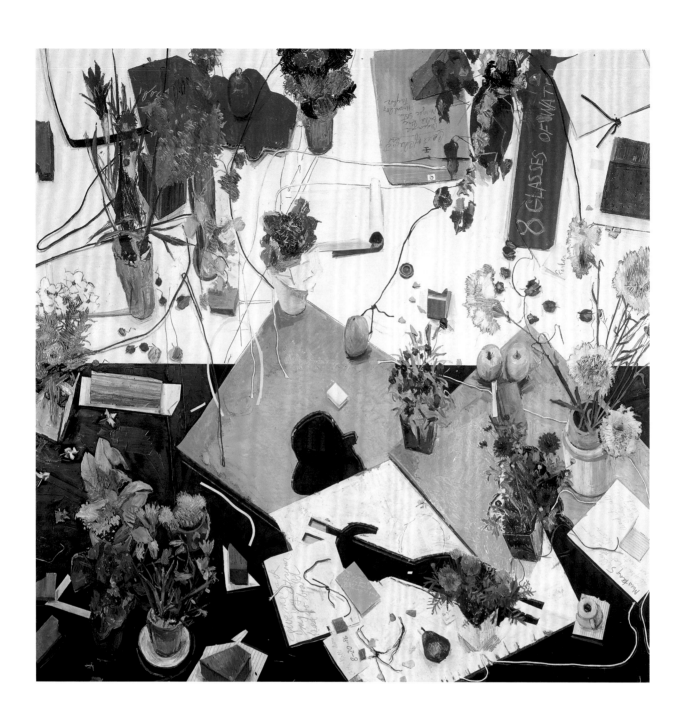

Cézanne avait écrit, 1986
Oil on board
72 x 72 inches

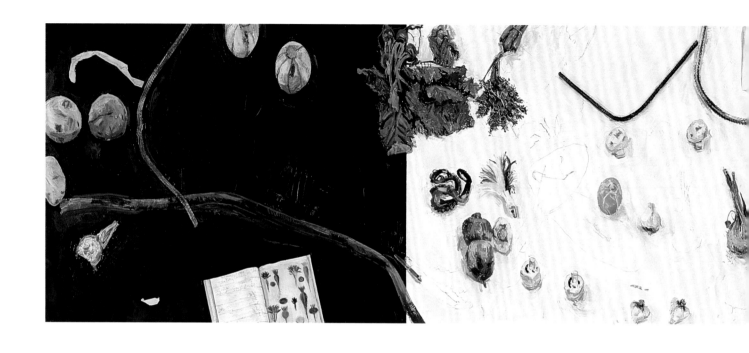

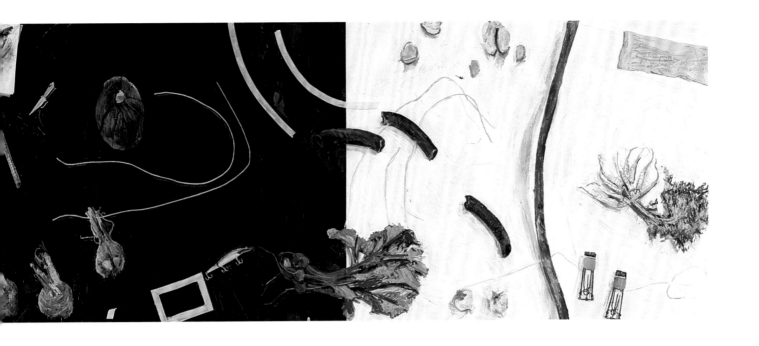

Lure, 1989
Oil on board
36 x 180 inches

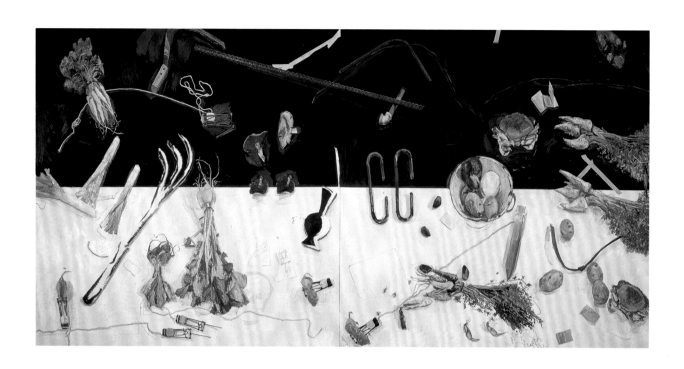

From the Bottom, 1989
Oil on board
60 x 120 inches

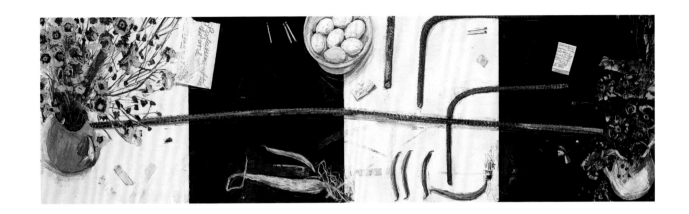

Profusion, 1990
Oil on board
21 x 72 inches

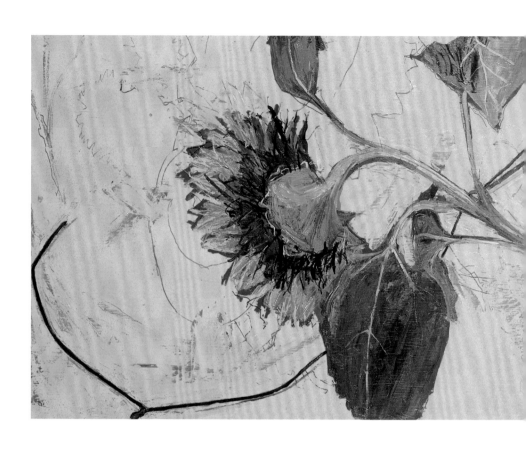

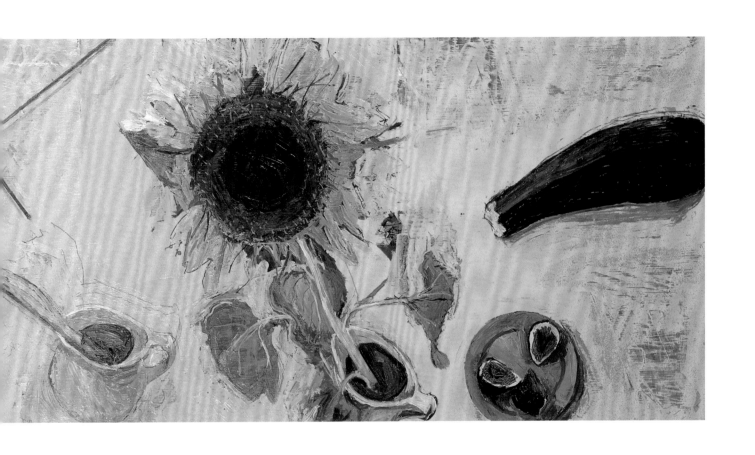

The Bifrontal Abstract Paintings

Sheldon Nodelman

The extensive series of shaped paintings on paper—more than two hundred and fifty works—created by Manny Farber between 1967 and 1975 has never received the critical attention that its extraordinary achievement demands. At the time of their creation, these works were generally discussed in relation to the color field painting of then-prominent figures such as Kenneth Noland or Jules Olitski. Their true affinities are elsewhere, however, with contemporary works that for the most part lie outside the conventional boundaries of painting or seem to belong outright to other genres in which process and material assert themselves as central to the intentional structure of the work in a radically unprecedented way. These include, among others, works as diverse as the thrown-lead pieces of Richard Serra, the metal-plate floor grids of Carl Andre, the horizontal scatterings of Barry Le Va, and the wall-hung felt-strip "sculptures" of Robert Morris. Farber acknowledges a particular kinship with the fragile, perilously exposed constructions —of indeterminate genre—of Richard Tuttle, whose nervous, high-risk aesthetic he shared. Explorations in many ways analogous to Farber's were contemporaneously being pursued on the Continent, notably by the Supports/Surfaces group in France, but their activities were unknown to him at the time. By addressing these factors within the format—and hence, implicitly within the tradition—of painting, Farber was able to put explicitly into question certain assumptions that had hitherto seemed to define, more or less automatically (and even unconsciously), the signifying economy of the picture.

Unstretched and eccentric in shape—an array of ovoids, circles, lozenges, fan shapes, trape-zoids, and others, among which the occasional rectangle is an exception—these paintings directly contravened key rules of the format that had largely conditioned pictorial structure since the invention of the normative Western "picture" in the fifteenth century. Of its constitutive elements —rigorous planarity of the display surface, typically rectangular boundaries, rigid three-dimensional substructure (whether solid panel or canvas over stretcher), and three-dimensional frame isolating the pictorial field from the world outside—Farber's paintings retained only the first, and even this in seriously compromised form. The altered playing field thereby created lent itself to the revisiting of some fundamental tropes of pictorial rhetoric, notably the transactions between willful intention and material circumstance, between applied figuration and subjacent object, between contained "illusion" and external "reality." In the traditional pictorial artifact, literal depth and rigidity of the support afforded a kind of metaphysical anchorage for the figuration's virtual space; its decisive delimitation of shape and plastically emphasized framing apparently justified—in any case, reinforced —its claim as an autonomous whole within which the local tensions and imbalances animating it are resolved: hence, "composition."

Unstretched surfaces and labile materials such as paper have a long history as supports for graphic figuration, as in the scrolls and hangings of East Asian tradition or our own familiar medium of drawing. These formats, characteristically intimate in scale and usage, commingle easily with the body-space of the viewer, and the figuration is typically vignetted or floated within the surface

field so that its provisionality, accessibility, and continuity with the actions of maker and viewer are subtly underlined. Farber's paintings, however, are often of monumental scale—easily the equals of the very large works of his prominent contemporaries in more conventional materials and format—and of an imposing presence (which at least initially holds the observer at a distance) and their figuration firmly appropriates the entire field of the support from edge to edge.

As usual in Farber's art, things are not simple: any move is countered by others serving to deflect or undermine it. Denuded of the sculptural authority and tectonic rationalism of the stretcher, the paintings are indeed very thin and nakedly exposed to the space surrounding them, but they are not fragile. Farber has internalized the rhetoric of construction from the prosthetic apparatus of stretcher and frame into the fabric of the paper surface itself. This is not an undifferentiated expanse, but very visibly a built structure. This insistence upon the materiality of the surface links these paintings visibly with precedents beginning with Robert Rauschenberg's crinkled monochromes of the early fifties and continuing with the latter's and with Jasper Johns's subsequent works, but conceptually also with works of a very different aspect—e.g., the slashed canvases of Lucio Fontana.

Farber's path to this outcome followed, typically for him, in very pragmatic fashion from the imperatives of material constraints and working procedures, a reflex of the discipline assimilated as second nature in long practice as a carpenter in the building trade; for years this "day job" supported his unremunerative pursuits of film criticism and painting. The painting surfaces were

Untitled (*verso*), ca. 1974
Acrylic on collaged paper
68⅝ x 67 inches

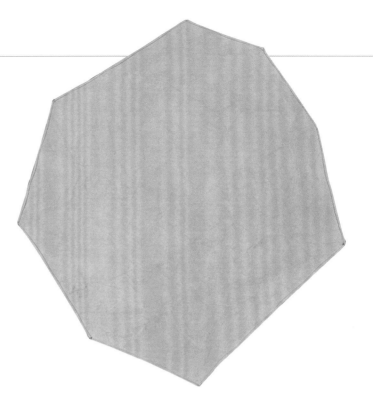

built of Kraft paper, available commercially in rolls of three- or four-foot width, which Farber would cut into uniform lengths and carefully assemble for maximum strength. For added strength and to counter the natural warping of the unrolled paper, he alternated segments in "header" and "stretcher" fashion, setting the directions of their weave perpendicularly to one another following established carpentry practice. To reinforce the glued joins, he pleated their edges, thus doubling the thickness. This scrupulous construction, as Farber recalls not without pride, consumed far more time and labor than the subsequent operation of painting.

The result was the creation of a simultaneously constructive and figurative regime, underlying and visible through the applied figuration—indeed influencing it through the pooling of the applied paint against the ridges formed by the thickened joins. A tectonic pattern, resembling that of ashlar masonry, imposes its regular rhythm and colossal scale—evocative of implacable megalithic architectures like those of Incan Cuzco or of Khafre's Valley Temple at Gizeh—against the particularities of the figurative surface (which range in scale from full-body gesturalism to near-microscopic perturbations) and against the typically curvilinear geometry of the work's external configuration. Arbitrarily interrupted by the latter, this substructure announces no internally prescribed limits, notionally extending itself indefinitely into the surrounding space.

The execution of these margins, cut out with short, discrete strokes of the mat knife, plays up this opposition. The contour is made to tremble imperceptibly, as if willfully drawn, so as to signal its continuity with the interior figuration. The traditional allocation of roles in which the external contour participates in and represents the "objective" order of the external world against the "subjective" virtual realm of the figuration within is thus questioned, and these activated perimeters become sites of a double transaction. One is the familiar function of containment, underlined by Farber's practice of visually reinforcing the exposed contours with a rim of altered tonality that may range from a slight, almost imperceptible darkening of a prevailing chromatic

Richard Tuttle
Light Pink Octagon, 1967
Canvas dyed with Tintex
56$\frac{3}{4}$ x 53 inches
Jack S. Blanton Museum of Art,
The University of Texas at Austin,
Gift of Mari and James A. Michener, 1991

field to the imposition of vigorously contrasting bands amounting to full-fledged compositional elements. The other, exploiting the dynamism inherent in the paintings' unusual and assertive shapes, is that of projection, in effect reversing the figure-ground relationship between the painting and the wall: the picture inflects the shape of the space around it, radiating its figurative energies outward.

Among the most remarkable features of these works is their bifaciality. Freed of servitude to the external support apparatus of a stretcher, the "back" surface of the painting becomes available as a field of pictorial display on the same terms as the "front." Again a practical consideration—painted on one side only, the paper surface would not lie flat—led to the discovery of the signifying possibilities of a new double-sided pictorial organism. Because of the different painting processes employed, the two faces are quite different in character. (They are however, in principle, of equal value, and a painting might be shown presenting one or the other face according to the interest of the moment.) Farber would lay out the paper, already cut into shape, on the studio floor atop a layer of plastic sheeting. Acrylic was poured over the paper surface and distributed with rollers. The paper would then be flipped facedown on the plastic to dry, and after a preparatory soaking with water, the process was repeated on the opposite side. This time, however, a sheet of muslin was placed atop it, and the paint was poured and spread through the cloth; when it was dry, in three to four hours, the muslin would be removed.

These treatments resulted in very different surface and image properties for the two faces. The first side (we might call it the "recto" without, however, any implication of primacy) was shiny and hard-surfaced from its contact with the plastic, and it also might pick up a certain grain from the underlying wood or cement of the floor. The figuration resulting from the more direct paint application would be more gestural and stronger in contrasts. The "verso," because of the diffusion of the paint through the absorbent layer of muslin and the dissimilar conditions under which the drying took place, emerged with a softer, matte surface, the figuration broader, gentler, often diaphanous. Many other variables, both deliberate and fortuitous, contribute to the specific image properties of each individual painting in the series, but this structural polarity remains fundamental.

Farber has underlined the distinction between these two physiognomies by systematically contrasting them chromatically and tonally within each painting; this readily lends itself to an anthropomorphic reading. Recto and verso evoke contrasted aspects—external and internal—of the human subject: the one hard-surfaced and extrovert, its figuration concentrated and active; the other softer and more diffuse, shaded toward the contemplative in mood. Just as do the outward persona and the private interiority within the human psyche, the two paint surfaces subtly affect and modulate one another. Conventionally hung, flat upon the wall, only one of these faces is apparent to a viewer. But the averted side is not inoperative: invisibly present in the mind of any forewarned observer, it qualifies the visible surface with a lurking alternative in the fugitive modes of memory, imagination, and expectation. (In the later stages of the series' evolution, Farber

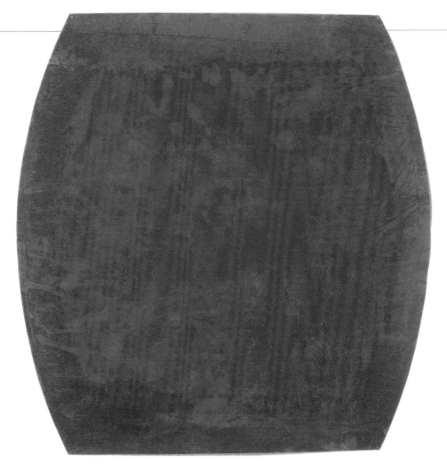

explored a number of stratagems to draw the averted face more immediately into the viewer's experience. The simplest of these entailed the folding over of part of the averted surface so that it hung exposed to view, partially masking the presented face of the painting. Once he juxtaposed a pair of upright rectangles of this sort, twins in size, color, and composition, but with the relationship between the presented and averted faces reversed. Other dispositions developed the three-dimensional potential adumbrated in the fold-overs with the aid of discreetly placed guystrings and thin wooden members that flexed the two-dimensional surfaces far more boldly, even into daring sail-like configurations. They recall the angular abruptness and hair-trigger balance of Farber's sculptural constructions of the early sixties.)

As they abolish the separation between display surface and support structure with the elimination of the stretcher (the function and even the tectonic articulation of the latter now internalized within the display surface itself), these paintings also dissolve the traditional distinction between surface and figuration imposed upon it. The fusion of paper (combining absorptiveness with fineness of grain) and poured acrylic applied to both sides to the point of total saturation generates a new kind of pictoriality in which surface and image are one. (The resulting image has virtually nothing in common with that achieved in the more or less contemporary "stain painting"—e.g., the work of Helen Frankenthaler or Morris Louis—with which it might superficially be compared, for the latter maintain or even emphasize the opposition between support surface and imposed figuration which Farber dissolves.) For the most part, it makes little sense to speak of "composition"

Untitled (*recto*), ca. 1974
Acrylic on collaged paper
68⅝ x 67 inches

in regard to these paintings. The imagery appears largely to grow out of events and circumstances intrinsic to the unified paper-acrylic surface itself. While there are indeed elements that seem to contravene this—that testify explicitly to interventions from without—and while these are both numerous and richly varied, they are, in a curious way, subsumed into a continuum that naturalizes human action itself and into which contingency of every sort is seamlessly interwoven.

An imagery of great complexity and formidable density of allusion is generated by this process. Its range extends from the gently lyrical to the fiercely dramatic, from the ecstatic to the queasily disquieting, often within the same painting. On the harder of the two faces—that dried against plastic—the acrylic, directly poured in its various dosages, colors, and tonal gradations, is layered in drifts of roller-swabbed, soaked-up texture, leathery like rhinoceros hide and cracked through differential rates of drying. The dense and clotted surface, with its sliding, overlapping planes and streaks, swarms with incident: creases, veins, whirls, and traceries. Pitted scars thicken and thin out; sometimes they are crackle-glazed like Japanese ceramics, with highlights glinting capriciously

Untitled, ca. 1972
Acrylic on collaged paper
102 3/4 x 70 3/4 inches each

according to the movement of the viewer's eye. One immediate set of associations is geologic: of dry creek beds and sedimented rock formations, evoking a vision of vast timeframes and slow accretions or sudden floodings and eruptions. The mute intentionality of inorganic matter is dramatized here in a manner reminiscent at lesser scale of the earth art projects of the same period. Another is organic: the same hydraulic energies are revisited as internal anatomical processes, alluding now to the slipperiness and pulsation of circulatory fluids, to vesicles, arteries, and porous membranes. The drama of matter in motion inevitably recalls Jackson Pollock and the brilliant early essay of 1945 in which Farber first called attention to the importance of materiality in Pollock's art.

The imagery of the "versos"—where the paint was applied through muslin—is different, less evocative of tangible substance than of spatial and atmospheric effects. The paint layers are thinner, with less build-up and superimposition; the softer texture is alive with shifting evanescent shapes. Its fluidity may evoke sky or water, sometimes (as in one vast blue expanse) a memory of Monet's late water lily paintings. Here, too, there are traceries of veins and rivulets, but fainter and more diffuse. Because of the relative thinness of the paint application, other sorts of figurative markings and traces figure prominently here; they are less noticeable—though equally frequent—amid the denser and stormier textures of the opposite sides.

The skeins and tidepools of poured and swabbed acrylic which dominate the paintings' imagery at first glance are seconded and rivaled by a further array of graphic or otherwise para- or quasi-figural signs. These interventions, like the acrylic deposits themselves, range in origin between the plainly intentional and the aleatoric. "Snap lines"—chalk traces of a taut-stretched string, a staple of carpenters' practice—and curvilinear trails made by the dragging of a paint-soaked length of string function sometimes as underdrawing beneath the applied acrylic, sometimes as elaboration atop it. Fine detailing in colored chalk is sometimes added. Paint spatters create archipelagos of contrasting color specks in unexpected places, and isolated spots of color—traces of still-wet paint serendipitously picked up from the floor or from contact with an adjacent, not yet dry painting—insouciantly intrude. Partially mingling with the acrylic figuration as accent or amplification, partially standing out from it as willful asides, these variously motivated or occasioned intrusions amplify the range of voices within the work, in somewhat the same manner that imaged representations, graphic logos, or text-bearing notes and detritus do in Farber's more recent "figural" paintings.

Some of these interventions are sufficiently assertive in scale, energy, or evident purpose-fulness to disrupt the otherwise prevailing economy of a painting or to reconfigure it entirely. Sometimes these are fortuitous effects: on more than one occasion, the imprinted contour of a painting, left lying beneath the newer one set out to dry, has rudely imposed the fragment of a geometric outline upon an otherwise alien figuration. Sometimes intruding zones or patches of color are attributable directly to outside volition: for example, when Farber has deliberately folded back or otherwise disarranged the muslin covering. The imprint of a rubber shoe sole, indexing Farber's physical presence within the work (as Pollock's handprints had once done), abruptly contravenes any sense of closure or of temporal separation from the process and moment of fabrication.

Most startling of all are the occasional paper patches, glued like Band-Aids (which they resemble in shape and seemingly erratic placement) on the paper surface—as if to repair nonexistent wounds —and painted over. Recalling the safety pins with which Marcel Duchamp mended a *trompe l'oeil* tear in his last painting, they snipe at the surface's portentously overscaled construction like irreverent graffiti.

Diffracting and unsettling any univocal effect to which the paintings might be taken to aspire, this population of para-figurative signs—most of which are comparatively inconspicuous in size or graphic emphasis—contributes to a further system of oppositions. Standing, for example, in front of one of the great trapezoids of assertively tectonic configuration with its heavily applied margins, its saturated color, its angular slashes or jutting ribs evoking the consciously heroic gesturalism of the abstract expressionist patriarchs, a viewer is first thrust backward into a secure distance. But it is strewn with lures which, if followed, draw one forward into the domain of another regime, that of the close surface. As one loses the overall view, this microsurface asserts itself envelopingly and proliferates with incident, so that one retreats again before threats of disorientation, sensory overload, and delirium. The viewer is suspended between the solicitations offered by mutually incompatible scale regimes, but the opposition is not only between scales; it is also, implicitly, between viewing positions.

If the painting's strong graphic shape anchors it, when viewed at eye level, as perpendicular to the observer's angle of view, this is not true in the same degree as the viewer draws nearer and the external contours are lost. The interior of the painting now floods the field of vision like a landscape panorama, a reading that the surface imagery—so easily interpretable in geologic/ topographical terms—readily accommodates. The observer's position is thus phantasmically transposed into one distant from and high above the object in view, producing a dizzying experience of virtual displacement. It is surely relevant that these works were painted on the floor (as Pollock's had been) and thus viewed by their maker from above. Angle of view, in certain conditions, can imply scale and distance—i.e., it can be in itself a virtualizing device and can carry telling cognitive and affective implications. (It is this phenomenon that Leo Steinberg identified under the designation "flatbed painting" as a crucial new departure in advanced pictorial practice beginning in the fifties.) A trenchant comparison, in Farber's case, might be with Duchamp's *Dust Breeding* of 1920, a steeply angled photo view of months of dust accumulation on the back surface of the *Large Glass* as it lay flat in his studio: an incunabulum of process art combined with a notional landscape in aerial view. The view from above, in a declarative form, would be a signature device of Farber's subsequent, ostensibly figurative painting since 1975. The edgy combination of seduction and violence which distinguishes these later works is clearly evident here in the unstable fusion of wall-plane and floor-plane views, of the perspectival and the cartographic, of proximity and distance, and of immersion and confrontation.

Untitled, ca. 1967
Acrylic on collaged paper
104 x 75 inches

125

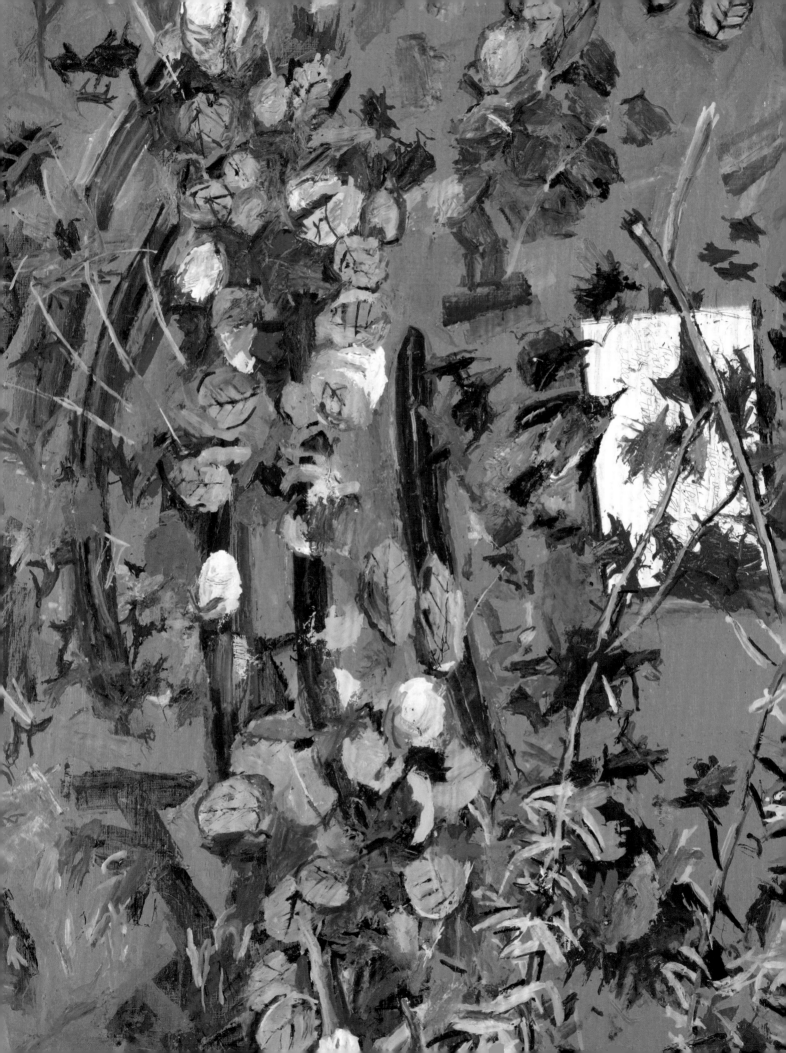

Manny Farber: The Garden of Earthly Routines

Jonathan Crary

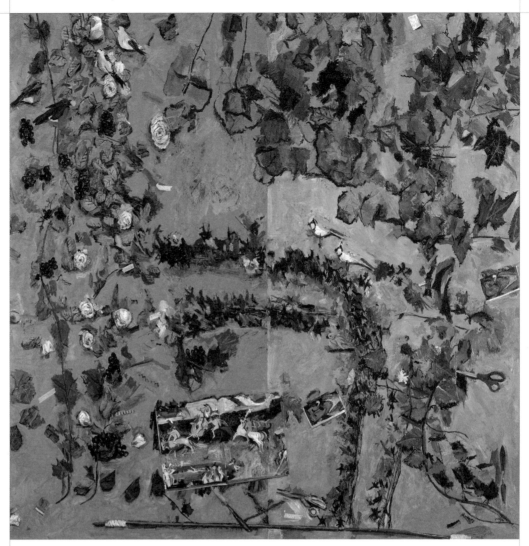

In his 1981 essay "American Quartet," artist Robert Morris put forth the claim that almost all significant American art since World War II can be mapped out in relation to the compass points of Jackson Pollock, Edward Hopper, Marcel Duchamp, and Joseph Cornell. It is a measure of Manny Farber's extraordinary richness and complexity that he is one of a handful of twentieth century American artists (Jasper Johns and Robert Smithson might be two others) whose work meaningfully intersects with the four poles of Morris's argument: with the large-scale chromatic ambitions and horizontal orientation of a Pollock, with the irony and linguistic provocations of a Duchamp, with the vacant realism of a Hopper, and with the repetitive assemblages and salvaged detritus of a Cornell. Whether or not these four exemplary artists are an adequate model of the creative limits of modern American art, what is indisputable is Farber's status as a major master of the second half of the twentieth century.

Like all major American painters beginning with John Singleton Copley, Farber's American formation and sensibility have collided with his awareness of and admiration for European painting. But the product of this encounter for Farber has been not sublimation/denial or emulation, but

left:
Ingenious Zeus (*detail*), 2000
Oil on board
72 x 72 inches

above:
Between Bosch and Cézanne, 2001
Oil on board
96 x 96 inches

rather a mobile dialogue in which a sense of both shared problems and cultural disparity has led to a series of stunning visual discoveries. One of the areas in which Farber's American and European identifications are most actively in contention is around the issue of still life. It could be justifiably argued that Farber's commitment as a painter, perhaps even from the first abstract works, has been to the social and epistemological premises of still life painting as opposed to the very different ambitions of narrative figural art or landscape painting: that is to say, Farber aligns his work with the modest pretensions of a "lower" genre, one that privileges the familiarity and even banality of the contents of a material world immediately "at hand." At the same time, this allegiance is also to one of the originary paradigms of painting itself: the accounts from antiquity that celebrate the lost works of Zeuxis, Parrhasius, and others which depicted subjects like "foodstuffs" or other inanimate things of small or medium size. Key work by Zurbarán, Chardin, Manet, Cézanne, and many others affirmed, as Farber knows so well, some of the unique aesthetic possibilities of this genre. But his engagement here is tempered by his refusal of the closed intimacy that is most often a constitutive element of still life, and by his more significant preoccupation with the centripetal effects of an open and expansive visual field.

Still life has always had an uneasy relationship to trompe l'oeil effects, and part of Farber's gamble has been to underscore this nebulous proximity. Trompe l'oeil, of course, is also part of painting's foundational mythology— Pliny's account of the counterfeit grapes of Zeuxis—and it appears intermittently throughout the subsequent history of European art. But Farber's interest in such effects seems closest to its specifically American incarnations in the work of late-nineteenth-century artists such as William Harnett, John Peto, and others: their images present a diverse array of objects drawn, seemingly indifferently, from the spheres of work and leisure, alongside the brand labels of an emerging consumer culture; these objects are vividly available to the tactile approach of the viewer. Farber's tabletop approach (like that seen in some of Picasso's early collages) replicates a crucial feature of trompe l'oeil strategies: representing objects as if positioning them, at their actual size, within a shallow space on the table surface. In particular, his frequent practice of depicting pieces of paper with his own handwriting on them fulfills the literality of trompe l'oeil illusionism in the sense that, while the index card or scrap of notebook paper is represented, the handwriting affirms the painting surface as exactly what it appears to be.

In spite of these features, Farber is obviously remote from any illusionistic aspirations. His work is a kind of experimental Brechtian enactment of a "realist" hypothesis: What would it mean to proceed as if there could be a direct transcription of the contents of a lived world to painting but without acceding to the dream of the seamless exchangability of the two? Farber takes the unusual position of refusing any condescension toward the popular attraction to trompe l'oeil satisfactions while at the same time emphasizing the pervasiveness of his own constructive and painterly activity. His worked surfaces finally expose

Foursquare, 1990
Oil on board
36 x 36 inches

the marks of hand and tools which, ever since the seventeenth century, have been the enemy of the touchless anonymity upon which illusion-for-its-own-sake depends. In the terms of André Bazin's meditations on cinematic illusion, Farber would occupy a willfully ambivalent position, in between those artists who "put their faith in the plastics of the image" and those who "put their faith in reality."

Much of Farber's art over the last two decades has explored the possibilities and limits of working with the shallow fictive space of still life/*trompe l'oeil* on large-scale surfaces that are incompatible with the small size that has historically defined these practices. Because of this, an individual work activates several very different patterns of visual response. Whether these responses happen simultaneously or in some kind of oscillating sequence is a question best left to cognitive scientists, but clearly the paintings affect us optically as large-scale enveloping chromatic fields, recalling aspects of work by Barnett Newman, Ellsworth Kelly, or even Robert Rauschenberg, and also as a perceptual scattering of many disconnected local visual events. A wide variety of two-dimensional adjacencies and tensions occurs both through the large-scale use of color and through the decorative dispersion of microevents amid his still-life contents, as well as through the willfully unreconciled spatial systems at work in his paintings. Whether his color fields are the relatively monochromatic checkerboard system of *Foursquare* (1990) or the deeply saturated blues and violets of *Ingenious Zeus* (2000), their geometries provide no clear indicators of spatial orientation (e.g., of inclination, of recession) to understand the illusory three-dimensional location of his painting contents. His paintings, for all of their willed casualness, generate a reciprocal sense of the precariousness of his arrangements (they seem about to slip down a steeply inclined surface) and the uncertainty of our own viewpoint (which migrates between an orientation to a vertical wall plane and the vertigo of a bird's-eye view). Since the mid-1980s Farber has introduced more disruptive spatial modulations with his use of (relatively tall) vases or other containers filled with flowers. These tend to create local pockets of amplified three-dimensional effects without resolving any of the perspectival derangement. In some works of the 1990s, such as *About Face* (1990), these effects verge on the deliriously baroque, as looming sunflowers soar abruptly out of small pitchers, wrenching us, with dramatic foreshortening, from a predominantly planar relation to the painting.

That plants, flowers, and garden implements figure so prominently in Farber's work of the late 1980s and 1990s is hardly incidental or arbitrary. Farber and Warhol might be said to be the two major flower painters of their generation, though Farber stands far removed from Warhol's subsumption of nature to the regressive claims of an inert image world. For Farber, the flower and the garden are never severed from the experience of direct perception, and the range of formal problems he engages are, at least in part, inherited from both the small late still lifes of Manet and the mural-scale works of Monet from Giverny. Beginning in the late 1980s and for the next decade, Farber overwhelms us with images of flowers in various stages of deterioration, long stems from shrubbery, zucchini, leeks, small branches with brittle leaves, melons, leafy greens freshly pulled with dirt still clinging to their ends, thin garden stakes wrapped with tape, digging implements, as well as objects from very different spheres of activity, such as dishware, scraps of paper, open books revealing color illustrations of well-known paintings, and perhaps most strikingly, long rusted reinforcing rods from some unknown construction work. Whether chromatic radiance is derived from art or nature, it is always experienced in Farber's work, not as an impossible isolated contemplation, but felt and known amid the signs and stories of work, of routine, of many ways of looking and reading—it is a radiance extracted from the uneven rhythms of lived time.

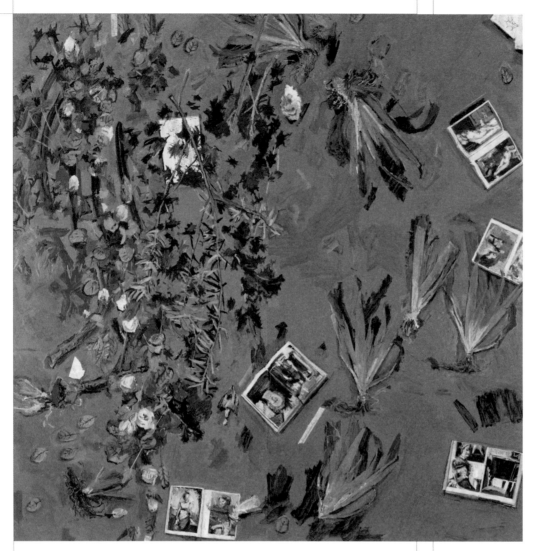

Over the last fifteen years, the garden has become Farber's most com-
pelling and persistent figure for the interface between art and work, between
perception and experience, between beauty and transience. If vision here is
always posed as a composite assemblage of acts, the process of making is
shown to be always incomplete, a shifting mix of play, of labor, of tedium, of
elation, and of loss. The ethical dimension of Farber's art is crucial, for he
operates, sometimes unsparingly, close to the edge of lyrical fatalism in his
disclosure not just of the processes of decay in nature and in built things,
but also of the hopelessness of all systems of organization, of storage, of
categorizing. But in the face of impermanence and disintegration, Farber's
choice of the ground plane as his field of activity, like Smithson's with the
Spiral Jetty, affirms the value of the contingent, the immediately available,
of matter and things at hand as the basis for rearrangement and redistribution
into provisional but revelatory constellations of heightened experience.

Ingenious Zeus, 2000
Oil on board
72 x 72 inches

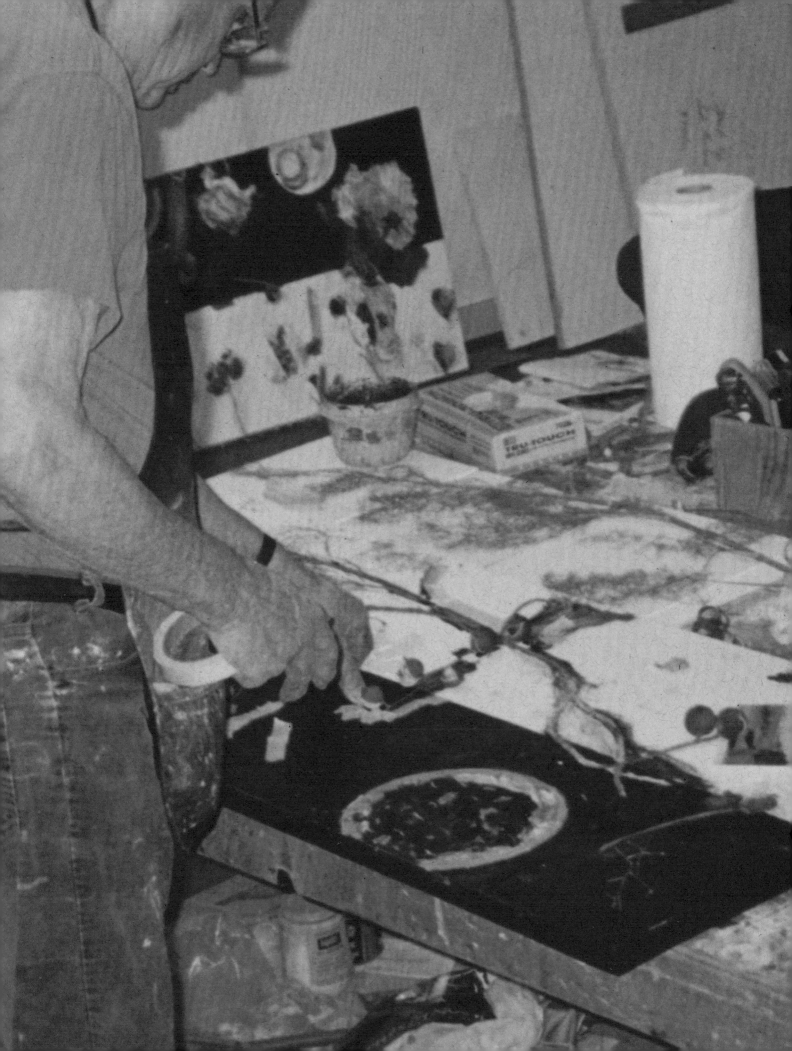

R

is for **radiance**, and for **Robert Rauschenberg**, one of the few artists who has ever shown as fluid and risky a sense of space as Farber's. **R** is for Farber as a **reactive** critic and painter and for his **re-viewing**, seeing something again and again—this process is an important part of Farber's film criticism and just as significant with his art. Are there any paintings in the history of art that seem so disparately layered from viewing to viewing and from varied angles of vision or physical approach? The smallest change of the light can cast a complete reemphasis on a Farber work.

S

is for **scattering**; for **Paul Schrader**, whose short film *Untitled: New Blue* examines a single Farber painting; and for **simultaneity** of multiple points of view and multiple moments of experience. **S** has to be for **space**, negative and proliferating, for the **"Stationery" series**, which featured scattered paper clips and tacks, white-out bottles and gum erasers. And **S** is for what Gorin and Amos refer to as **"still lifes that resist stillness."**

T

is for **tabletops** (or **not-quite-tabletop**), for richness and variety of **texture** and **topography**, and for **tondos**, that circle shape rarely seen in the twentieth century, which Farber employed in part to avoid hierarchy. And **T** is for **touch**: the sense of palpability of whatever Farber depicts and the deftness with which he creates it.

U

is for **underpainting**—that is, painting beneath the overlaid, not painting insufficiently—which is linked to Farber's textural developments, to his peerless color matching, and to the increasing integration or cross-breeding of the abstract and the figurative in his paintings of the last decade.

V

is for **versions** and re-**visions** of subject matter in different styles and speeds, with different kinds of readability.

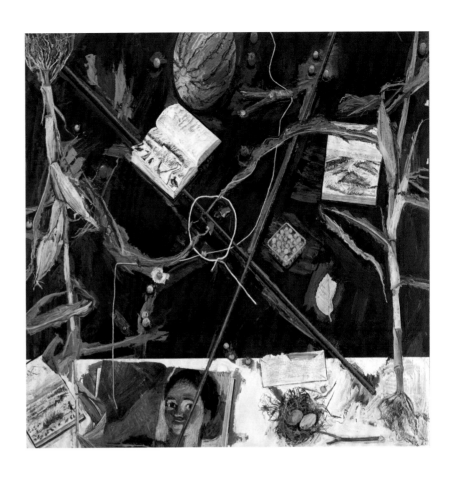

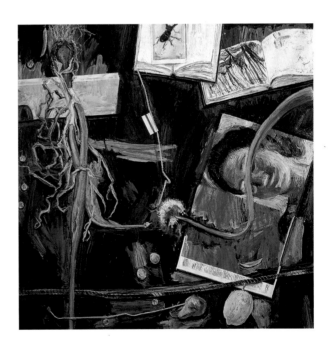

Entwinement, 1993
Oil on board
60 x 60 inches

Cross-eyes, 1992
Oil on board
40 x 40 inches

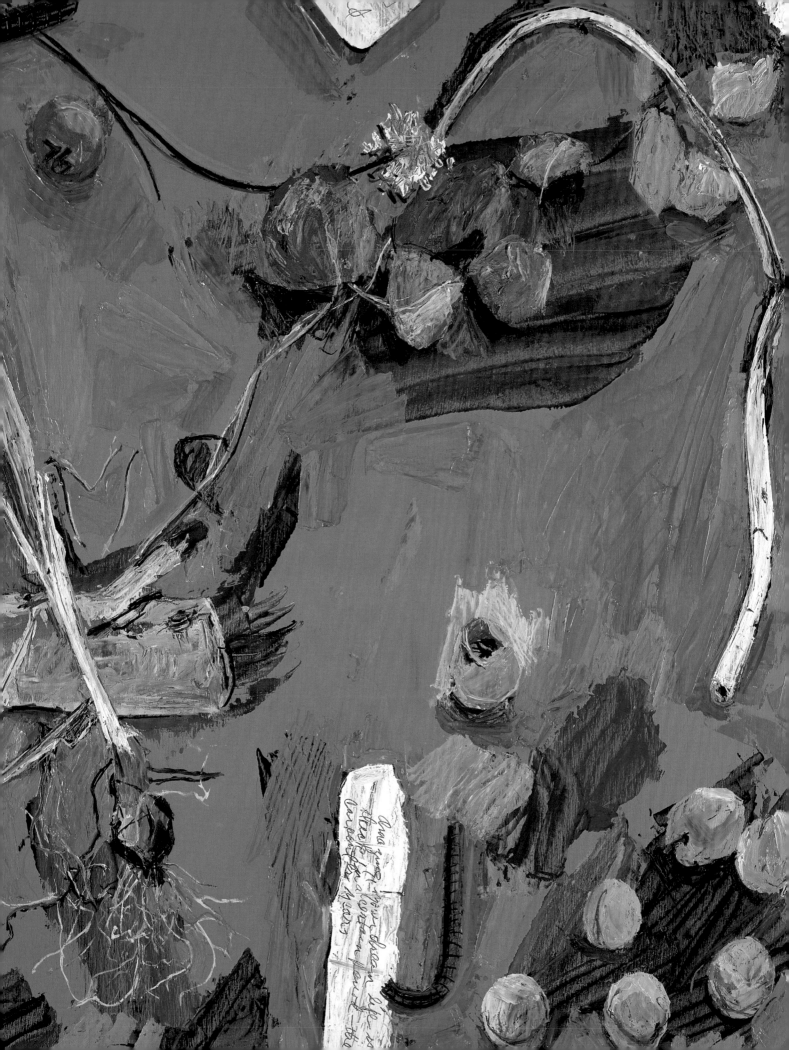

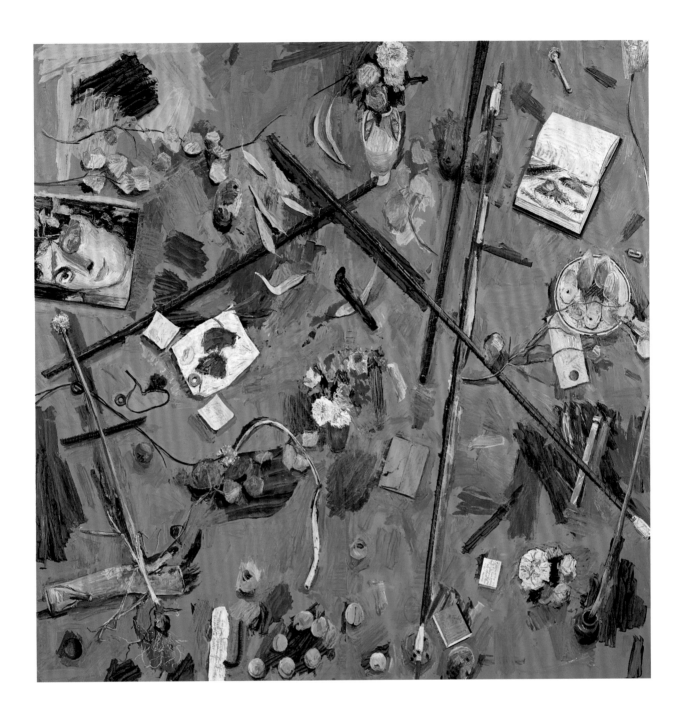

New Blue (*details, pages 134—136*), 1993
Oil on board
72 x 72 inches

137

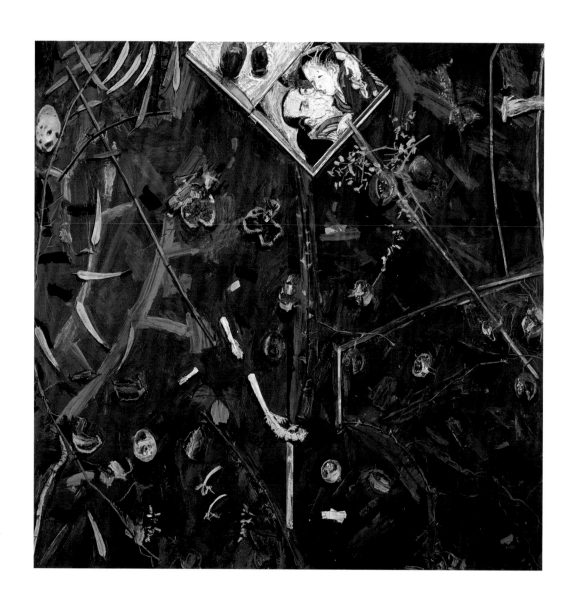

Late Autumn (*detail, opposite*), 1995
Oil on board
60 x 60 inches

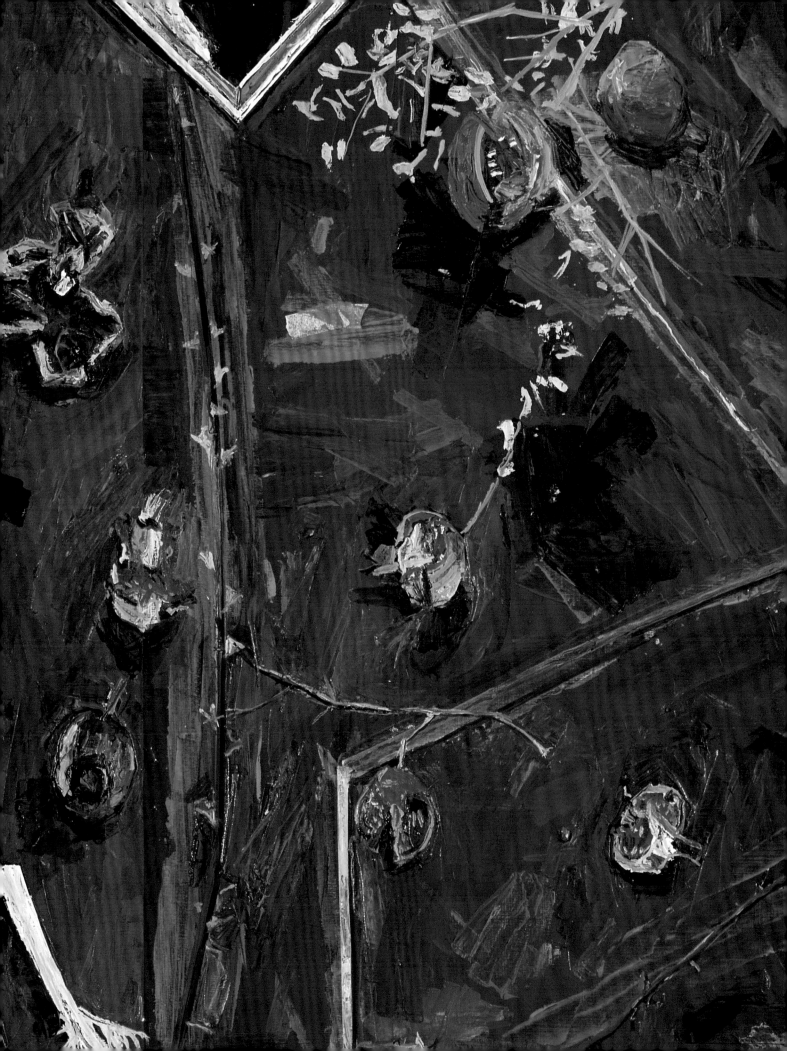

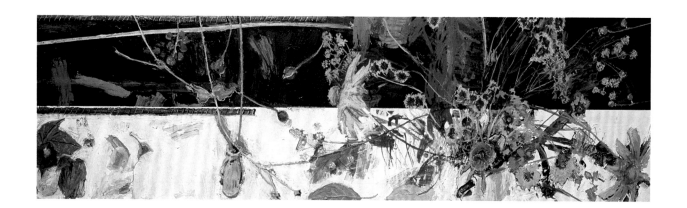

Calliopsis, 1998
Oil on board
21 x 72 inches

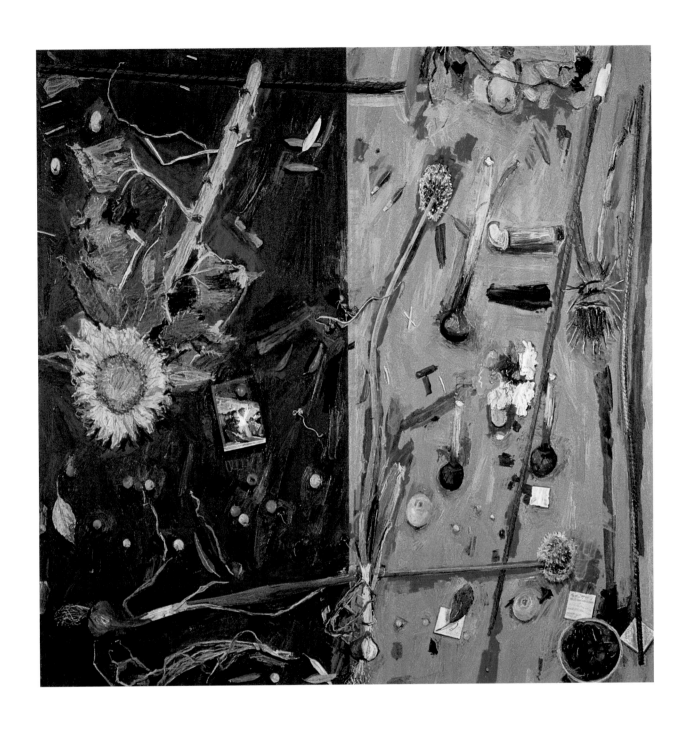

June 6, 1994, 1994
Oil on board
72 x 72 inches

141

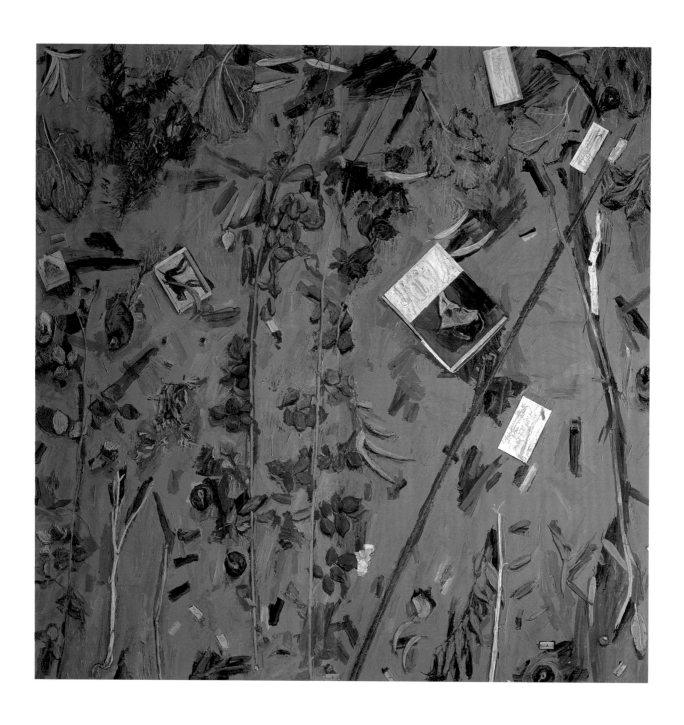

Corot's Italian Women, 1996
Oil on board
72 x 72 inches

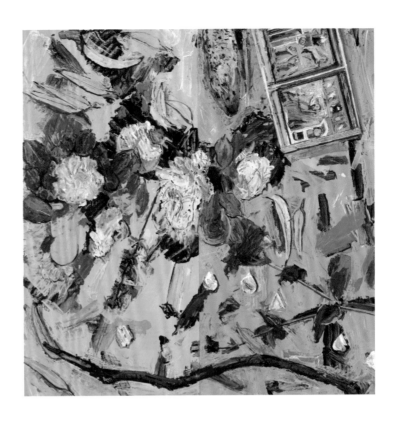

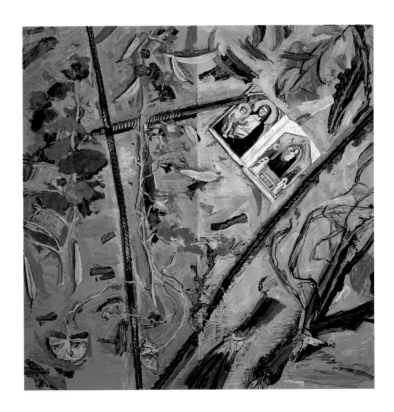

Giotto I, 1995
Oil on board
36 x 36 inches

Giotto II, 1995
Oil on board
36 x 36 inches

143

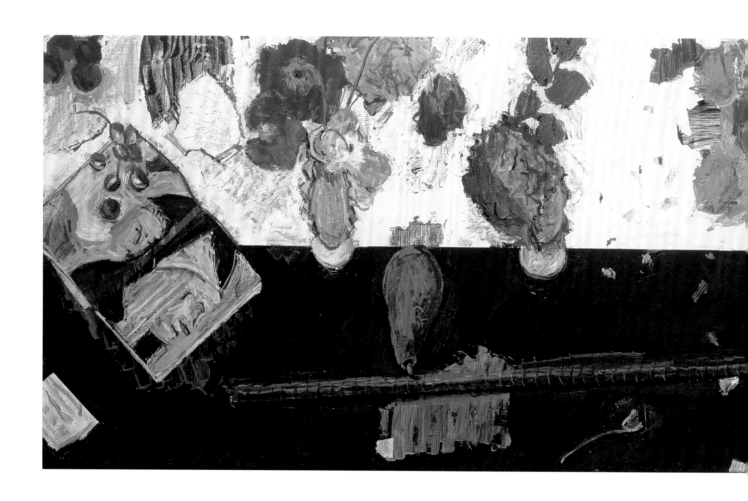

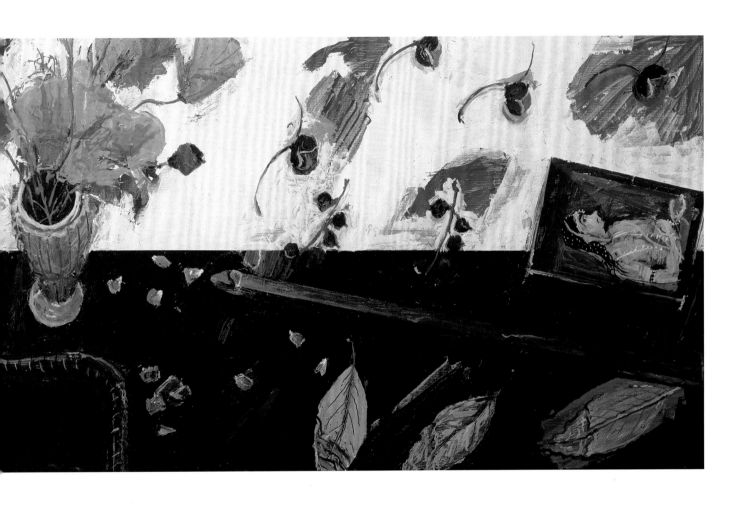

Sacred and Profane Love, 1998
Oil on board
21 x 72 inches

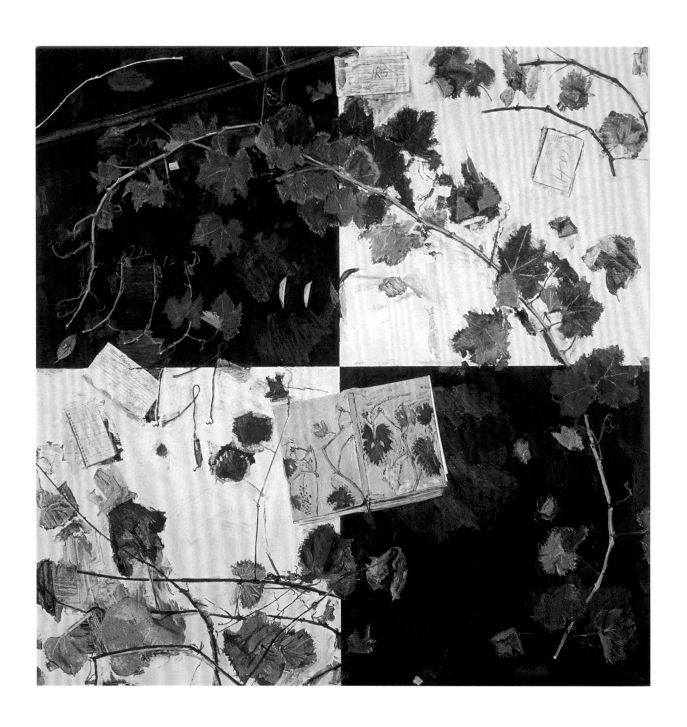

end of messages, 1999
Oil on board
72 x 72 inches

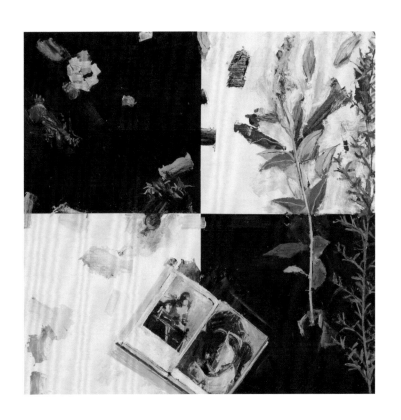

Lace Maker, 2001
Oil on board
36 x 36 inches

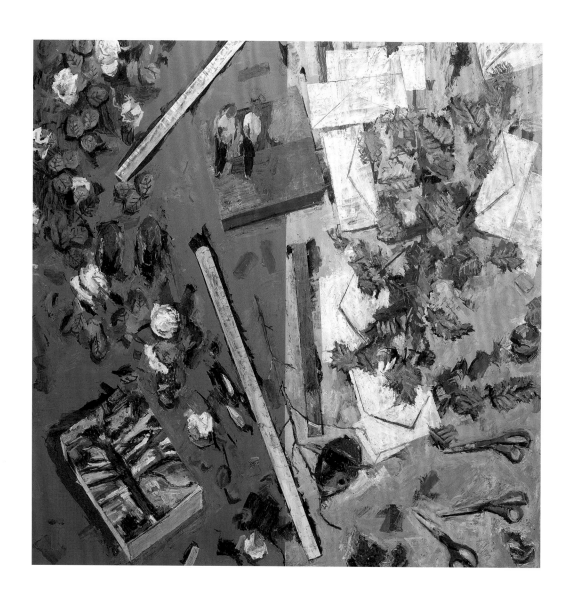

Birds and Rulers, 2002
Oil on board
50 x 50 inches

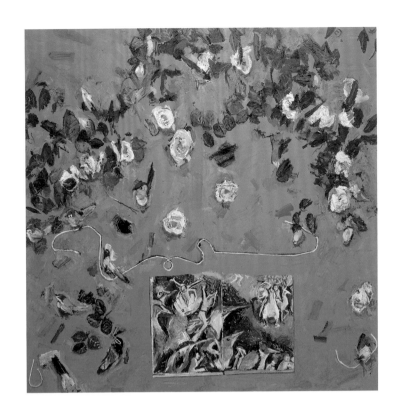

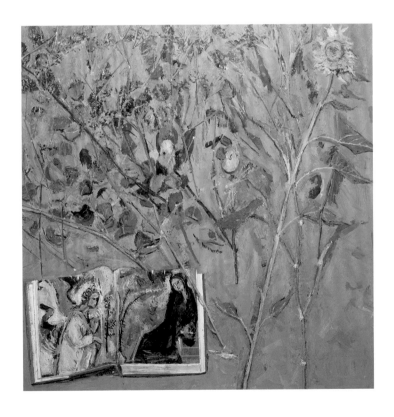

Patricia's Painting, 2002
Oil on board
50 x 50 inches

Big News, 2002
Oil on board
50 x 50 inches

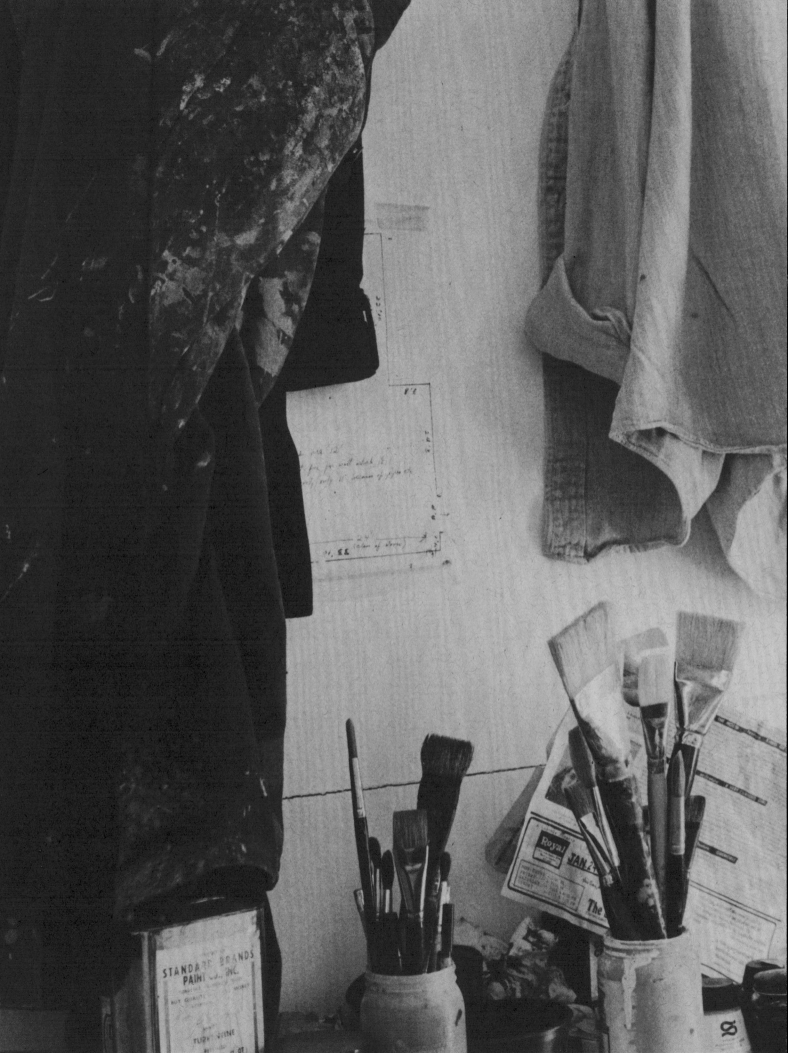

W

W is for **worrying**, which Farber does an enormous amount of.

X

X is for those things we'll never know, of course—for the writings and paintings Farber has managed to suppress as he has edited and reshaped his own career.

Y

Y is for the regular **yapping** and **yelping**—in the studio, on the street, in the car, and around the lagoons—of Farber's late, lamented dog Annie, whose daily walks provided many branches, pods, and other ingredients that found their way into paintings.

Z

Z is for **zeitgeist**, which, as a highly responsive/reactive artist, Farber is always monitoring very closely; for **zigzag** pathways through each painting; and for the **zoom effect**, the feeling of having been brought slowly closer to the intimate life of whatever Farber depicts.

Jonathan Crary, Professor, Department of Art History and Archaeology, Columbia University, New York. Dr. Crary is co-founder of Zone Books and author of *Techniques of the Observer: On Vision and Modernity in the Nineteenth Century* (1990) and *Suspensions of Perception: Attention, Spectacle and Modern Culture* (1999).

Stephanie Hanor, Assistant Curator, Museum of Contemporary Art San Diego. Dr. Hanor has organized several exhibitions, including work by Andy Goldsworthy, Christo and Jeanne-Claude, Helen Altman, Dario Robleto, and Alex Webb, as well as selections from MCASD's permanent collection. She has written critical reviews for *Art Papers* and *Artlies*, and was a catalogue essayist for *Lewis DeSoto: Paranirvana* (2002).

Sheldon Nodelman, Professor, Department of Visual Arts, University of California, San Diego. Dr. Nodelman is the author of *The Rothko Chapel Paintings* (1997), a frequent contributor to *Art in America*, and is currently at work on a book on Marcel Duchamp.

Robert Polito, Director, Writing Programs, The New School, New York. Dr. Polito is the author of *Doubles* (1995), *Savage Art: A Life of Jim Thompson* (1995), *A Reader's Guide to James Merrill's The Changing Light at Sandover* (1994), and *At Titan's Breakfast: Three Essays on Byron's Poetry* (1987), and he is the editor of a forthcoming collection of writing by Manny Farber.

Robert Walsh, Legal Affairs Editor, *Vanity Fair*. Mr. Walsh is the editor of the 1998 edition of Manny Farber's *Negative Space*. He has worked as an editor at *The New Yorker* and on books by Harold Brodkey and Susan Sontag.

Checklist of the Exhibition

Untitled, 1960–62 (p. 59)
Acrylic on wood
44 x 11¼ x 5 inches
Collection of Museum of Contemporary Art
San Diego, Gift of Marsha Picker

Untitled, 1960–62 (p. 59)
Acrylic on wood
60 x 22 x 5 inches
Collection of Dr. David Schiebel, Englewood,
New Jersey

Untitled, 1960–62 (p. 59)
Acrylic on wood
52 x 41½ x 2 inches
Courtesy of the artist and Quint
Contemporary Art, La Jolla, California

Untitled, ca. 1967 (p. 125)
Acrylic on collaged paper
104 x 75 inches
Courtesy of the artist and Quint
Contemporary Art, La Jolla, California

Untitled, ca. 1972 (p. 122)
Acrylic on collaged paper
102¾ x 70¾ inches each
Courtesy of the artist and Quint
Contemporary Art, La Jolla, California

Untitled, ca. 1972 (pp. 31/32)
Acrylic on collaged paper
116¾ x 83½ inches
Courtesy of the artist and Quint
Contemporary Art, La Jolla, California

Untitled, ca. 1972 (pp. 68/69)
Acrylic on collaged paper
44¾ x 101 inches
Courtesy of the artist and Quint
Contemporary Art, La Jolla, California

Untitled, ca. 1974 (pp. 118/121)
Acrylic on collaged paper
58⅝ x 67 inches
Courtesy of the artist and Quint
Contemporary Art, La Jolla, California

Untitled, ca. 1974 (p. 76)
Acrylic on collaged paper
89¾ x 115½ inches
Courtesy of the artist and Quint
Contemporary Art, La Jolla, California

Untitled, ca. 1974 (p. 75)
Acrylic on collaged paper
59¾ x 73 inches
Courtesy of the artist and Quint
Contemporary Art, La Jolla, California

Untitled, ca. 1974 (pp. 73/74)
Acrylic on collaged paper
100¾ x 118¾ inches
Courtesy of the artist and Quint
Contemporary Art, La Jolla, California

Untitled, ca. 1974 (pp. 61/62)
Acrylic on collaged paper
105½ x 114 inches
Courtesy of the artist and Quint
Contemporary Art, La Jolla, California

Untitled, ca. 1974 (pp. 63/64)
Acrylic on collaged paper
89¾ x 115 inches
Courtesy of the artist and Quint
Contemporary Art, La Jolla, California

Cracker Jack, 1973–74 (p. 78)
Oil on paper
23¼ x 21¾ inches
Collection of Sheila and Michael Sharpe,
Del Mar, California

Black Crows, 1974 (p. 78)
Oil on paper
23¼ x 21¾ inches
Courtesy of the artist and Quint
Contemporary Art, La Jolla, California

Hacks, 1975 (p. 101)
Oil on paper
23¼ x 21¾ inches
Collection of the Flaster Family, La Jolla,
California

Kits, 1975 (p. 79)
Oil on paper
23¼ x 21¾ inches
Collection of Douglas A. Simay,
La Jolla, California

McCabe and Mrs. Miller, 1976
(p. 85)
Oil on paper
23¼ x 21¾ inches
Courtesy of the artist and Quint
Contemporary Art, La Jolla, California

**The Red Can, the Push Pin,
and the White Label**, 1976
(p. 83)
Oil on paper
14 x 17 inches
Collection of the Solomon R. Guggenheim
Museum, New York, Exxon Corporation
Purchase Award, 81.2799

School Boy Taffy, 1976 (p. 84)
Oil on paper
23¼ x 21¾ inches
Collection of Dr. S. Sanford and Charlene S.
Kornblum, Los Angeles

Untitled, 1973 (p. 80)
Oil on paper
18 x 24 inches
Courtesy of the artist and Quint
Contemporary Art, La Jolla, California

Untitled, 1973 (p. 80)
Oil on paper
18 x 24 inches
Courtesy of the artist and Quint
Contemporary Art, La Jolla, California

Untitled, 1973 (p. 81)
Oil on paper
18 x 24 inches
Courtesy of the artist and Quint
Contemporary Art, La Jolla, California

Untitled, 1973 (p. 81)
Oil on paper
18 x 24 inches
Courtesy of the artist and Quint
Contemporary Art, La Jolla, California

The Lady Eve, 1976–77 (p. 86)
Oil on paper
23¼ x 21¾ inches
Collection of Wim Wenders, Los Angeles

A Dandy's Gesture, 1977 (p. 87)
Oil on paper
23¼ x 21¾ inches
Collection of Meredith Brody,
Orinda, California

**The Films of R. W.
Fassbinder**, 1977 (p. 89)
Oil on paper
23¼ x 21¾ inches
Collection of Marc and Patty Brutten,
Rancho Santa Fe, California

Howard Hawks II, 1977 (p. 87)
Oil on paper
23¼ x 21¾ inches
Private Collection, New York

**Jean Renoir's "La Bête
Humaine,"** 1977 (p. 86)
Oil on paper
23¼ x 21¾ inches
Collection of Bennett Tramer and Sonya
Sones, Santa Monica, California

**Ad Sheet with Yellow Thayer
Box**, 1978 (p. 82)
Oil on paper
14 x 17 inches
Collection of the San Diego Museum of Art,
Gift of Mr. and Mrs. Norton S. Wallbridge

Eight Liquid Paper Bottles,
1978 (p. 82)
Oil on paper
14 x 17 inches
Courtesy of the artist and Quint
Contemporary Art, La Jolla, California

**Razor and Two Tobacco
Boxes**, 1978 (p. 82)
Oil on paper
14 x 17 inches
Collection of David Wilson,
Knoxville, Tennessee

Birthplace: Douglas, Ariz.,
1979 (p. 36)
Oil on board
44¼ x 57¾ inches
Collection of Douglas A. Simay, La Jolla,
California

Honeymoon Killers, 1979 (p. 39)
Oil on board
44 x 57½ inches
Collection of The Museum of Contemporary Art,
Los Angeles, Gift of Dr. and Mrs. Stuart Landau

**Thinking About "History
Lessons,"** 1979 (p. 48)
Oil on board
89 x 57¾ inches
Collection of Jean-Pierre Gorin,
La Jolla, California

Roads and Tracks, 1981
Oil on board (p. 93)
89 x 57 inches
Private Collection, New York

**"Thank God I'm still an
atheist,"** 1981 (p. 103)
Oil on board
68 inches diameter
Collection of Margaret and Terry Singleton,
Escondido, California

Rohmer's Knee, 1982 (p. 43)
Oil on board
72 inches diameter
Collection of Elyse and Bruce Miller,
Newport Coast, California

Sherlock, Jr., 1982 (p. 104)
Oil on board
48 inches diameter
Collection of Robert and Fran Preisman,
La Jolla, California

"Have a chew on me," 1983
(pp. 44/45)
Oil on board
58 x 134½ inches
Collection of Michael Krichman and
Carmen Cuenca, San Diego

"The Joyces felt humiliated,"
1983 (p. 27)
Oil on board
68 inches diameter
Bloom Collection, La Jolla, California

Nix, 1983 (p. 106)
Oil on board
58 x 133½ inches
Collection of Douglas A. Simay,
La Jolla, California

Earth, Fire, Air, Water, 1984
(p. 46)
Oil on board
96 x 96 inches
Robert A. Rowan Collection,
Pasadena, California

"Keep blaming everyone," 1984
(p. 28)
Oil on board
72 inches diameter
Collection of Mark-Elliott Lugo, San Diego

"Passive is the ticket," 1984
(p. 105)
Oil on board
21 x 60½ inches
The Rose Art Museum, Brandeis University,
Waltham, Massachusetts, On Extended Loan
from Mr. and Mrs. Matthew Mason

Domestic Movies, 1985 (p. 99)
Oil on board
96 x 96 inches
Collection of Charles J. Williams and
Sharon M. Little, San Diego

Steve's Stencils, 1985 (p. 107)
Oil on board
68 inches diameter
Collection of Jeanne K. Lawrence, New York

Story of the Eye, 1985 (pp. 20/21)
Oil on board
36 x 180 inches
Collection of Museum of Contemporary Art
San Diego, Museum purchase with matching
funds from the National Endowment for the
Arts and Contemporary Collectors Fund

Cézanne avait écrit, 1986
(p. 108)
Oil on board
72 x 72 inches
Collection of Charles J. Williams and
Sharon M. Little, San Diego

From the Bottom, 1989 (p. 112)
Oil on board
60 x 120 inches
Bloom Collection, La Jolla, California

Lure, 1989 (pp. 110/111)
Oil on board
36 x 180 inches
Collection of Michael Krichman and
Carmen Cuenca, San Diego

About Face, 1990 (pp. 114/115)
Oil on board
21 x 72 inches
Collection of Colette Carson Royston and
Dr. Ivor Royston, La Jolla, California

Entropy, 1990 (p. 47)
Oil on board
36 x 36 inches
Collection of Pauline Foster, Rancho Santa Fe,
California

Foursquare, 1990 (p. 128)
Oil on board
36 x 36 inches
Collection of Esther and Bud Fischer, San Diego

Profusion, 1990 (p. 113)
Oil on board
21 x 72 inches
Collection of Sue K. and Charles C. Edwards,
M.D., La Jolla, California

Abundance, 1991 (pp. 4/5)
Oil on board
60 x 120 inches
Collection of Pauline Foster, Rancho Santa Fe,
California

Cross-eyes, 1992 (p. 133)
Oil on board
40 x 40 inches
Collection of J. Paul and Zillah Reddam,
Laguna Beach, California

Entwinement, 1993 (p. 133)
Oil on board
60 x 60 inches
Collection of Alan Ritchie, La Jolla, California

New Blue, 1993 (p. 137)
Oil on board
72 x 72 inches
Collection of Paul Schrader, New York

Purple Lake, 1993 (p. 41)
Oil on board
37 x 37 inches
Collection of Nina MacConnel, Encinitas,
California

April 13, 1994, 1994 (p. 49)
Oil on board
72 x 72 inches
Collection of Sheri Jamieson, La Jolla,
California

June 6, 1994, 1994 (p. 141)
Oil on board
72 x 72 inches
Collection of Matt and Nancy Browar,
La Jolla, California

July 6, 1994, 1994 (p. 14)
Oil on board
72 x 72 inches
Courtesy of the artist and Quint
Contemporary Art, La Jolla, California

Batiquitos, 1995 (p. 17)
Oil on board
72 x 72 inches
Collection of Museum of Contemporary Art
San Diego, Museum Purchase, International
and Contemporary Collectors Fund

Cherry Pits, Onion Flowers,
1995 (p. 16)
Oil on board
72 x 72 inches
Collection of Scott and Cissy Wolfe, Rancho
Santa Fe, California

Giotto I, 1995 (p. 143)
Oil on board
36 x 36 inches
Collection of Renée Comeau and Terry Gulden,
La Jolla, California

Giotto II, 1995 (p. 143)
Oil on board
36 x 36 inches
Collection of Anne and Bob Nugent, Rancho
Santa Fe, California

Late Autumn, 1995 (p. 138)
Oil on board
60 x 60 inches
Courtesy of the artist and Quint
Contemporary Art, La Jolla, California

Corot's Italian Women, 1996
(p. 142)
Oil on board
72 x 72 inches
Collection of Victor and Gilda Vilaplana,
La Jolla, California

Carpaccio's Dog, 1997 (p. 47)
Oil on board
36 x 36 inches
Collection of Renée Comeau and Terry Gulden,
La Jolla, California

Mantegna, 1997 (p. 159)
Oil on board
16 x 16 inches
Collection of Renée Comeau and Terry Gulden,
La Jolla, California

Raphael, 1997 (p. 157)
Oil on board
16 x 16 inches
Collection of Raphael J. Gregoire, San Diego

Calliopsis, 1998 (p. 140)
Oil on board
21 x 72 inches
Collection of Larry and Sally Dodge,
La Jolla, California

Sacred and Profane Love, 1998
(pp. 144/145)
Oil on board
21 x 72 inches
Collection of Wilson-Strauss Trust,
La Jolla, California

end of messages, 1999 (p. 146)
Oil on board
72 x 72 inches
Collection of Esther and Bud Fischer, San Diego

Ingenious Zeus, 2000 (p. 130)
Oil on board
72 x 72 inches
Courtesy of the artist and Quint
Contemporary Art, La Jolla, California

**Between Bosch and
Cézanne**, 2001 (p. 127)
Oil on board
96 x 96 inches
Collection of Amanda Farber, San Diego

Lace Maker, 2001 (p. 147)
Oil on board
36 x 36 inches
Courtesy of the artist and Quint
Contemporary Art, La Jolla, California

Birds and Rulers, 2002 (p. 148)
Oil on board
50 x 50 inches
Courtesy of the artist and Quint
Contemporary Art, La Jolla, California

Patricia's Painting, 2002
(p. 149)
Oil on board
50 x 50 inches
Courtesy of the artist and Quint
Contemporary Art, La Jolla, California

Big News, 2002 (p. 149)
Oil on board
50 x 50 inches
Courtesy of the artist and Quint
Contemporary Art, La Jolla, California

*Titles in color exhibited at
MCASD venue only.*

One-Person Exhibitions

2003 *Manny Farber: About Face*, Museum of Contemporary Art San Diego. Traveled to Austin Museum of Art, Texas; P.S.1 Contemporary Art Center, Long Island City, New York

2001 Manny Farber: New Paintings, Quint Contemporary Art, La Jolla, California

2000 Manny Farber: New Paintings, Quint Contemporary Art, La Jolla, California

1999 Manny Farber: Recent Paintings, Quint Contemporary Art, La Jolla, California

1998 Manny Farber: New Paintings, Quint Contemporary Art, La Jolla, California

1997 Six Solo Exhibitions, California Center for the Arts Museum, Escondido

1996 Manny Farber, Charles Cowles Gallery, New York
 Manny Farber: New Paintings, Quint Contemporary Art, La Jolla, California

1995 Manny Farber: New Paintings, Quint Contemporary Art, La Jolla, California

1994 Manny Farber: New Paintings, Quint Contemporary Art, La Jolla, California
 Manny Farber: Recent Work, Carnegie Museum of Art, Pittsburgh
 New Paintings, Frumkin-Adams Gallery, New York

1993 About Looking: Manny Farber Paintings, 1984–1993, Rose Art Museum, Brandeis University, Waltham, Massachusetts
 Manny Farber: New Paintings, Rosa Esman Gallery, New York
 Manny Farber: Works on Paper from the Seventies, Quint Krichman Projects, La Jolla, California

1992 Mandeville Gallery, University of California, San Diego
 Quint Krichman Projects, La Jolla, California

1991 Susanne Hilberry Gallery, Birmingham, Michigan
 Quint Krichman Projects, La Jolla, California

1990 Krygier-Landau Gallery, Los Angeles
 Quint Gallery, La Jolla, California

1988 Dietrich Jenny Gallery, San Diego
 Texas Gallery, Houston

1987 Krygier-Landau Gallery, Los Angeles

1986 Krygier-Landau Gallery, Los Angeles
 Quint Gallery, San Diego
 Texas Gallery, Houston

1985 Manny Farber, The Museum of Contemporary Art, Los Angeles

1984 Quint Gallery, San Diego

1983 Larry Gagosian Gallery, Los Angeles

1982 Diane Brown Gallery, Washington, D.C.
 Janus Gallery, Los Angeles
 Oil and Steel Gallery, New York

1981 James Crumley Gallery, MiraCosta College, Oceanside, California

1980 Tyler School of Art, Temple University, Philadelphia

1978 Manny Farber (retrospective exhibition), La Jolla Museum of Contemporary Art [now Museum of Contemporary Art San Diego], La Jolla, California
 Milliken Art Gallery, Converse College, Spartanburg, South Carolina
 Hansen-Fuller Gallery, San Francisco
 Ruth Schaffner Gallery, Los Angeles

1977 O.K. Harris, New York
 Seder/Creigh Gallery, Coronado, California

1976 Illinois Wesleyan University, Bloomington

1974 Jack Glenn Gallery, Los Angeles

1973 Manny Farber, O.K. Harris, New York
 Manny Farber, Parker Street 470 Gallery, Boston
 Suzanne Saxe Gallery, San Francisco
 David Stuart Gallery, Los Angeles

1972 San Diego State University
 O.K. Harris, New York

1971 O.K. Harris, New York
 Parker Street 470 Gallery, Boston
 San Diego State University

1970 Studio Show, New York

1969 Warren Street Studio (sponsored by O.K. Harris), New York

1968 Bard College, Annandale-on-Hudson, New York

1967 Warren Street Studio, New York

1962 Kornblee Gallery, New York

1957 Tibor de Nagy Gallery, New York

Group Exhibitions

2003 **Two for the Road: Sketchbooks of Patricia Patterson and Manny Farber**, Athenaeum Music and Arts Library, La Jolla, California

2001 **In Their Eighties: Noteworthy Works by Artists in Their Ninth Decade of Life**, Earl and Birdie Taylor Library, San Diego

2000 **Made in California: Art, Image, and Identity, 1900–2000**, Los Angeles County Museum of Art

1997 **Paintings from the Nineties**, California Center for the Arts Museum, Escondido
Perception and Experience: Works from the Permanent Collection, Museum of Contemporary Art San Diego, La Jolla, California
Quint Contemporary Art, La Jolla, California
Salient Green, Susanne Hilberry Gallery, Birmingham, Michigan
Tabletops: Morandi's Still-Lifes to Mapplethorpe's Flower Studies, California Center for the Arts Museum, Escondido
Visual Arts 30th Anniversary Faculty Exhibition, University Art Gallery, University of California, San Diego

1994 Quint Gallery, La Jolla, California

1983 **American Still Life: 1945–1983**, Contemporary Arts Museum, Houston
California Current, L.A. Louver Gallery, Venice, California
Drawings by Painters, Long Beach Museum of Art, Long Beach, California. Traveled to: Mandeville Art Gallery, University of California, San Diego; Oakland Museum of Art
Works from the Collections, San Diego Museum of Art

1982 **Works on Paper**, Larry Gagosian Gallery, Los Angeles

1981 **19 Artists: Emergent Americans**, Exxon National Exhibition, Solomon R. Guggenheim Museum, New York
33rd Annual Hassam and Speicher Fund Purchase Exhibition, American Academy of Arts and Letters, New York
A Continuation of the Figurative Tradition, Baker Gallery, La Jolla, California

1980 **University of California, San Diego, Faculty Art Exhibition**, Mandeville Art Gallery, University of California, San Diego

1979 **Narrative Art of the Seventies**, American Foundation of the Arts, Miami

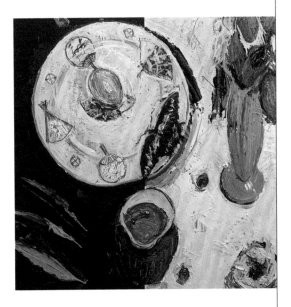

1978 **Big San Diego Show**, Newspace Gallery, Los Angeles
Gallery Artists, Hansen-Fuller Gallery, San Francisco
O.K. Harris Group Show, New York
P.S.1 Contemporary Art Center, Long Island City, New York
Southern California Styles of the Sixties and Seventies, La Jolla Museum of Contemporary Art [now Museum of Contemporary Art San Diego]
Transportation Show, M. H. de Young Memorial Museum, San Francisco
University of California, San Diego, Faculty Art Exhibition, Mandeville Art Gallery, University of California, San Diego

1976 **University of California, San Diego, Faculty Art Exhibition**, Mandeville Art Gallery, University of California, San Diego

1973 Newark Museum, Newark, New Jersey

1971 **Highlights of the 1970–71 Season**, Aldrich Museum of Contemporary Art, Ridgefield, Connecticut
Painting without Supports, Bennington College, Bennington, Vermont

1970 **Whitney Annual Painting Exhibition**, Whitney Museum of American Art, New York

1969 **Art on Paper**, Witherspoon Gallery, Greensboro, North Carolina
O.K. Harris Group Show, New York

1962 Kornblee Gallery, New York

1951 Group show organized by Peggy Guggenheim at Art of This Century Gallery, New York

Raphael, 1997
Oil on board
16 x 16 inches

2003　*Manny Farber: About Face*. La Jolla, Calif.:
　　　Museum of Contemporary Art San Diego.
　　　Exhibition catalogue.
　　　Yard, Sally. *Two for the Road: Sketchbooks of
　　　Patricia Patterson and Manny Farber*. La Jolla,
　　　Calif.: Athenaeum Music and Arts Library.
　　　Exhibition catalogue.

2002　Polito, Robert. "Painter of Pictures." *Artforum*
　　　40, no. 5 (April): 122–27.

2000　Bromley, Carl, ed. *Cinema Nation: The Best
　　　Writing on Film from* The Nation, *1913–2000*.
　　　New York: Thunder Mouth Press/Nation Books.
　　　(Reprints eleven essays by Manny Farber.)
　　　Hiss, Mark. "Still Life with Garden." *San Diego
　　　Home/Garden Lifestyles* (September), pp. 66–71,
　　　82–85.
　　　Jones, Kent. "The Throbbing Acuity of Negative
　　　Space." *Film Comment* 36, no. 2 (March/April):
　　　14–16.
　　　Pincus, Robert L. "He Paints It Like It Is." *San
　　　Diego Union-Tribune*, 18 May, sec. E, pp. 1, 4–5.

1999　*Framework: The Journal of Cinema and Media*, no.
　　　40 (April). (Issue dedicated to Manny Farber.)
　　　Lewinson, David. "Artist Farber's Work Continues
　　　to Evolve." *La Jolla Light*, 15 April, p. 5.
　　　Ollman, Leah. "Manny Farber at Quint
　　　Contemporary Art." *Art in America* 87, no. 10
　　　(October): 174, 175.
　　　Pincus, Robert L. "Bountiful Blossoms: Art
　　　History, Color Frolic in Manny Farber's Vibrant
　　　Paintings." *San Diego Union-Tribune*, 29 April,
　　　Night and Day, p. 57.

1998　Christensen, Judith. "Manny Farber: New
　　　Paintings." sandiego.sidewalk.com, 28 April.
　　　Farber, Manny. *Negative Space: Manny Farber on
　　　the Movies*. New York: Da Capo Press, 1998.
　　　(Expanded edition of *The Movies by Manny
　　　Farber*. New York: Hillstone, 1972.)
　　　Flood, Richard. "Reel Crank." *Artforum* 37, no. 1
　　　(September): 15–16.
　　　Pincus, Robert L. "The Art of Looking." *San Diego
　　　Union-Tribune*, 19 March, Night and Day sec., p. 16.
　　　Wolcott, James. "Hall of Fame." *Vanity Fair* (June),
　　　p. 146.

1997　Ollman, Leah. "Report from San Diego: A Change
　　　of Weather?" *Art in America* 85, no. 7 (July):
　　　34–39, 41, 43.
　　　Pincus, Robert L. "A Feast for Both Eye and Mind
　　　Is Laid out on Tabletops." *San Diego Union-
　　　Tribune*, 12 October, sec. E, pp. 3, 4.
　　　___. "Of Birds, Words and Presidents." *San Diego
　　　Union-Tribune*, 24 July, Night and Day sec.,
　　　pp. 30–32.

1996　Heartney, Eleanor. "Manny Farber at Charles
　　　Cowles." *Art in America* 84, no. 6 (June): 101.

1995　Pincus, Robert L. "No Surprise, Farber's Art
　　　Lovely." *San Diego Union-Tribune*, 23 February,
　　　Night and Day sec., p. 43.

1994　Edelstein, David. "A Painter, but Still a Critic."
　　　The New Yorker, 17 October, p. 22.
　　　"Manny Farber at Frumkin-Adams." *The New
　　　Yorker*, 17 October, p. 26.
　　　Kramer, Hilton. "Manny Farber." *New Criterion* 13,
　　　(October): 53.
　　　Ollman, Leah. "Manny Farber." *Art News* 93, no. 6
　　　(June): 188.
　　　Pincus, Robert L. "The Spirit of 76." *San Diego Union-
　　　Tribune*, 24 February, Night and Day sec., p. 26.

1993　*About Looking: Manny Farber Paintings,
　　　1984–1993*. Waltham, Mass.: Rose Art Museum,
　　　Brandeis University. Exhibition catalogue.
　　　Bertrand, François. "Manny Farber." *The New
　　　Yorker*, 12 April, p. 16.
　　　Hagen, Charles. "Manny Farber." *New York Times*,
　　　23 April, sec. C, p. 27.
　　　Johnson, Ken. "Manny Farber at Rosa Esman
　　　Gallery." *Art in America* 81, no. 10 (October): 134.
　　　Pagel, David. "Manny Farber: Rosa Esman
　　　Gallery." *Artforum* 32, no. 2 (October): 88–90.
　　　Pincus, Robert L. "In Retrospect, Two County
　　　Artists Gain Stature." *San Diego Union-Tribune*,
　　　18 June, sec. E, p. 6.
　　　Silver, J. "Manny Farber Rose Art Museum." *Art
　　　News* 92, no. 9 (November): 170.
　　　Stapen, Nancy. "Manny Farber's Visual Feast."
　　　Boston Globe, 1 July, pp. 25, 29.
　　　Tallmer, Jerry. "Vow Set in Concrete." *New York
　　　Post* (23 April 1993).

1992　Baker, Kenneth. "Farber Paintings All Over San
　　　Diego." *San Francisco Chronicle*, 26 October,
　　　sec. E, pp. 1–2.
　　　Freudenheim, Susan. "Small, Large Joys at Farber
　　　Show." *Los Angeles Times*, 9 March, sec. F, pp. 1, 9.
　　　Lister, Pricilla. "Manny Farber: Dean of Local
　　　Painters Piques." *San Diego Daily Transcript*,
　　　14 September, sec. A, pp. 1, 5.
　　　Ollman, Leah. "Still Life or Not Still Life?"
　　　Los Angeles Times (San Diego edition), 2 October,
　　　sec. F, pp. 1, 27.
　　　Pincus, Robert L. "Art: Paradoxical Period
　　　Continued, with No Shift Toward Coherence."
　　　San Diego Union-Tribune, 27 December, sec. E, p. 4.
　　　___. "Farber Onions Provide for Some Tasty Art."
　　　San Diego Union-Tribune, 15 October, Night and
　　　Day sec., pp. 45–46.
　　　___. "Farber's Art and His Life Won't Sit Still."
　　　San Diego Union-Tribune, 10 March, sec. E, pp. 1, 6.
　　　Quackenbush, Alyce. "State Your Case in Black and
　　　White." *La Jolla Light*, 22 October, sec. C, pp. 1, 8.

1991　Freudenheim, Susan. "Small, Large Joys at Farber
　　　Shows." *Los Angeles Times*, 9 March, p. F1.
　　　Jarmusch, Ann. "Farber Mixes Mundane Matters,

Anxious Dreams." *San Diego Union-Tribune*,
　　　22 February, sec. C, p. 22.
　　　Ollman, Leah. "Divided, Yet One in Art."
　　　Los Angeles Times (San Diego edition),
　　　15 February, pp. F1, F14–16.
　　　Yard, Sally. *Manny Farber: Paintings of the
　　　Eighties*. La Jolla, Calif.: Quint Krichman Projects.
　　　Exhibition catalogue.

1990　Agalides, S. "Allegories of Desire." *Artweek*,
　　　12 April, p. 14.
　　　"Manny Farber at Iris Krygier Contemporary Art."
　　　Sunset (October), p. 90.
　　　Pagel, David. "Manny Farber." *Arts Magazine* 64,
　　　no. 10 (Summer): 83.
　　　Pincus, Robert L. "Still Lifes and Times."
　　　San Diego Union, 14 January, sec. E, pp. 1, 9.

1988　Freudenheim, Susan. "Reviews: Manny Farber,
　　　Dietrich Jenny Gallery." *Artforum* 27, no. 2
　　　(October): 157–58.
　　　Perine, Robert. *San Diego Artists*. Encinitas,
　　　Calif.: Artra Publishing, Inc.

1987　McDonald, Robert. "Farber Puts His Visions on
　　　Display." *Los Angeles Times*, 21 April, sec. 6,
　　　pp. 1–2.
　　　Pincus, Robert L. "The Arts." *San Diego Union*,
　　　7 May, sec. C, p. 7.

1986　Amos, Patrick, and Jean-Pierre Gorin. "The Farber
　　　Machine." *Art in America* 74, no. 4 (April):
　　　176–85, 207.
　　　McDonald, Robert. "At the Galleries." *Los Angeles
　　　Times*, 8 August, sec. J, p. 19.
　　　McManus, Michael. "Incarnation: A Phenomenological
　　　Realism." *Artweek*, 11 January, p. 1.
　　　Wolcott, James. "Manny Farber's Termite Art."
　　　Vanity Fair (May), pp. 40, 43.

1985　Baker, Kenneth. "Manny Farber Paints It All."
　　　San Francisco Chronicle, 27 December, p. 74.
　　　Dubin, Zan. "The Many Facets of Manny Farber."
　　　Los Angeles Times, 1 November.
　　　Manny Farber. Los Angeles: The Museum of
　　　Contemporary Art. Exhibition catalogue.
　　　Knight, Christopher. "Farber Makes Difficulty
　　　Attractive." *Los Angeles Herald Examiner*,
　　　24 November, sec. E, p. 2.
　　　Lewinson, David. "Manny Farber Does It Again."
　　　San Diego Magazine (November), pp.182–85, 307.
　　　McDonald, Robert. "Wood Is the Word at Quint
　　　Gallery." *Los Angeles Times*, 2 August, sec. J, p. 1.
　　　Parker, Kevin. "Manny Farber and Landscape."
　　　Artforum 23, no. 6 (February): 72–75.

Pincus, Robert L. "Farber's Diary Is His Canvas." *San Diego Union*, 10 November, sec. E, pp. 1, 6.
___. "Contrasts in Life and Light." *San Diego Union*, 15 December, sec. E, p. 2.
Thwaites, Lynette. "Artist Turns Still Life into Landscape of Private World." *La Jolla Light*, 27 June, sec. B, pp. 1, 10.

1984 "Be Imaginative." *KPBS On Air*, 1 July, p. 6.
Hyman, Barry. "Gimme a Hammer." *New Indicator* (La Jolla), 29 May, p. 8.
Lewinson, David. "Influences of Film." *Artweek* 9 June, p. 10.
___. "Looking at Farber's Paintings Can Be a Movie Experience." *San Diego Union*, 31 May, sec. B, p. 11.
Lugo, Mark-Elliott. "Farber Show 'Nothing Short of Spectacular.'" *San Diego Evening Tribune*, 1 June, sec. F, p. 1.
Ponti, Roland. "Between Pollock and Pop." *San Diego Reader*, 17 May, pp. 1, 6.

1983 Crary, Jonathan. "Review of Exhibitions: Manny Farber at Larry Gagosian." *Art in America* 71, no. 12 (December): 155.
Wilson, William. "The Galleries." *Los Angeles Times*, 6 May, sec. 6, p. 13.

1982 Bass, Ruth. "New York Reviews: Manny Farber, Oil and Steel." *Art News* 81, no. 4 (April): 217.
Storr, Robert. "Manny Farber: Oil and Steel." *Art in America* 70, no. 3 (March): 139.

1981 Ashbery, John. "An Exhilarating Mass." *Newsweek*, 23 February, p. 82.
Hoberman, J. "Termite Makes Right: The Subterranean Criticism of Manny Farber." *Village Voice*, 20 May.
Hughes, Robert. "Quirks, Clamors, and Variety." *Time*, 2 March, pp. 84–87.
Knight, Christopher. "'Emergent Americans' a Pluralistic Affair." *Los Angeles Herald Examiner*, 23 March, sec. B, pp. 1–2.
Perreault, John. "Exxon-Erated?" *Soho News*, 4 February, p. 49.
Rickey, Carrie. "Curatorial Conceptions—The Guggenheim: Singular Pluralism." *Artforum* 19, no. 8 (April): 58–60.
Russell, John. "A Roundup of Emerging Artists." *New York Times*, 8 February, sec. 11, pp. 33, 35.
Schjeldahl, Peter. "Stock Options." *Village Voice*, 18 February, p. 73.
Tallmer, Jerry. "A Critic Paints in Puns and Jokes." *New York Post*, 7 February, p. 15.

1980 Miller, Elise. "UC San Diego Faculty Exhibit Presents Panorama of the Arts." *Los Angeles Times* (San Diego edition), 7 June, p. 5.

1978 Cleigh, Zenia. "Urban Eye: Termite Art." *San Diego Magazine* (May), p. 38.

Goldin, Amy. "Manny Farber: Reforming Formalism." *Art in America* 66, no. 5 (May/June): 94–99.
Goldin, Amy, and Richard Armstrong. *Manny Farber*. La Jolla, Calif.: La Jolla Museum of Contemporary Art (now Museum of Contemporary Art San Diego) . Exhibition catalogue.
Guheen, Elizabeth. "Object Lessons." *San Diego Reader*, 8 June, p. 10.
Jennings, Jan. "Exhibit Shows the Traditional with Painting." *San Diego Evening Tribune*, 9 May, sec. D, p. 3.
King, Pamela. "Farber's Vision on Display in La Jolla." *Los Angeles Herald Examiner*, 4 June, sec. F, p. 8.
Muchnic, Suzanne. "Ex-Carpenter Nails Down a Niche as Sculptor." *Los Angeles Times*, 28 May, Calendar sec., p. 86.
Rigby, Ida. "Manny Farber: From Abstraction to Realism." *Artweek*, 27 May, p. 1.
Rye, Bjorn. "Manny Farber, Ruth S. Schaffner Gallery." *Artforum* 16, no. 9 (May): 70.
Smith, Susan. "Manny Farber: Artist Critic." *Los Angeles Times*, 23 June, sec. 4, p. 16.
Wasserman, Isabelle. "It's an Honor of a Lifetime." *San Diego Union*, 6 June, sec. E, p. 1.

1977 Frank, Peter. "Review of Exhibitions: Manny Farber at Seder-Creigh." *Art in America* 65, no. 11 (November): 137.
Rickey, Carrie. "Manny Farber." *Arts Magazine* 52, no. 1 (September): 9.

1976 Baker, Kenneth. "A Painting by Manny Farber." *Arts Magazine* 51, no. 4 (December): 122–23.
Phelan, Ellen. "Manny Farber's Reversible Paintings." *Artweek*, 16 November, p. 13.
Plagens, Peter. "Review of Exhibitions: Manny Farber at David Stuart." *Art in America* 62, no. 1 (January/February): 106–107.
Reilly, Richard. "UCSD Show Demonstrates a Faculty of Arts." *San Diego Union*, May/June, sec. E, p. 1.

1973 Baker, Kenneth. "Art: Critic as Painter." *Boston Phoenix*, 2 January, p. 14.
___. "Review of Exhibitions: Manny Farber at Parker 470." *Art in America* 61, no. 5, (May/June): 106.
Campbell, Lawrence. "Reviews and Previews: Manny Farber." *Art News* 72, no. 5 (May): 96.

Dunham, Judith. "Manny Farber 'Paintings.'" *Artweek*, 27 October, p. 1.
Stitelman, Paul, and Richard Channin. "New York Galleries: Manny Farber, O.K. Harris." *Arts Magazine* 48, no. 1 (September): 60.
Wilson, William. "Manny Farber's Paintings Exhibited at David Stuart Galleries." *Los Angeles Times*, 16 November, sec. 4, p. 18.

1972 Channin, Richard. "The Rise of Factural Autonomy." *Arts Magazine* 47, no. 3 (November): 30–37.
Ratcliff, Carter. "Chronicles: New York Letter." *Art International* 16 (February): 54.
Shirley, David. "Farber Paintings Show Shift to a Quieter Style." *New York Times*, 1 January, p. 9.
Taylor, Robert. "Farber Captures Imagination Without Even Using a Frame." *Boston Globe*, 20 December, p. 42.

1971 Baker, Kenneth. "Film Critic Farber in Two Art Shows." *Christian Science Monitor*, 22 February, p. 4.
Farber, Manny. *Negative Space: Manny Farber on the Movies*. New York: Praeger, 1971. Reprinted in paperback as *Movies*. New York: Hillstone, 1972.
Linville, Kasha. "Manny Farber, O.K. Harris." *Artforum* 9, no. 8 (April): 81–82.
Schwartz, Barbara. "Reviews and Previews: Manny Farber." *Art News* 70, no. 4 (April): 12.
Shirley, David. "Downtown Scene: Shaped Paintings of a Film Critic." *New York Times*, 3 March, p. 38.
Wills, Domingo. "New York Galleries: Manny Farber at O.K. Harris." *Arts Magazine* 45, no. 8 (April): 82.

1970 Pincus-Witten, Robert. "Manny Farber, O.K. Harris Gallery Studio Exhibition." *Artforum* 8, no. 9 (May): 74.
Rosenstein, Harris. "Reviews and Previews: Manny Farber." *Art News* 69, no. 5 (May): 65.
Sandler, Irving. "Reviews and Previews: Manny Farber." *Art News* 69, no. 10 (October): 13.

1962 "Exhibition at Kornblee Gallery." *Art News* 61, no. 10 (October): 12.

1961 "Insiders and Others." *Arts Magazine* 35, no. 5 (January): 42–45.

1956 Hess, Thomas. "Manny Farber: Writing as Painting." *Art News* 55, no. 11 (November): 37.
Sawin, Martica. "In the Galleries: Manny Farber." *Arts Magazine* 31, no. 4 (December): 61.

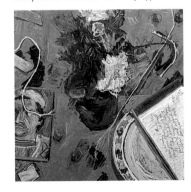

opposite page:
Pathos, 1998
Oil on board
19 x 19 inches

Mantegna, 1997
Oil on board
16 x 16 inches

Allendale Insurance Company, Boston

Carnegie Museum of Art, Pittsburgh

Solomon R. Guggenheim Museum, New York

Los Angeles County Museum of Art

James A. Michener Collection, Jack S. Blanton
 Museum of Art, University of Texas at Austin

MIT List Visual Arts Center, Cambridge,
 Massachusetts

The Museum of Contemporary Art, Los Angeles

Museum of Contemporary Art San Diego

Museum of Fine Arts, Boston

Orange County Museum of Art, Newport Beach,
 California

Prudential Life Insurance, Newark, New Jersey

Rose Art Museum, Brandeis University, Waltham,
 Massachusetts

San Diego Museum of Art

University Art Gallery, University of California,
 San Diego

Whitney Museum of American Art, New York

Worcester Art Museum, Worcester, Massachusetts

Barbara Bloom
Meredith Brody
Matt and Nancy Browar
Marc and Patty Brutten
Renée Comeau and Terry Gulden
Larry and Sally Dodge
Sue K. and Charles C. Edwards, M.D.
Amanda Farber
Esther and Bud Fischer
The Flaster Family
Pauline Foster
Jean-Pierre Gorin
Raphael J. Gregoire
Solomon R. Guggenheim Museum, New York
Sheri Jamieson
Dr. S. Sanford and Charlene S. Kornblum
Michael Krichman and Carmen Cuenca
Jeanne K. Lawrence
Mark-Elliott Lugo
Nina MacConnel
Matthew Mason
Elyse and Bruce Miller
The Museum of Contemporary Art, Los Angeles
Anne and Bob Nugent
Robert and Fran Preisman
Private Collections, New York
J. Paul and Zillah Reddam
Alan Ritchie
The Rose Art Museum, Brandeis University,
 Waltham, Massachusetts
Robert A. Rowan Collection
Colette Carson Royston and Dr. Ivor Royston
San Diego Museum of Art
Dr. David Schiebel
Paul Schrader
Sheila and Michael Sharpe
Douglas A. Simay
Margaret and Terry Singleton
Bennett Tramer and Sonya Sones
Victor and Gilda Vilaplana
Wim Wenders
Charles J. Williams and Sharon M. Little
David Wilson
Lise Wilson and Steve Strauss
Scott and Cissy Wolfe

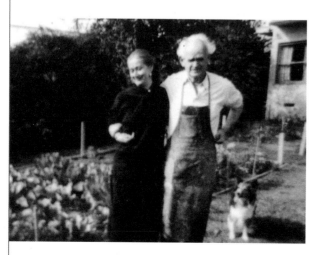